BALTIMORE STREETCAR
MEMORIES

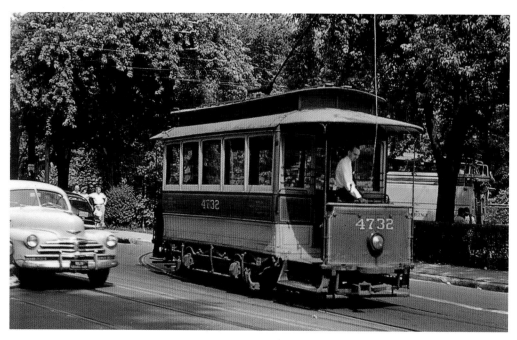

On July 11, 1954, car No. 4732 is on Baltimore Transit Company (BTC) route 8 on Frederick Road at Irvington loop marking its donation by the BTC to the Maryland Historical Society. Believed to be built as horse car no. 417 in 1885 by the Baltimore City Passenger Railway Company, it was electrified as United Railways and Electric Company (UR&EC) No. 427 in 1895 with two Westinghouse type 49 motors, and later became No. 4732. Weighing 16,300 pounds and seating 20 passengers, it was preserved by the Baltimore Transit Company from 1935 to 1954, preserved by the Maryland Historical Society from 1954 to 1968, and since 1968 has been at the Baltimore Streetcar Museum. (Bob Crockett photograph—C. R. Scholes collection.)

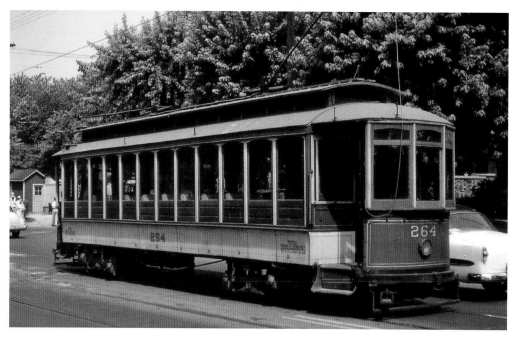

Baltimore Transit Company (BTC) route 8 on Frederick Road at Irvington loop is the location of car No. 264 on July 11, 1954 marking its donation and the donation of the historic streetcar collection by the BTC to the Maryland Historical Society. Weighing 31,700 pounds, seating 46 passengers, and powered by two Westinghouse type 56 motors, this convertible type car was built by the Brownell Car Company in 1900. It was first preserved by the Baltimore Transit Company from 1935 to 1954, preserved by the Maryland Historical Society from 1954 to 1968, and since 1968 has been at the Baltimore Streetcar Museum. (Bob Crockett photograph—C. R. Scholes collection.)

BALTIMORE
STREETCAR
MEMORIES

KENNETH C. SPRINGIRTH

AMERICA
THROUGH TIME®
ADDING COLOR TO AMERICAN HISTORY

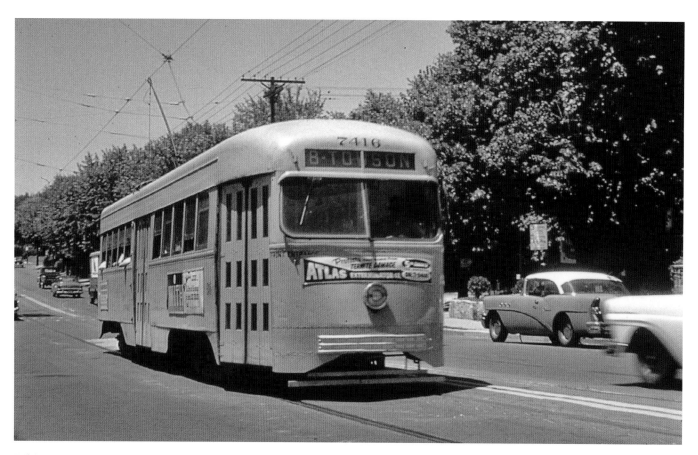

Baltimore Transit Company route 8 Presidents' Conference Committee (PCC) car No. 7416 is on Frederick Road at Irvington loop in 1963. This was one of 25 PCC cars Nos. 7404-7428 built by Pullman-Standard Car Manufacturing Company and delivered between November and December 1944. Powered by four Westinghouse type 1432 motors, each car weighed 36,000 pounds and seated 55 passengers. (Bob Crockett photograph—C. R. Scholes collection.)

On the top portion of cover: Route 15 PCC car No. 7104 is pulling out of Walbrook Junction loop heading for Overlea in 1963. This was one of 50 PCC cars Nos. 7098-7147 built by Pullman Standard Car Manufacturing Company (each powered by four General Electric type 1198 motors) and delivered between April and July 1944. Before the end of 1963, Baltimore Transit Company would have its last streetcar routes 8 and 15 converted to bus operation. (Bob Crockett photograph—C. R. Scholes collection.)

On the bottom portion of cover: In 1946, Baltimore Transit Company car No. 5860 (originally numbered 2636) is leading a two-car train in downtown Baltimore on Lombard and Calvert Streets. This was one of 50 cars built in 1919 by J. G. Brill Company, originally Nos. 2601-2650 (renumbered 5825-5874 during 1922). These cars were actually purchased by the United States Emergency Fleet Corporation and leased to the UR&EC. (Bob Crockett photograph—C. R. Scholes collection.)

Back cover: Lakeside loop off Roland Avenue is the location of Baltimore Transit Company car No. 5706 in 1954. Powered by four General Electric type 200-I motors, this car, originally No. 3107, was one of 100 cars built in 1917 by J. G. Brill Company and renumbered 5645-5744 in 1922. These cars, equipped with fully enclosed platforms and mechanically operated folding doors and steps, were virtually identical to the 85 cars, Nos. 5560-5644, that were received in 1914. (C. R. Scholes collection.)

America Through Time is an imprint of Fonthill Media LLC

First published 2017

Copyright © Kenneth C. Springirth 2017

ISBN 978-1-64399-034-9

Typeset in Utopia Std

Published by Arcadia Publishing by arrangement with Fonthill Media LLC

For all general information, please contact Arcadia Publishing:

Telephone: 843-853-2070
Fax: 843-853-0044
E-mail: sales@arcadiapublishing.com
For customer service and orders:
Toll-Free 1-888-313-2665

Visit us on the internet at www.arcadiapublishing.com

Contents

Acknowledgments

Thanks to the Erie County (Pennsylvania) Public Library system for their excellent staff and inter library loan system. All postcard scenes are from the author's collection. Clifford R. Scholes was an excellent source for pictures and is noted on the picture credit line as C. R. Scholes. Books that served as excellent reference sources were *Who Made All Our Streetcars Go? The Story Of Rail Transit In Baltimore* by Michael R. Farrell; *The Best Way To Go, The History of the Baltimore Transit Company* by Fr. Kevin A. Mueller; *Baltimore Streetcars 1905-1963: The Semi-Convertible Era* by Bernard J. Sachs, George F. Nixon, and Harold E. Cox; *Baltimore Streetcars The Postwar Years* by Herbert H. Harwood, JR.; *Baltimore's Light Rail Line* by Herbert H. Harwood, JR.; *A Guide To The Baltimore Streetcar Museum* by Andrew S. Blumberg; and *The Trolley Coach in North America* by Mac Sebree and Paul Ward. Motor Coach Age magazine November-December 1988 had an excellent article titled "Baltimore Transit under NCL." Thanks to the Baltimore Streetcar Museum 1901 Falls Road, Baltimore, Maryland 21211 for preserving their large collection of Baltimore streetcars, website www.baltimorestreetcar.org, and the Seashore Trolley Museum 195 Log Cabin Road, Kennebunkport, Maine 04046, website www.trolleymuseum. org, for saving Baltimore Peter Witt streetcar No. 6144 and semi-convertible type No. 5748. The fantastic volunteers at both museums and at trolley/train museums in the United States and Canada have done an amazing job of preserving our rail heritage.

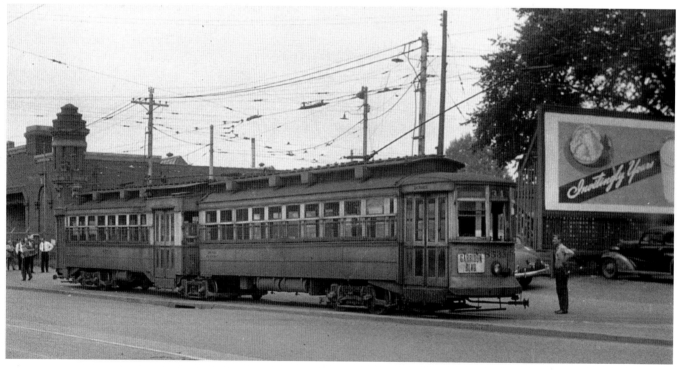

On July 7, 1946, Baltimore Transit Company articulated streetcar No. 8533 (built from open bodies Nos. 1081 and 1082 that were originally built in 1902) is at the Belvedere carhouse. This was one of 16 articulated streetcars built by UR&EC (six in 1926 Nos. 8521-8526 and ten in 1930-1931 Nos. 8527-8536). UR&EC shipped car No. 8525 to the 1926 and 1927 convention of the American Electrical Railway Association in Cleveland to show other transit companies that they could also build articulated cars, but none did. With the ability to handle large crowds, these cars were used for rush hour, special event runs, and throughout World War II on heavy ridership routes 5, 6, 8, 15, 20, 26, and 31. By the end of 1948, all of these cars had been scrapped. Baltimore was ahead of its time with articulated cars. In 2017, articulated cars are used on modern light rail systems. (Bob Crockett photograph—C. R. Scholes collection.)

Introduction

With the formation of the United Railways and Electric Company (UR&EC) in 1899, Baltimore's streetcar operation with its 5 foot 4.5 inch wide gauge track, the widest in North America, was unified. Over a period of time, the wide variety of equipment was replaced by 885 semi-convertible streetcars (a streetcar with windows that could be raised into the pocket of the car roof in warm weather and closed in cold weather) built by the J. G. Brill Company of Philadelphia. The UR&EC purchased 150 Peter Witt type streetcars in 1930 with 100 cars Nos. 6001-6050 and Nos. 6101-6150 built by J. G. Brill Company, and 50 cars Nos. 6051-6100 built by Cincinnati Car Company. Designed by Cleveland Transit commissioner Peter Witt, passengers boarded through the front doors and paid just before they exited. The increased use of automobiles and the Great Depression resulted in ridership declining from 193 million in 1929 to about 104 million by 1933. The company went bankrupt and was placed in receivership on January 6, 1933. Court appointed receivers William H. Meese (Western Electric plant manager) and Lucius Storrs (UR&EC president) changed the fixed interest payments that were made to bondholders even if the company was not making any money to paying dividends only if the company was profitable.

The company emerged from bankruptcy and became known as the Baltimore Transit Company (BTC) on July 9, 1935. Federal restrictions prohibiting laying streetcar tracks on federally funded roadways resulted in streetcar cutbacks. With the building of the Orleans Street viaduct, the eastern half of streetcar route 4 was combined with route 6 on December 31, 1935. A new bridge on Wilkens Avenue over Gwynns Falls resulted in converting route 3 from Halethorpe to Wilkens Avenue and Brunswick Street to bus operation. The remainder of route 3 was converted to bus operation on November 15, 1936.

A design committee formed in 1929 (it became the Electric Railway Presidents' Conference Committee) developed a new, quiet, comfortable, and faster streetcar. Baltimore was the third city in North America to place the new Presidents' Conference Committee (PCC) cars in service. Brooklyn & Queens Transit Company received the first PCC car on May 28, 1936 followed by Pittsburgh Railways Company on July 26, 1936 and Baltimore Transit Company on September 2, 1936. By the end of 1944, Baltimore had 275 PCC cars, ranking it eighth in North America after Toronto with 745, Chicago with 683, Pittsburgh with 666, Philadelphia with 559, Washington D.C. with 489, Boston with 344, and St. Louis with 300. The peak number of streetcars operated by BTC was 1,080 in 1942 and 1943.

Route 21 (Preston Street) was replaced by trackless trolleys on March 6, 1938. Baltimore's first trackless trolley line was operated by the UR&EC between Randallstown and Gwynn Oak Junction from 1922 until replaced by buses in 1931. The reintroduction of trackless trolleys in Baltimore occurred because the BTC viewed trackless trolleys as the best vehicle for medium density routes. Streetcar route 22 (Washington Street-Canton) was eliminated on June 23, 1938 with replacement by extending some route 34 (Canton) streetcar trips. Trackless trolleys replaced streetcars on route 27 (Federal Street) on January 1, 1939. Route 10 (Roland Park-Highlandtown) became trackless trolley on April 14, 1940.

By February 1945, National City Lines (NCL), organized and funded by General Motors, Firestone Tire, Standard Oil of California, and Phillips Petroleum, had acquired a sizeable amount of BTC stock and wanted to have two members on the BTC Board of Directors, which was granted. With the retirement of BTC president Bancroft Hill on July 1, 1945, NCL's Fred A. Nolan became BTC president. During 1945, BTC announced a plan to abandon half of its streetcar system. BTC, relieved from removing rail, paid the City of Baltimore $2.5 million, primarily for street paving and maintenance.

On June 22, 1947, a number of streetcar lines were converted to bus operation. BTC came under considerable criticism after the first major changes were made. The Public Service Commission (PSC) conducted hearings in January 1948 and concluded BTC was responsible to make improvements. However, conversion to bus operation was not halted. When the route 26 (Sparrows Point) was converted to bus operation on August 31, 1958, only two streetcar routes, 8 (Towson-Catonsville) and 15 (Overlea-Walbrook), remained. Both lines had the highest ridership and made their last runs in the early morning hours of November 3, 1963. PCC car No. 7407 on a rail excursion made the last run into the Irvington carhouse at 6:34 a.m., and that car has been preserved at the Baltimore Street Museum.

A new era began almost 29 years later on April 3, 1992 when the first section of the Baltimore Central Light Rail Line opened. With the completion of several extensions, the line totaled 29.3 miles on September 9, 1997.

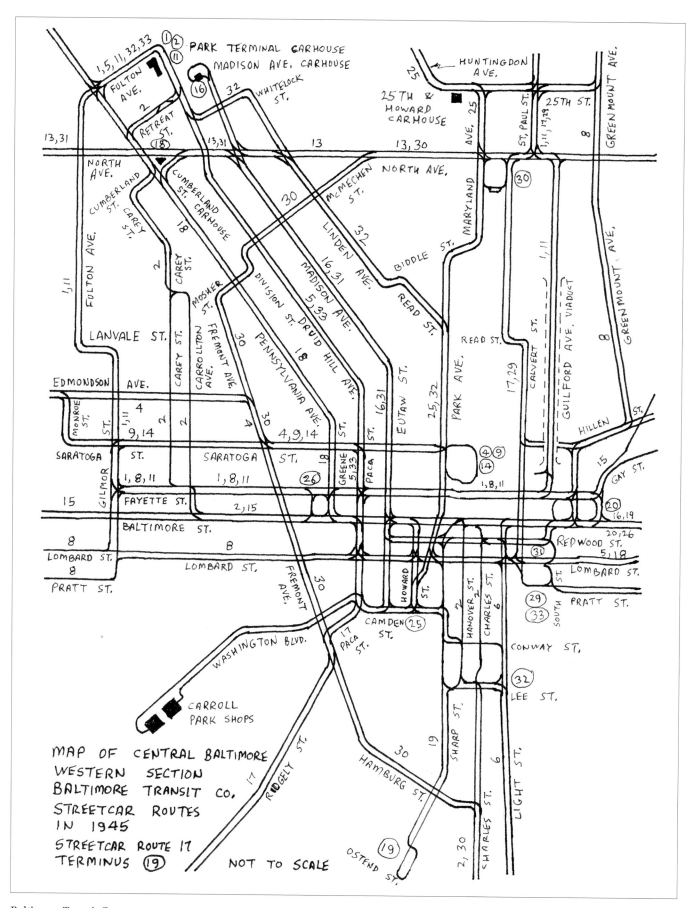

Baltimore Transit Company streetcar routes in central Baltimore from Greenmount Avenue and west are shown in this 1945 map.

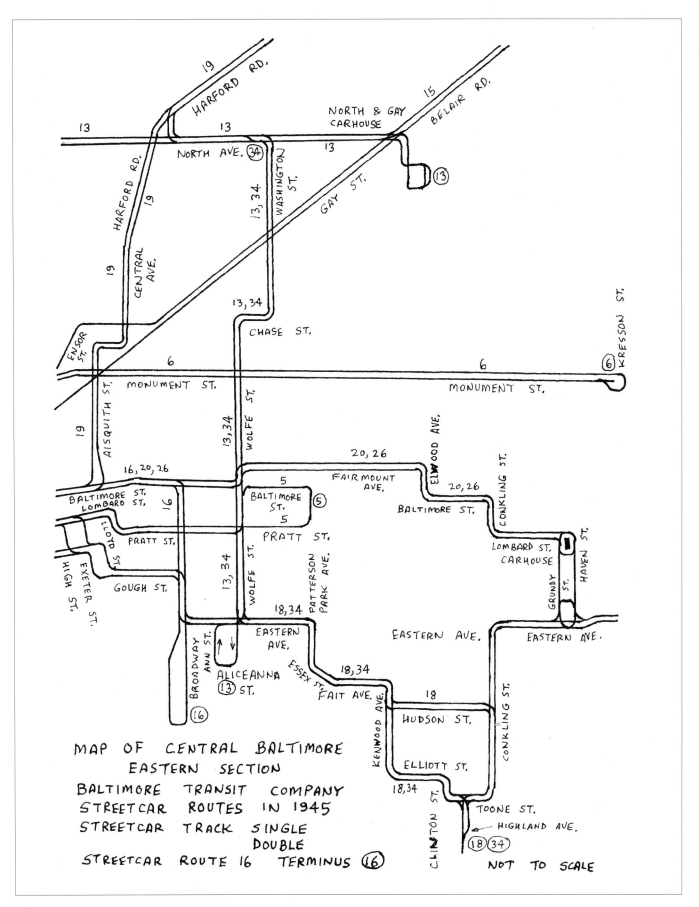

MAP OF CENTRAL BALTIMORE
EASTERN SECTION
BALTIMORE TRANSIT COMPANY
STREETCAR ROUTES IN 1945
STREETCAR TRACK SINGLE
 DOUBLE
STREETCAR ROUTE 16 TERMINUS ⑯

NOT TO SCALE

Baltimore Transit Company streetcar routes in central Baltimore east of Greenmount Avenue are shown in this 1945 map.

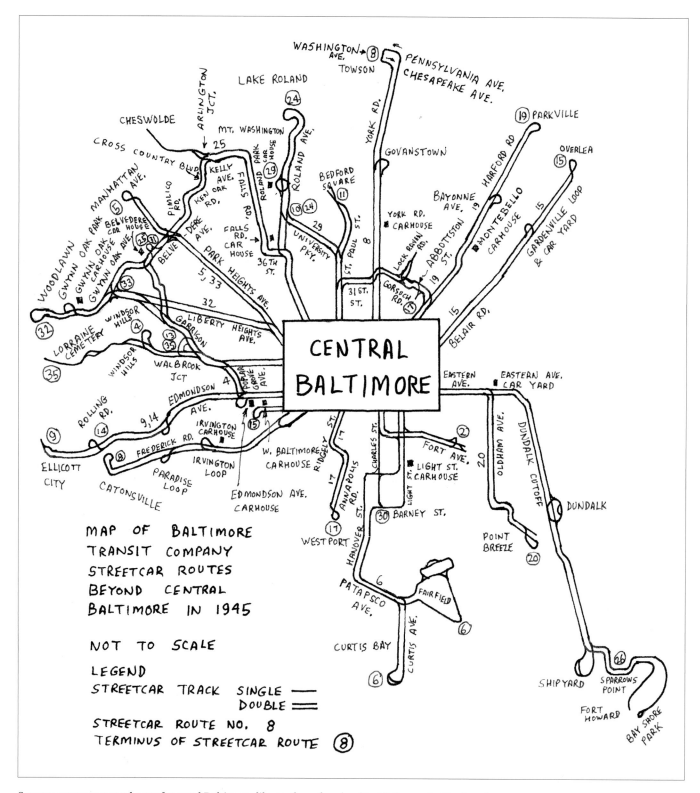

Streetcar routes spread out of central Baltimore like spokes of a wheel in 1945 as noted in the above map.

Chapter 1

Baltimore Streetcar History

In March 1876, the Baltimore & Hampden Railway opened a horse-drawn, later mule-drawn, car line from Howard Street and Huntingdon Avenue to Roland Avenue and 40th Street in Hampden. Professor Leo Daft, founder of the Daft Electrical Company, installed electric locomotives (that received power from a third rail located in the center of the tracks) pulling passenger cars for the Baltimore & Hampden Railway over a portion of this line, beginning August 15, 1885, making it the first electric line in the United States.

However, in 1889, the electrical system was worn out, and the line went back to animal power. On June 10, 1891, the Baltimore & Hampden Railway was leased to the Baltimore Union Passenger Railway and became part of its electrified Maryland Avenue line, which had overhead wire.

Baltimore Traction Company opened a cable car line from Druid Hill Park through downtown Baltimore to Patterson Park on May 25, 1891. Central Railway opened an overhead electric streetcar line from Clifton Avenue and Druid Hill Avenue via Fulton Avenue, Lanvale Street, Argyle Avenue Biddle Street, Bolton Street, Preston Street, and Caroline Street to Lancaster Street on September 22, 1892.

The Lake Roland Elevated Railway opened the first electric line operating on an elevated line in the United States over Guilford Avenue between Lexington and Chase Streets on May 3, 1893. Baltimore Traction Company converted its Druid Hill Avenue cable car line to overhead trolley wire on October 4, 1896.

The many Baltimore public transit companies merged into three companies by 1898: Baltimore Consolidated Railway Company with 818 cars and 181 miles of track, Baltimore City Passenger Railway Company with 407 cars and 103 miles of track, and Baltimore & Northern Electric Railway Company with 53 cars and 40 miles of track. On January 25, 1899, Baltimore's streetcar companies were consolidated into the United Railways & Electric Company (UR&EC).

Between November 1905 and November 1919, UR&EC placed in service 885 semi-convertible cars Nos. 5001-5884. Car bodies and trucks were built by J. G. Brill Company. Motors, controllers, and final assembly were completed at UR&EC's new shops at Carroll Park.

Jitneys, basically a truck body with benches, appeared in Baltimore in 1915, cruising streetcar routes to pick up passengers, which decreased the company's revenues. The Public Service Commission introduced regulations which eventually resulted in the end of jitney operation. With various parties approaching the City of Baltimore to establish a bus system, in July 1915, the UR&EC began bus service under the subsidiary Baltimore Transit Company. Three other bus subsidiaries were created by the UR&EC (City Motor Company, East Fayette Bus Company, and Baltimore Bus Company). In 1926, the four bus subsidiaries were merged into the Baltimore Coach Company.

On November 1, 1922, UR&EC opened a trackless trolley line on Liberty Road from Gwynn Oak Junction to Randallstown, using three trackless trolleys built by J. G. Brill Company. The trackless trolley line was replaced by motor buses on August 31, 1931. In spite of efforts to control costs, by 1932, expenditures were $2 million more than revenue. The UR&EC went bankrupt and was placed in receivership on January 6, 1933. In August 1933, route 23 (Back & Middle Rivers) was cut back because a bridge over the Black River was severely damaged by a hurricane. Instead of repairing the bridge, the UR&EC placed a shuttle car on the isolated portion of the line between Black and Middle Rivers, beginning August 24, 1933. A year later the line was replaced by a bus.

Under court appointed receivers William H. Meese (Western Electric Point Breeze plant manager) and Lucius Storrs (UR&EC president), the former fixed interest payments that were made to bondholders were eliminated. Dividends would be paid only if the company was profitable. The company emerged from bankruptcy and became known as the Baltimore Transit Company (BTC) on July 9, 1935.

Baltimore Transit Company (BTC) ordered 27 of the new modern Presidents' Conference Committee (PCC) Cars Nos. 7001-7027 from St. Louis Car Company during 1936. Car No. 7023 was the first PCC car to be delivered to BTC on September 2, 1936. It made its first public revenue run on a special downtown routing on October 26, 1936. Route 31 (Garrison Boulevard) was the first line to receive one PCC car on December 1, 1936. Additional PCC cars were placed in service on route 31 beginning December 6, 1936. On March 6, 1938, trackless trolleys returned to Baltimore, replacing streetcars on route 21 (Preston St.-Caroline St.). In November

1938, BTC ordered 40 PCC cars from Pullman-Standard Car Manufacturing Company at a price of $15,921.50 per car, and delivery of these cars began on May 2, 1939. Trackless trolleys replaced route 27 (Howard-Federal-Preston) streetcars on January 1, 1939. Streetcar route 10 (Roland Park-Highlandtown) was converted to trackless trolley on April 14, 1940.

During World War II, many of the old semi-convertible streetcars were rehabilitated at the BTC Carroll Park shops to help handle the increased ridership. World War II resulted in a temporary halt to the abandonment of streetcar lines. However, in response to a State Roads Commission request to BTC that route 23 track and overhead wire be removed in Baltimore County so that Eastern Avenue could be rebuilt, BTC abandoned the portion of streetcar route 23 from Highlandtown to Black River on February 11, 1942, which was replaced by bus route P (Middle River). Having lost 251 employees for the war effort before the end of 1942, BTC hired its first woman operator on October 27, 1942.

In October 1943, 25 PCC cars Nos. 7404-7428 were ordered from Pullman Standard Car Manufacturing Company and were delivered during November-December 1944. These were the last streetcars delivered to BTC.

In 1945, National City Lines (NCL) had acquired a sizeable amount of BTC stock. On July 1, 1945, Fred A. Nolan, president of Los Angeles Transit Lines that was controlled by NCL, became president of BTC. When NCL acquired a transit property, streetcar lines were soon converted to bus operation. Plans were being made to convert half of BTC's streetcar lines to bus operation. To implement the plan, BTC had to be relieved of renewing its streetcar franchises. The City of Baltimore and BTC had been in a disagreement over taxes. On December 7, 1945, BTC agreed to pay the City of Baltimore $401,246 with the city agreeing to free BTC from renewing its streetcar franchises. The City of Baltimore's plan for one way streets was also a factor in the conversion to bus operation which began on June 22, 1947. Streetcar routes 11, 17, and 29 were abandoned. Streetcar route 1 was cut back to Fayette and Gay Streets. On March 21, 1948, route 6 (Monument and Kresson to Curtis Bay) was replaced by buses. On May 9, 1948, most of the West Baltimore Street streetcar tracks were paved over. Route 16 (Madison Avenue) was replaced by buses. Route 20 was cut back to its prewar operation between Highlandtown and Point Breeze. Bus route 20 replaced the downtown to Highlandtown portion of streetcar route 20 and the West Baltimore Street portion of streetcar route 15 as route 15 was cut back to Fayette and Pearl. Route 19 was cutback to Hanover and Lombard. Routes 1, 2, 18, and 26 were rerouted over Fayette Street. On June 15, 1948, route 33 from West Arlington to Pratt and South Streets was replaced by buses. Route 5 was converted to buses. Along with this change, route 33 trackage from Gwynn Oak Junction to Belvedere carhouse was taken over by a branch of route 32. The

section of route 32 north of North Avenue was rerouted from Linden and Druid Hill to Pennsylvania Avenue. On July 24, 1948, the remaining portion of route 20 was converted to bus. Route 2 (Carey Street-Fort Avenue) was replaced by trackless trolleys on December 12, 1948. Buses replaced streetcars over the portion of route 25 between Mt. Washington and Camden Station on April 24, 1949.

With approval granted by the Public Service Commission (PSC) on December 5, 1949 to abandon the Guilford Avenue Elevated, route 8, the only line using the Guilford Avenue Elevated, went back to its Greenmount Avenue routing (that it had last used June 21, 1947) on January 1, 1950. Streetcar route 24 was replaced by the route 56 bus on January 29, 1950. The last day for streetcar route 34 (Eastern and Oldham to Conkling and Toone) was March 4, 1950. Effective July 30, 1950, route 26 (Sparrows Point) streetcars no longer operated between Fayette and Pearl Streets in downtown Baltimore to Highlandtown. Route 26 streetcars only operated between Highlandtown (Pratt and Grundy Streets) and Sparrows Point.

In 1951, the City of Baltimore paid most of the costs of renewing track and overhead wire, and no streetcar lines were abandoned. When plans to make certain streets one way resulted in track changes, BTC noted it could not afford to make any changes without financial assistance, and the city provided the financial assistance.

On June 7, 1952, route 18 (Pennsylvania Avenue) was converted to bus operation resulting in the closure of the Park Terminal carhouse. Route 9, the Ellicott City line through car service to downtown Baltimore on August 8, 1952 was discontinued. On October 13, 1952, route 32 (Woodlawn) was cut back from Light and Lee Streets to Camden Station, and route 31 (Garrison Boulevard) was absorbed by the route 19 (Harford Road). The Fort Howard shuttle, which operated between Sparrows Point and Fort Howard, made its last streetcar run on October 18, 1953.

On March 1, 1954, the Baltimore Coach Company (formed as a subsidiary to operate buses by UR&EC in 1926) merged into the BTC on March 1, 1954. Buses replaced Route 13 (North Avenue) streetcars on January 10, 1954, and buses replaced route 35 (Lorraine) streetcars on February 27, 1954. Streetcar route 15 was extended to take over route 4, and streetcar route 14 was replaced by extending the route 23 (Middle River) bus to West Baltimore on September 19, 1954. Buses replaced route 9 streetcars on June 20, 1955, and buses replaced route 32 (Woodlawn) streetcars on September 4, 1955. On June 19, 1956, buses replaced route 19 (Harford Road) streetcars along with the Walbrook-Windsor Hills branch of streetcar route 15. On August 31, 1958, the remainder of route 26 from Highlandtown to Sparrows Point was replaced by buses. The final two streetcar routes, 8 and 15, were replaced by buses on November 3, 1963.

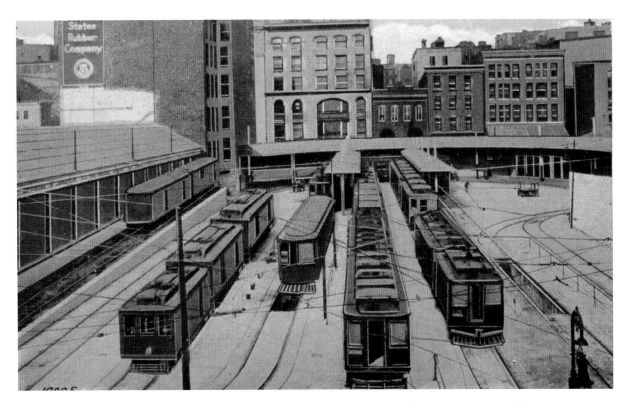

The Washington, Baltimore & Annapolis Electric Railroad (WB&A) terminal at Howard and Lombard Street in Baltimore is shown is this view around 1920. The WB&A merged with the Baltimore & Annapolis Railroad on February 21, 1921 and ceased operations on August 20, 1935. Under reorganization, rail passenger service continued to operate between Baltimore and Annapolis by the Baltimore & Annapolis Railroad Company.

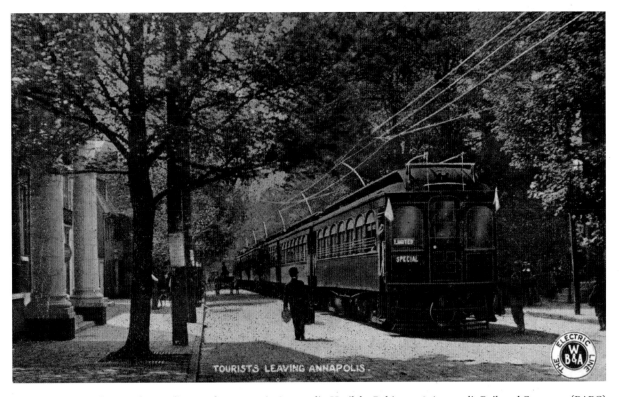

This 1920s postcard scene shows a lineup of streetcars in Annapolis. Until the Baltimore & Annapolis Railroad Company (BARC) converted to bus operation on February 5, 1950, there was frequent electric interurban service between Baltimore and Annapolis. On April 29, 1973, the Mass Transit Administration (MTA) acquired the BARC bus system, and the line to Annapolis became MTA bus route 14. The southernmost 6 miles of the Baltimore Central Light Rail Lines uses the former interurban right of way.

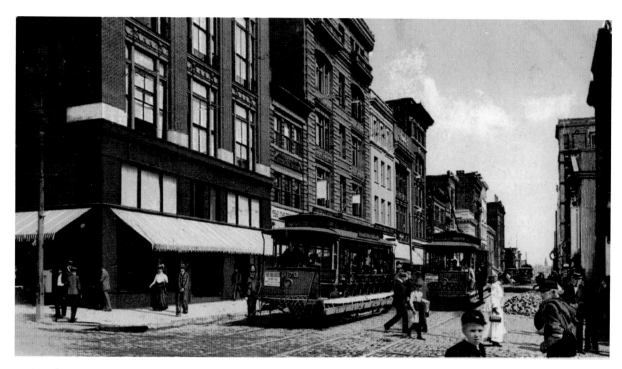

In this postcard scene around 1900, two United Railways and Electric Company (UR&EC) open summer streetcars pass on Baltimore Street east of Charles Street. These cars were popular with the public because they provided a nice way to cool off in Baltimore's hot summer.

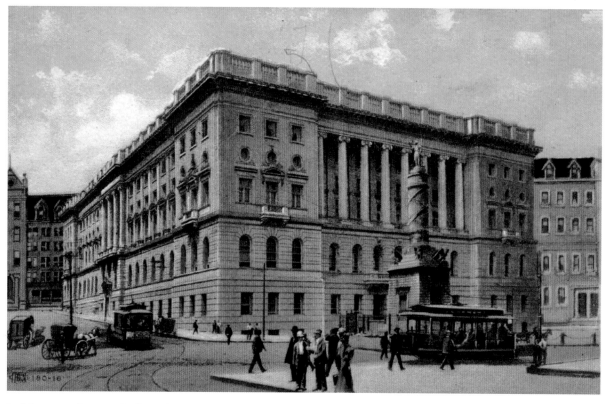

In this postcard postmarked March 10, 1909, a UR&EC open streetcar is by the Battle Monument on North Calvert Street, while another UR&EC streetcar is alongside the Federal Courthouse in Baltimore. The Battle Monument, designed by architect Maximillian Godefroy and built in 1815, honors the 39 Baltimoreans who died in the War of 1812 between the United States and Great Britain. Across from the Battle Monument is the Greek Revival style Federal Courthouse, with its eight ionic columns and white marble façade, designed by the Baltimore architecture firm of Wyatt and Nolting and completed in 1900.

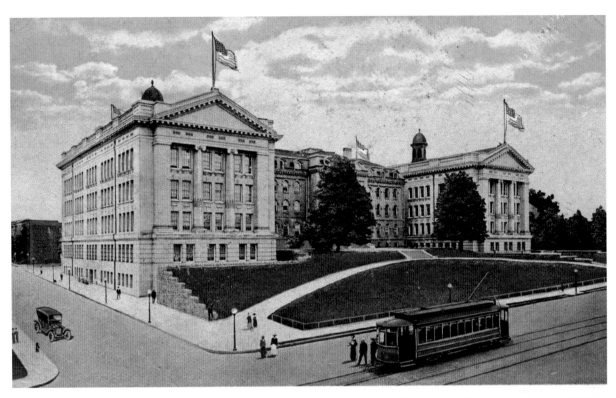

A UR&EC streetcar is at a passenger stop on North Avenue and Calvert Street at the Baltimore Polytechnic Institute (BPI) in this postcard postmarked September 18, 1918. The BPI was founded in 1883 as a school for instruction in engineering. In 1913, the school relocated from downtown Baltimore to North Avenue and Calvert Street. The school relocated in 1967 to Falls Road.

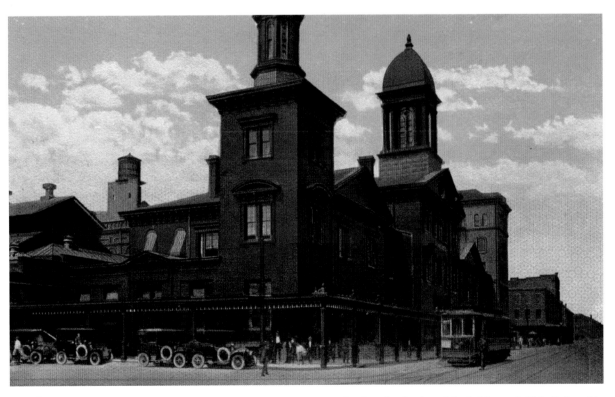

On Camden Street in downtown Baltimore, a UR&EC streetcar passes the Camden Station of the Baltimore & Ohio Railroad in this postcard view around 1920. Station construction began in 1856 with the center section largely completed by 1857. Two wings and towers were added, completing the station by 1867. Beginning in 1887, the Annapolis and Baltimore Short Line Railroad used the station. It was later merged into the Washington, Baltimore & Annapolis Electric Railway (later became Baltimore & Annapolis Railroad), which operated electric interurban service until conversion to bus operation on February 5, 1950.

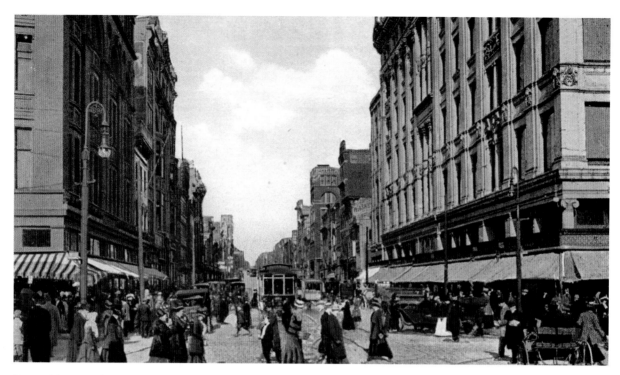

Howard Street in downtown Baltimore's shopping district in the 1920s is teaming with activity as a UR&EC semi-convertible streetcar makes it way along a crowded pedestrian intersection. Between 1838 and 1872 the Baltimore & Ohio Railroad and the Buffalo & Susquehanna Railroad had track on Howard Street. In the 1930s, numerous streetcar lines including routes 3, 4, 12, 17, 25 and 32, were on parts of Howard Street. On July 3, 1941, all streetcar lines had been removed from Howard Street north of Baltimore Street. Route 32, operating on the remaining streetcar track on Howard Street south of Baltimore Street, was converted to bus operation on September 4, 1955. Since 1992, Baltimore's Central Light Rail Line operates over a major portion of Howard Street.

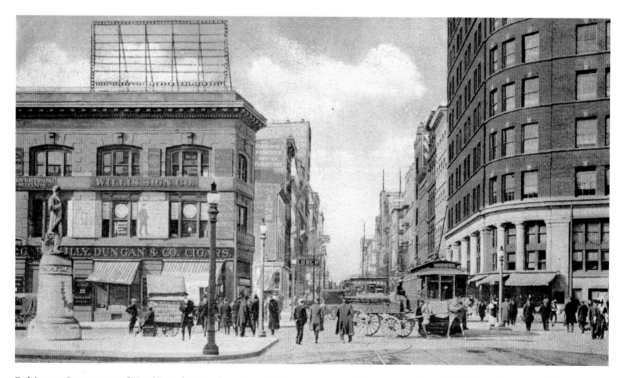

Baltimore Street west of Hopkins Place in downtown Baltimore makes it slow going for a UR&EC semi-convertible streetcar with a horse drawn carriage and plenty of pedestrians in this postcard dated October 26, 1920. Baltimore City Council passed a resolution in 1945 to remove streetcars from Baltimore Street. On May 9, 1948, all streetcars were replaced by buses on Baltimore Street except for the portion needed for the Pearl Street loop.

Chapter 2

Routes 1 and 11

In 1945, Routes 1 (Gilmore Street-Guilford Avenue) and 11 (Bedford Square) operated from Druid Hill Park Terminal via Fulton Avenue, Lanvale Street, Gilmore Street, Fayette Street, Guilford Avenue, North Avenue, St. Paul Street where route 1 turned at 25th Street to Greenmount Avenue and route 11 continued on St. Paul Street to Bedford Square. Routes 1 and 11 used the Guilford Avenue elevated line, which was built over the Northern Central Railroad (later Pennsylvania Railroad), to reach downtown Baltimore. In June 1892, the contract to build the elevated line was given to the Pennsylvania Steel Company. With completion of the 0.67 mile double track elevated steel girder structure over Guilford Avenue between Lexington and Chase Streets, company officials made the first trip over the elevated line on May 3, 1893. Within a few days the line opened for public service. People were attracted to the line, operated by the Lake Roland Elevated Railway, which had become known as the "Sky ride." This was the first electrified elevated line in the United States. The Lake Roland Elevated Railway later became part of the Consolidated Railways. All of vertical columns of the structure were of the same height, which meant that the structure had a series of dips and rises following the land contour. The Pennsylvania Steel Company was again selected to eliminate the dips and rises, and that work was completed on May 21, 1898. In preparation for the use of heavy double truck semi-convertible streetcars, the structure was overhauled in 1910. On June 22, 1947, route 11 was discontinued, and route 1 was cut back to Fayette and Gay Streets, eliminating its operation over the Guilford Avenue elevated line. The Retreat Street carhouse was modified for trackless trolleys on February 15, 1948. On August 1, 1948, route 1 was replaced by trackless trolleys.

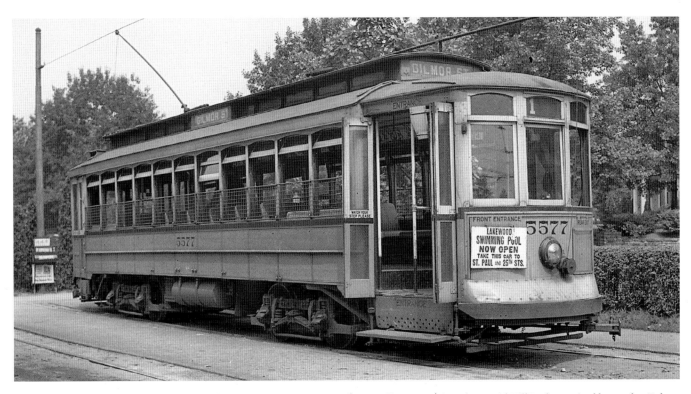

In 1940, Baltimore Transit Company (BTC) route 1 streetcar No. 5577 (originally No. 318) is at the Druid Hill Park terminal located at Fulton Avenue and Druid Hill Avenue. Powered by four General Electric type 200-I motors, this was one of 85 closed platform semi-convertible cars Nos. 301-355 and Nos. 1701-1730 built by J. G. Brill Company in 1914 that went through many car number changes. (C. R. Scholes collection.)

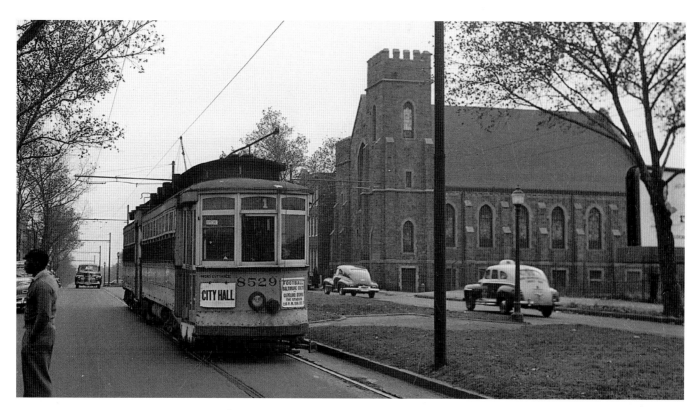

Route 1 BTC articulated streetcar No. 8529 (built from open car bodies 1073 and 1074 that were originally built in 1902) is at North Fulton Avenue and Laurens Street on December 7, 1947 in the Sandtown-Winchester neighborhood of western Baltimore. This was one of 16 cars Nos. 8521-8536 built in 1930 from open car bodies that were originally built in 1902. (Bob Crockett photograph—C. R. Scholes collection.)

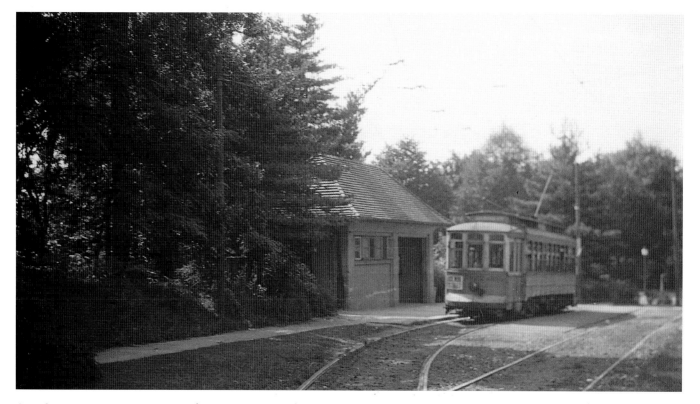

On July 27, 1946, BTC car No. 5832 (originally No. 2608) is at the vintage Bedford Square route 11 terminal station on St. Paul and Charles Streets in the Guilford neighborhood of northern Baltimore. Powered by four Westinghouse type 532B motors, this was one of 50 semi-convertible cars built by J. G. Brill Company in 1919 as Nos. 2601-2650 for the Emergency Fleet Corporation, and in 1922 were renumbered 5825-5874. The cars were designed to run in two and three car trains. (Bob Crockett photograph—C. R. Scholes collection.)

Chapter 3

Routes 4, 5, 25, 31, 32, & 33

In 1917, route 4 (Edmondson Avenue) was extended to Windsor Hills via Clifton Avenue. With the opening of the Orleans Street viaduct, route 4 (Windsor Hills) was cut in half with the eastern half merged into route 6 on December 31, 1935. In 1945, route 4 operated from Windsor Hills via Clifton Avenue, Bloomingdale Avenue, Polar Grove Street, Edmondson Avenue, Fremont Avenue, Saratoga Street, Charles Street, and ended in downtown Baltimore on Charles Street at Lexington Street. On September 19, 1954, route 15 was extended to take over route 4 by rerouting route 15 north of Eutaw Street to Saratoga Street and following route 4 to Windsor Hills.

On July 25, 1892, the Pimlico & Pikesville Railroad Company opened up an electric streetcar line on Reisterstown Road and cross-country over what became Park Heights Avenue to Pikesville. This became route 5 (Druid Hill Avenue-Emory Grove), which was cut back from Emory Grove to Pikesville on July 3, 1932. Trackage on Slade Avenue and Reisterstown Road was abandoned on April 3, 1938, when route 5 north of Park Heights Avenue and Manhattan Avenue was replaced by bus service. South of that point, streetcar route 5 operated on Park Heights Avenue, Reisterstown Road, Pennsylvania Avenue, North Avenue, Druid Hill Avenue, Paca Street, Lombard Street, Pratt Street, Wolfe Street, Baltimore Street, and returned via Patterson Park Avenue and Baltimore Street for the return trip. Route 5 was converted to bus operation on June 27, 1948.

In 1945, route 25 (Mount Washington) connected the Pimlico, Mount Washington, and Hampden neighborhoods of Baltimore via Belvedere Avenue, Pimlico Road, Ken Oak Road, Cross Country Boulevard, Kelly Avenue, Falls Road, 36th Street, Chestnut Avenue, 33rd Street, Huntingdon Avenue, 25th Street, and Maryland Avenue to downtown Baltimore. Along Pimlico Road, route 25 was on the east side of the Pimlico Race Track. Professor Leo Daft, founder of the Daft Electrical Company, installed electric locomotives pulling horse cars for the Baltimore & Hampden Railway over a portion of this line in 1885, making it the first electric line in the United States. PCC cars began operating on route 25 on December 20, 1936. On April 24, 1949, route 25 was converted to bus operation south of Kelly Avenue in the Mount Washington section of Baltimore to Camden Station. The remainder of route 25 from Kelly Avenue to Pimlico became a bus line on September 14,

1950. In 1970, the route 25 designation was assigned to the line operated by the Baltimore Streetcar Museum, because at one time route 25 streetcars operated on nearby Falls Road.

Route 31 (Garrison Boulevard) was established on June 10, 1917 to provide direct service from Forest Park to downtown Baltimore. On December 1, 1936, the first PCC car was placed in regular service on route 31. In 1945, route 31 operated from Belvedere Ave via Garrison Boulevard, North Avenue, Madison Avenue, and Eutaw Street to downtown Baltimore. The City of Baltimore paid $200,670 to rebuild 2.28 miles of track (originally installed in 1911) used by route 31 on Garrison Boulevard, because of the need to resurface the road. On October 13, 1952, route 19 was extended by taking over route 31 (Garrison Boulevard).

On August 17, 1939, route 32 (Woodlawn) was rerouted from Howard Street to Park Avenue except for a short section between Camden and Liberty Streets. In 1945, route 32 connected the community of Woodlawn and Gwynn Oak Park in Baltimore County via Gwynn Oak Avenue, Liberty Heights Avenue, Reistertown Road, Fulton Avenue, Druid Hill Avenue, Whitelock Street, Linden Avenue, and Park Avenue to downtown Baltimore. The Baltimore & Powhatten Railroad Company opened Gwynn Oak Park just outside the northwest corner of Baltimore in 1894. Featuring three roller coasters, The Big Dipper, The Little Dipper, and The Wild Mouse, the 64-acre amusement park also had a carousel and the "Dixies Ballroom" dance hall. The park was purchased from the BTC in 1944 and closed in 1973 after Hurricane Agnes caused Gwynn Falls Creek to overflow, resulting in extensive damage. The section of route 32 north of North Avenue was rerouted in June 1948 from Linden and Druid Hill to Pennsylvania Avenue. On October 13, 1952, route 32 was cut back from Light and Lee streets to Camden station. With the City of Baltimore planning to repave Liberty Heights Avenue in 1955, BTC estimated it would cost about $86,000 to rebuild the route 32 (Woodlawn) trackage. To avoid that expense, buses replaced route 32 streetcars on September 4, 1955. That ended streetcar service to Baltimore's only remaining amusement park.

On June 27, 1948, route 33 (West Arlington) from West Arlington to Pratt and South Streets was replaced by buses. Along with this change, route 33 trackage from Gwynn Oak Junction to Belvedere carhouse was taken over by a branch of route 32.

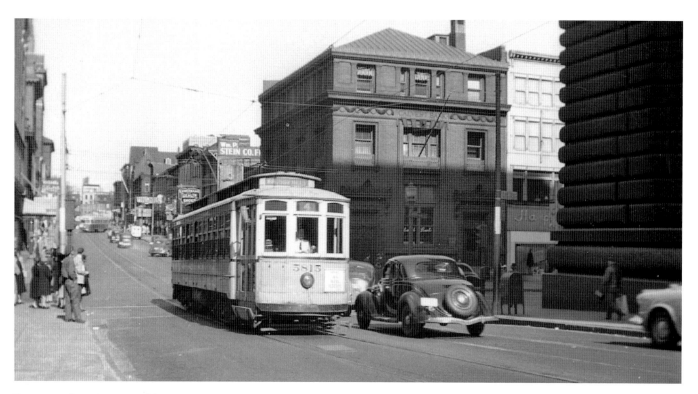

Route 4 BTC semi-convertible car No. 5815 is at Saratoga and Howard Streets on July 19, 1947. This was built by J. G. Brill Company as car No. 1571 in 1918, later became No. 1951, and became No. 5815 in 1922. The 80 cars of this series, Nos. 5745-5824, were designated 1500 series cars because 70 were assigned to route 15 with the remainder assigned to route 19. By the 1920s, these cars were assigned to a number of lines. (C. R. Scholes collection.)

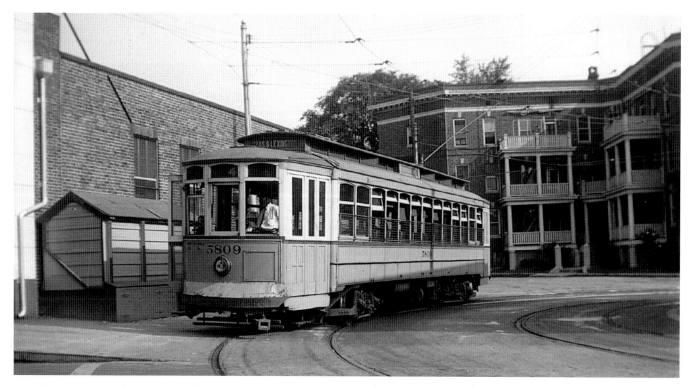

On July 29, 1948, BTC semi-convertible car No. 5809 (original No. 1565) is at the route 4 terminal on Clifton Avenue and Windsor Mill Road. Powered by four General Electric type 200-I motors, this was one of 80 cars Nos. 1501-1580 built by J. G. Brill Company in 1918 and in 1922 renumbered 5745-5824. These 13 window (on the side) cars were 2.83 feet longer, seating 55 passengers versus the earlier shorter 11 window (on the side) 745 semi-convertible cars seating 47 passengers. However, each window on the 13 window cars was two inches narrower than those on the 11 window cars, meaning that the seats were closer spaced, resulting in less leg room. (C. R. Scholes collection.)

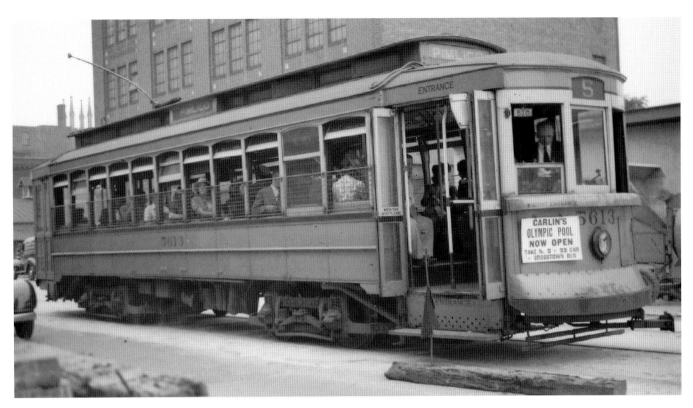

Route 5 BTC closed platform semi-convertible car No. 5613 is at a downtown Baltimore passenger stop at South and Pratt Streets in August 1941. This was originally car No. 354 built by J. G. Brill Company in 1914 and became No. 5613 in 1922. (Bob Crockett photograph—C. R. Scholes collection.)

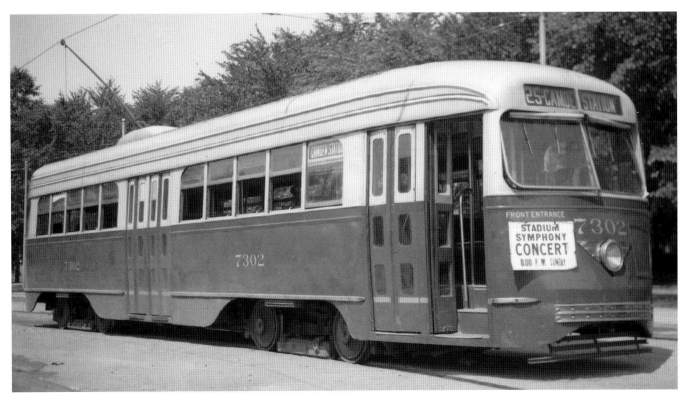

In July 1940, BTC route 25 Presidents' Conference Committee (PCC) car No. 7302 is at the Belvedere Loop off Belvedere Avenue in the Arlington neighborhood of northwest Baltimore. This was one of five PCC cars Nos. 7301-7305 built by St. Louis Car Company and delivered in October-November 1936. Powered by four Westinghouse type 1432 motors, each car seated 54 passengers and weighed 34,000 pounds. (Bob Crockett photograph—C. R. Scholes collection.)

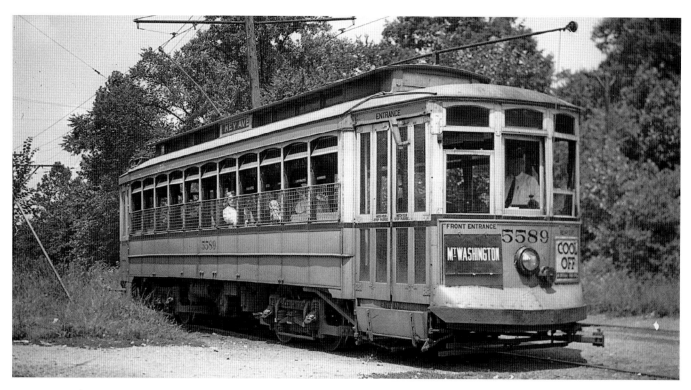

Kelly Avenue and Cross Country Boulevard known as Arlington Junction is the location of route 25 (Mount Washington) car No. 5589 in July 1940. This was built by J. G. Brill Company as car No. 330 in 1914 and was renumbered 5589 in 1922. The 85 cars of this series, Nos. 5560-5644, were the first to have fully enclosed platforms (in place of open platforms that exposed the crew to snow and rain) and mechanically operated folding doors and steps. (Bob Crockett photograph—C. R. Scholes collection.)

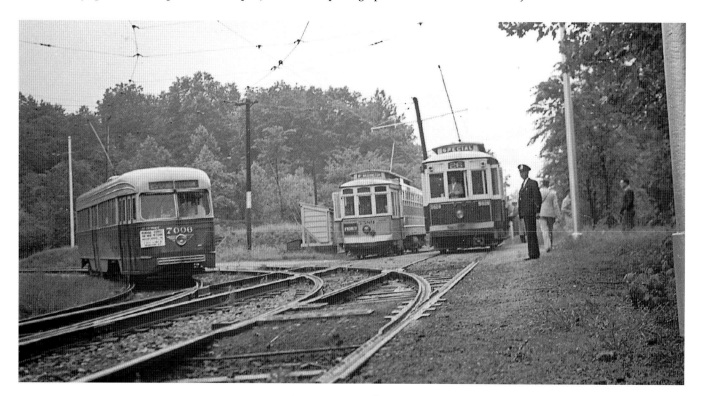

On May 30, 1941, BTC route 25 PCC car No. 7006 (built by St. Louis Car Company in 1936), semi-convertible car No. 5589 (built by J. G. Brill Company as car No. 330 in 1914), and multiple unit semi-convertible car No. 5828 (built by J. G. Brill Company as car No. 2604 in 1919 for the United States Shipping Board Emergency Fleet Corporation) are at Arlington Junction, which is Kelly Avenue and Cross Country Boulevard. Car No. 5589 was 22 years older than the PCC car. (Bob Crockett photograph—C. R. Scholes collection.)

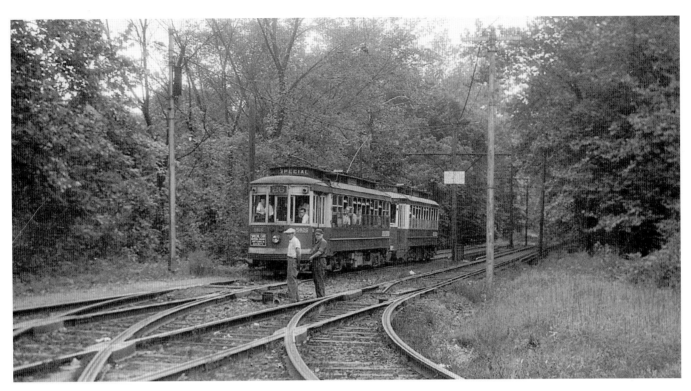

BTC semi-convertible car No. 5826 (built by J. G. Brill Company as car No. 2602 in 1919 for the United States Shipping Board Emergency Fleet Corporation) is in multiple unit operation with semi-convertible car No. 5181 (built by J. G. Brill Company as car No. 1410 in 1905) on route 25 at Arlington Junction, which is Kelly Avenue and Cross Country Boulevard. With special on the rollsign, this might be a rail excursion. (Bob Crockett photograph—C. R. Scholes collection.)

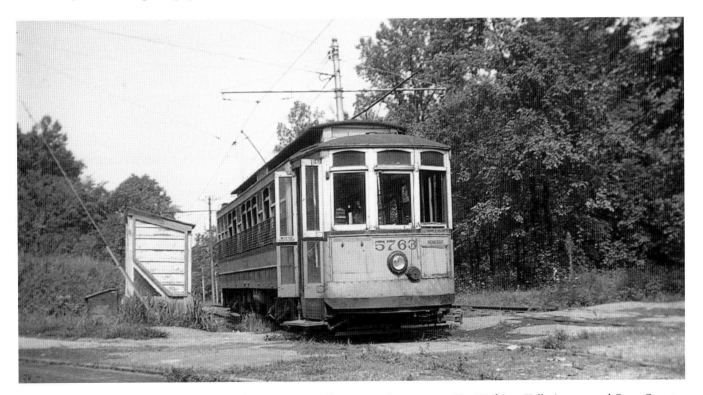

Route 25 BTC semi-convertible car No. 5763 (built by J. G. Brill Company in 1918 as car No. 1519) is at Kelly Avenue and Cross Country Boulevard on July 29, 1948. The Kelly Avenue and Cross Country Boulevard trackage was placed in service on October 18, 1897 by the Baltimore & Northern Railway, which operated on Falls Road (adjacent to the Baltimore Streetcar Museum which opened to the public on July 3, 1970) with trackage rights over the Baltimore City Passenger Railway on Charles, Read, and Calvert Streets to reach Baltimore Street in downtown Baltimore. (C. R. Scholes collection.)

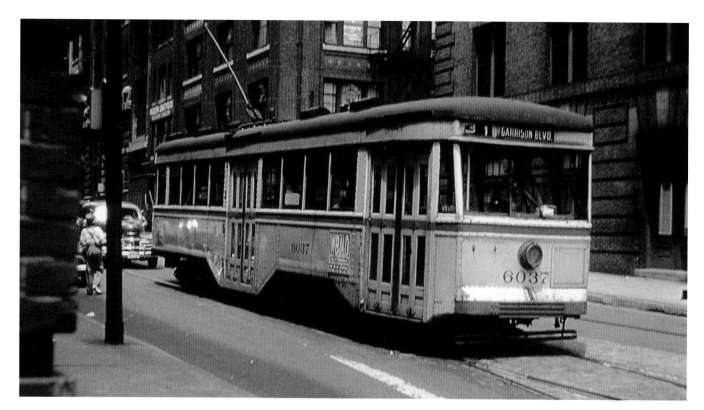

In 1946, BTC route 31 Peter Witt type car No. 6037 is on Calvert Street in downtown Baltimore. This was one of 50 cars, Nos. 6001-6050, built by J. G. Brill Company in 1930 for UR&EC. Each car was powered by four Westinghouse type 516 motors, seated 52 passengers on leather seats, and weighed 39,550 pounds. The single cars had an emergency controller and brake valve behind the bay seat cushions for backing movements. (Bob Crockett photograph—C. R. Scholes collection.)

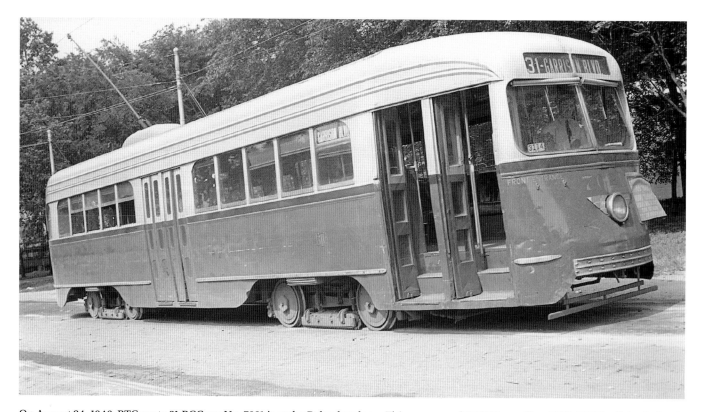

On August 24, 1946, BTC route 31 PCC car No. 7021 is at the Belvedere loop. This was one of 22 PCC cars Nos. 7001-7022 built by St. Louis Car Company and delivered in October-November 1936. Seating 54 passengers, each car was powered by four General Electric type 1198 motors and weighed 34,280 pounds. (C. R. Scholes collection.)

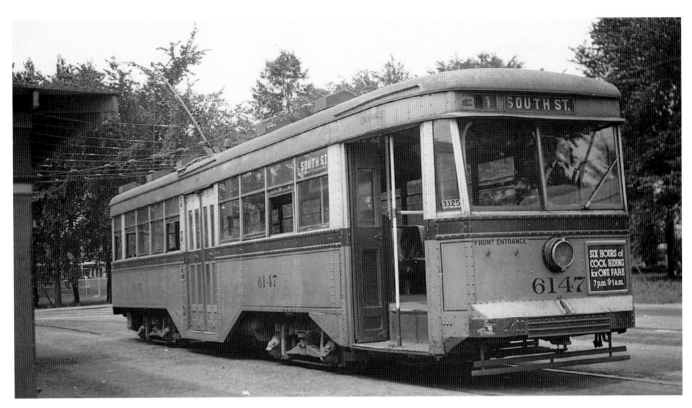

BTC Route 31 Peter Witt type car No. 6147 is at Belvedere loop in July 1940. The car was named after Peter Witt, a Cleveland Railway Company commissioner, who designed the front entrance center exit car. This was one of 30 cars Nos. 6121-6150 built by J. G. Brill Company and delivered in September-October 1930. Each car was powered by four Westinghouse type 1426 motors and weighed 35,700 pounds. (Bob Crockett photograph—C. R. Scholes collection.)

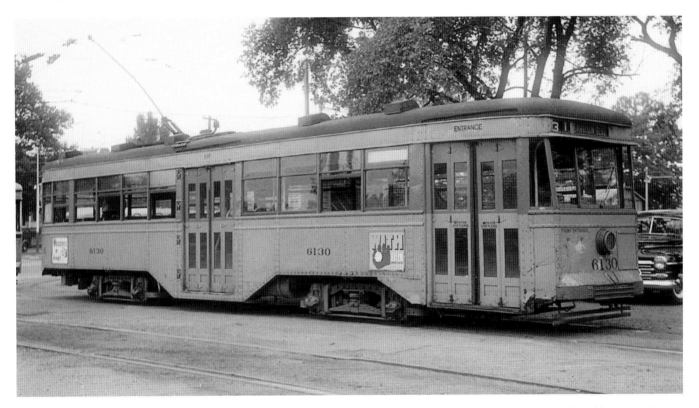

In 1950, BTC route 31 Peter Witt car No. 6130 is at the Belvedere loop waiting for departure time. The fast and comfortable Peter Witt cars were the first modern steel streetcars for Baltimore, and within a short time in service they were exclusively used in one-man operation. (C. R. Scholes collection.)

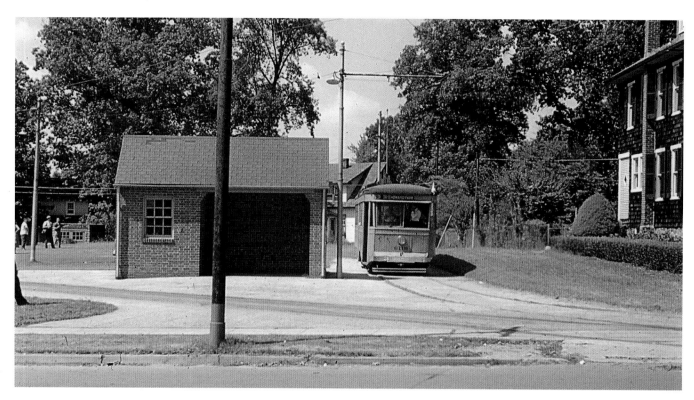

Howard Park loop off Gwynn Oak Avenue, with its attractive waiting shelter, is the location of BTC route 32 Peter Witt car No. 6119 on August 27, 1955. This was one of 20 cars Nos. 6101-6120 built by J. G. Brill Company in September 1930. Weighing 38,500 pounds, each car was powered by four General Electric type 301 motors. Car No. 6119 has been preserved at the Baltimore Streetcar Museum. (Bob Crockett photograph—C. R. Scholes collection.)

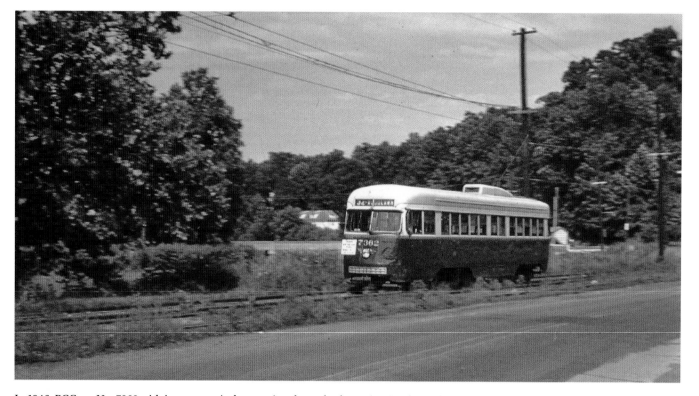

In 1946, PCC car No. 7362 with its cream window section, lower body section in Alexandria blue and orange stripe below the windows, is on the BTC route 32 (Woodlawn) Gwynn Oak Avenue private right of way. This was one of 25 cars Nos. 7354-7378 delivered by Pullman-Standard Car Manufacturing Company in May-June 1941. Seating 55 passengers, each car was powered by four Westinghouse type 1432 motors and weighed 36,000 pounds. (Bob Crockett photograph—C. R. Scholes collection.)

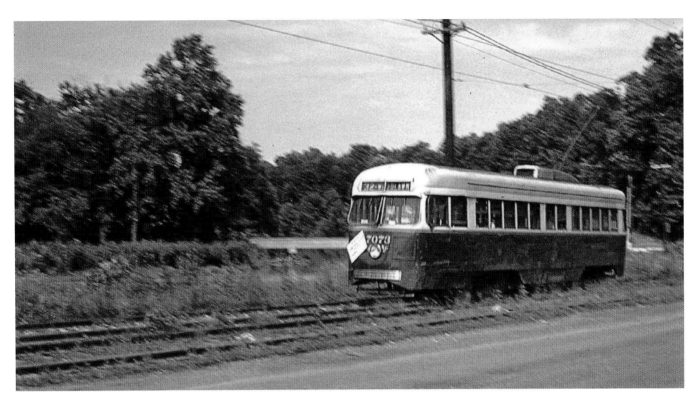

The Gwynn Oak Avenue private right of way of BTC route 32 is the location of PCC car No. 7073 in 1946. This was one of 24 cars Nos. 7054-7077 delivered by Pullman-Standard Car Manufacturing Company in March-April 1941. Powered by four General Electric type 1198 motors, each car weighed 36,000 pounds and seated 55 passengers. (Bob Crockett photograph—C. R. Scholes collection.)

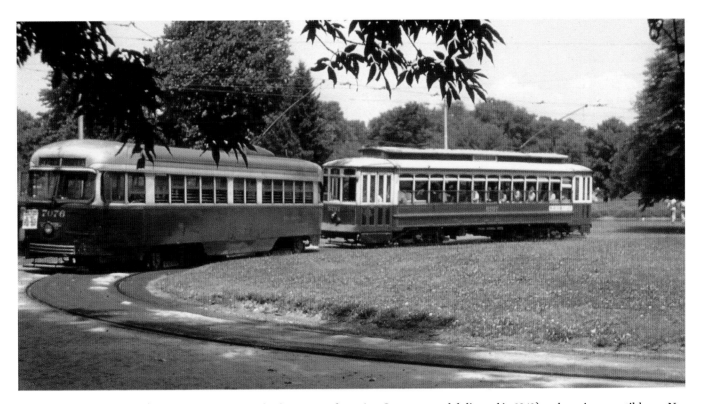

In 1946, PCC car No. 7076 (built by Pullman-Standard Car Manufacturing Company and delivered in 1941) and semi-convertible car No. 5797 (built in 1918 as car No. 1553 by J. G. Brill Company) are at the BTC route 32 Woodlawn loop off Gwynn Oak Avenue. This scene is an example of the development of the streetcar, as car No. 5797 was 23 years older than the streamlined PCC car No. 7076. (Bob Crockett photograph—C. R. Scholes collection.)

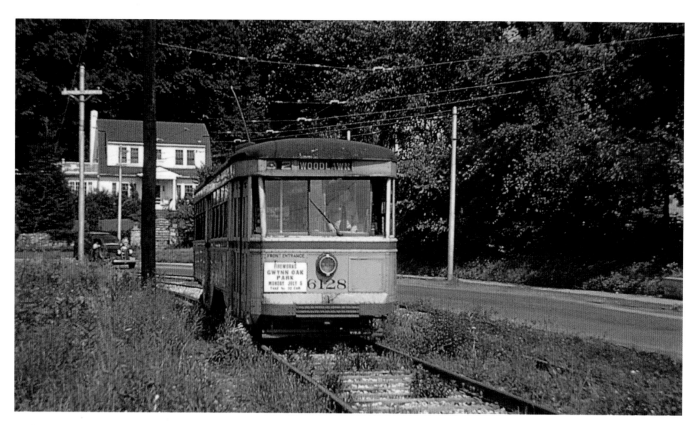

In the community of Woodlawn just west of the city of Baltimore, BTC route 32 Peter Witt car No. 6128 is traversing the scenic private right of way along Gwynn Oak Avenue in 1946. (Bob Crockett photograph—C. R. Scholes collection.)

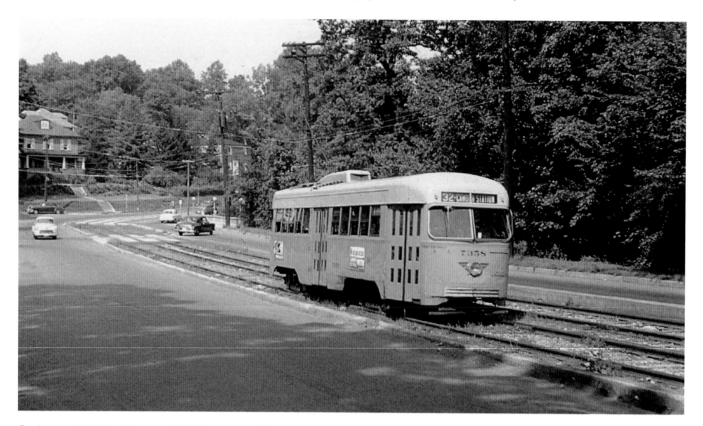

On August 27, 1955, BTC route 32 PCC car No. 7358 is on the center of the road private right of way of Gwynn Oak Avenue heading to downtown Baltimore. The streetcars made good time in the suburban areas where the tracks were on private right of way. (C. Able photograph—C. R. Scholes collection.)

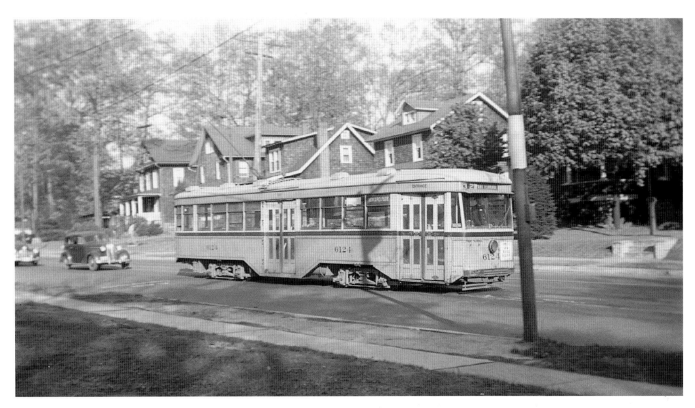

BTC route 32 Peter Witt car No. 6124 is on Liberty Heights Avenue in the western part of Baltimore on July 19, 1947. When the Peter Witt cars were placed in service in 1930, they were comfortable with leather bucket seats, plus fast with an acceleration rate of three miles per hour per second and reached 40 miles per hour. That was not a recommended speed in city traffic, but was applicable in areas of private right of way. (C. R. Scholes collection.)

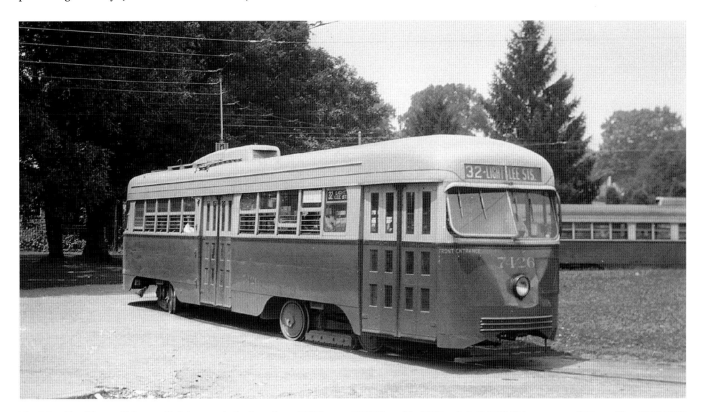

The Woodland loop off Gwynn Oak Avenue is the location of BTC route 32 PCC car No. 7426 on July 7, 1946. This was one of 25 cars Nos. 7404-7428 built by Pullman-Standard Car Manufacturing Company and delivered between November and December 1944. Powered by four Westinghouse type 1432 motors, each car weighed 36,000 pounds and seated 55 passengers. (Bob Crockett photograph—C. R. Scholes collection.)

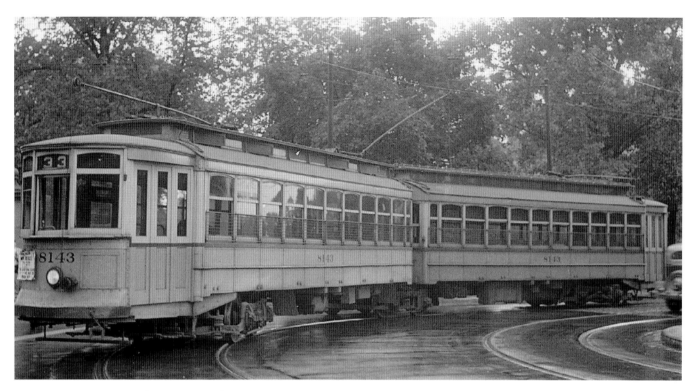

On May 30, 1940, route 33 (West Arlington) BTC car No. 8143 is at the Gwynn Oak Junction terminus. This was one of 38 articulated cars Nos. 8101-8128 and 8137-8146 that were built from semi-convertible cars that were originally built by J. G. Brill Company. Car No. 8143, powered by four new Westinghouse type 306-CV4 motors and seating 87 passengers, was built from semi-convertible cars Nos. 5085 and 5086 at the Carroll Park Shop in 1926 where one vestibule, platform, and truck were removed from each car. The cars were joined together by a large metal drum over an unpowered truck. Acting as a hinge, the drum allowed the car to operate around sharp curves and had a waterproof passage permitting passengers to pass through each car. (C. R. Scholes collection.)

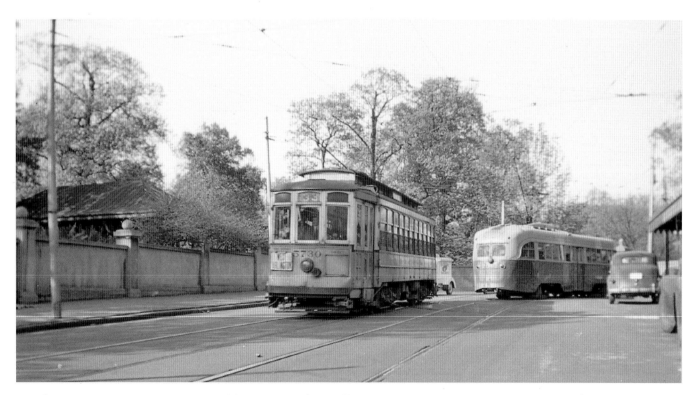

On July 20, 1947, BTC route 33 semi-convertible car No. 5730 (originally car no. 3131 built by J. G. Brill Company in 1917) is at Belvedere loop off Belvedere Ave after passing PCC car No. 7352 (one of 19 cars Nos. 7335-7353 delivered in January-February 1941 by Pullman-Standard Car Manufacturing Company). (C. R. Scholes collection.)

Chapter 4
Routes 6, 17, and 30

Route 6 began as an electric streetcar line on May 28, 1892, and by 1893 reached Patapsco and Curtis Avenues. As part of the World War II effort, the United States Government asked the BTC, in June 1941, to extend streetcar route 6 into the Bethlehem Steel Fairfield Shipbuilding plant. The single-track extension was completed in September 1941 from Chesapeake Avenue on Fairfield Avenue, Brady Street, Weedon Street, Sun Street, and back to Chesapeake Avenue. In 1945, route 6 (Monument and Kresson to Curtis Bay) connected the Curtis Bay neighborhood in the southern part of Baltimore via Curtis Avenue, Patapsco Avenue, Annapolis Avenue, Light Street to downtown Baltimore and left downtown via Monument Street to its terminus at Kresson Street in the Orangeville neighborhood in the eastern part of Baltimore. On March 21, 1948, route 6 was replaced by buses, and the Light Street carhouse, which housed route 6, closed.

When streetcar route 12 (John Street-Westport) was discontinued on January 1, 1939, streetcar route 17 was extended from Camden Station to Westport to take over the lower portion of route 12. In 1945, route 17 (Gorsuch Avenue-Westport) operated from the Westport neighborhood in south Baltimore via Annapolis Road, Ridgely Street and Paca Street to downtown Baltimore and left downtown via Charles Street, North Avenue, St. Paul Street, 31st Street, Greenmount Avenue, Gornish Avenue, Kirk Avenue, and on Abbottson Street terminating at Harford Road. On June 22, 1947, route 17 was taken over by three bus routes.

In 1945, route 30 (Fremont Avenue) circled the west side of Baltimore from Charles Street, North Avenue, Mc Mechen Street, Division Street, Mosner Street, Fremont Street, Hamburg Street, and Charles Street on the south side of Baltimore. Trackless trolleys replaced streetcars on route 30 on March 26, 1950.

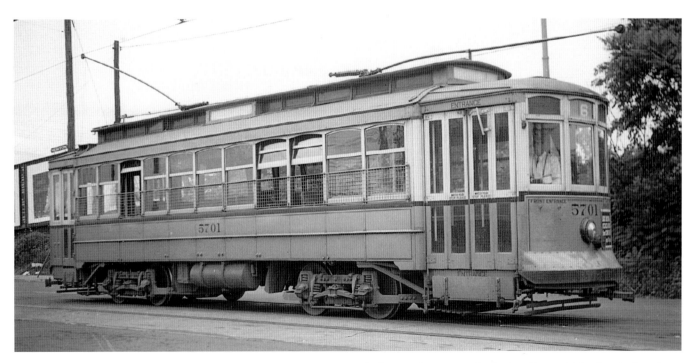

In July 1940, BTC route 6 semi-convertible car No. 5701 is at Patapsco and Chesapeake Avenues in the Brooklyn neighborhood of southern Baltimore. This was originally car No. 3102 built by J. G. Brill Company in 1917. Beginning in 1916, motorman's seats were installed in semi-convertible cars assigned to long runs. By 1917, motorman seats were installed in all semi-convertible cars and on new orders. Seats were also installed for conductors. (Bob Crockett photograph—C. R. Scholes collection.)

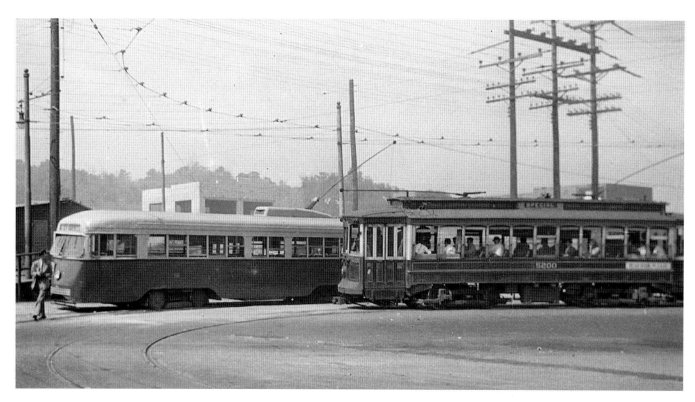

High speed semi-convertible car No. 5200, with longer wheelbase trucks for faster operation, and a PCC car are at the BTC route 6 Curtis Bay loop off Curtis Avenue in the Curtis Bay neighborhood along the waterfront area in the southern part of Baltimore on September 8, 1946. Car No. 5200 (one of 40 cars built by J. G. Brill Company in 1905) was originally car No. 1409. This car experienced many renumberings based on the line it served. In 1922, the decision was made to separate car numbers from route numbers, and the car became No. 5200, the highest number in the 40 cars Nos. 5161-5200. Each of these cars was originally powered by four General Electric type 90 motors which were replaced by Westinghouse type 101B motors by 1927. (Bob Crockett photograph—C. R. Scholes collection.)

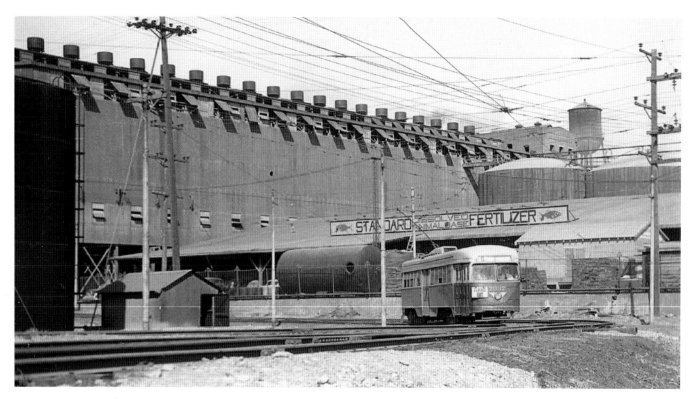

On March 20, 1948, BTC route 6 PCC car No. 7337 is entering the Curtis Bay loop off Curtis Street on the last day of streetcar operation for route 6. Buses took over this line the next day. (Bob Crockett photograph—C. R. Scholes collection.)

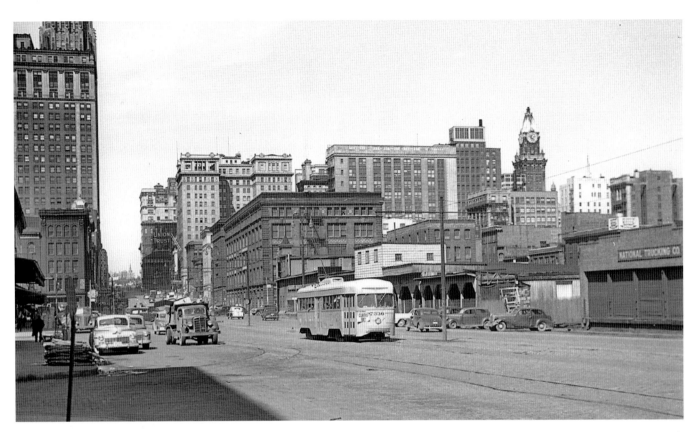

BTC route 6 PCC car No. 7336 is on Light Street at Conway Street in downtown Baltimore on March 20, 1948, on the last day of this route's streetcar operation. (Bob Crockett photograph—C. R. Scholes collection.)

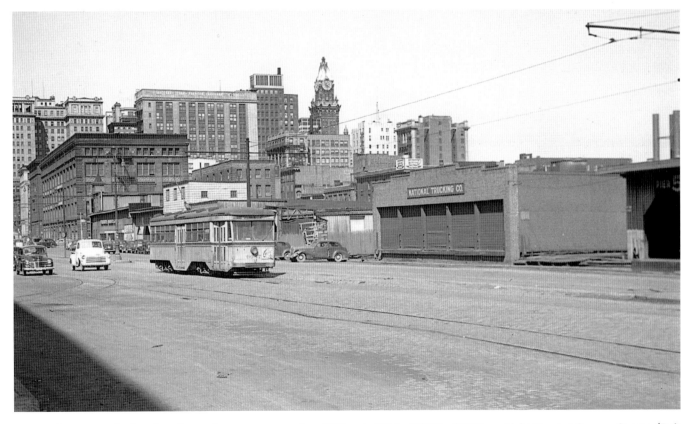

On March 20, 1948, the last day of route 6 streetcar operation, BTC route 6 Peter Witt No. 6027 is on Light Street at Conway Streets. (Bob Crockett photograph—C. R. Scholes collection.)

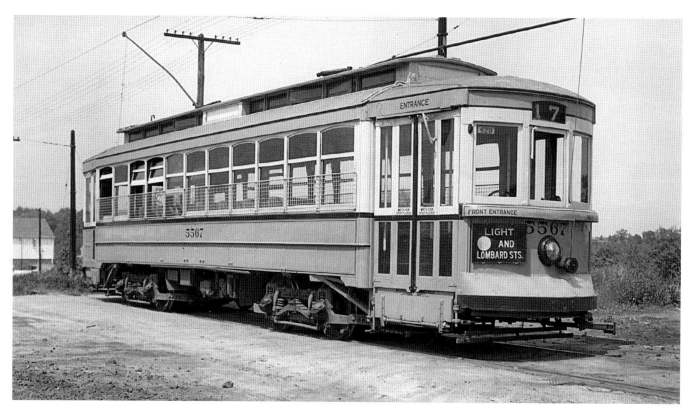

BTC route 17 semi-convertible car No. 5567 is at the Westport loop located at Annapolis Road and Waterview Avenue. This car was originally No. 308 built by J. G. Brill Company in 1914. (Bob Crockett photograph—C. R. Scholes collection.)

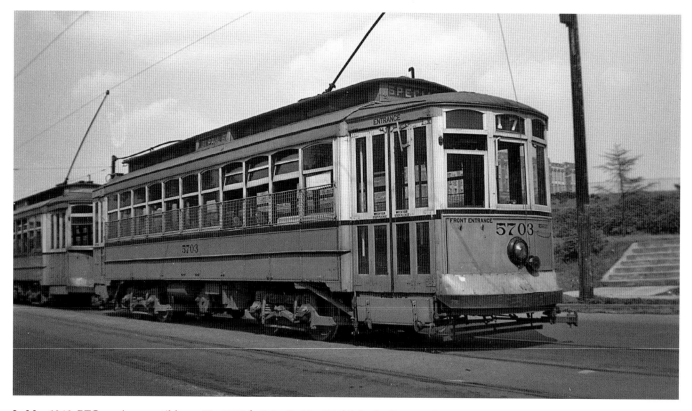

In May 1946, BTC semi convertible car No. 5703 (originally No. 3104) is in the lineup of cars on Loch Raven Road near 33rd Street, ready to handle crowds from the Memorial Stadium on trackage that was a branch line of route 17 to handle stadium events. This was one of 100 cars built by J. G. Brill Company in 1917 that in a 1922 renumbering became Nos. 5645-5744. Each of these cars was powered by four General Electric type 200-I motors. (Bob Crockett photograph—C. R. Scholes collection.)

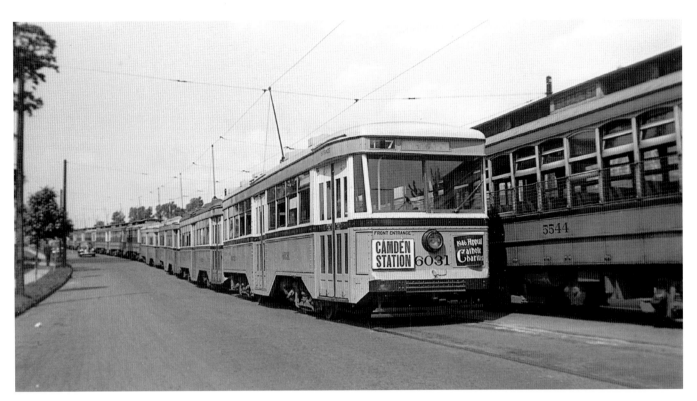

BTC route 17 Peter Witt car No. 6031 is heading a lineup of cars on Loch Raven Road near 33rd Street, ready to handle the crowd at the Memorial Stadium in May 1946. Since there was no regular service on this branch line, the cars were parked there to take the crowd home after the game ended. The stadium, built in 1922 and razed in 2004, was once used by the Baltimore Colts football team and the Baltimore Orioles baseball team. (Bob Crockett photograph—C. R. Scholes collection.)

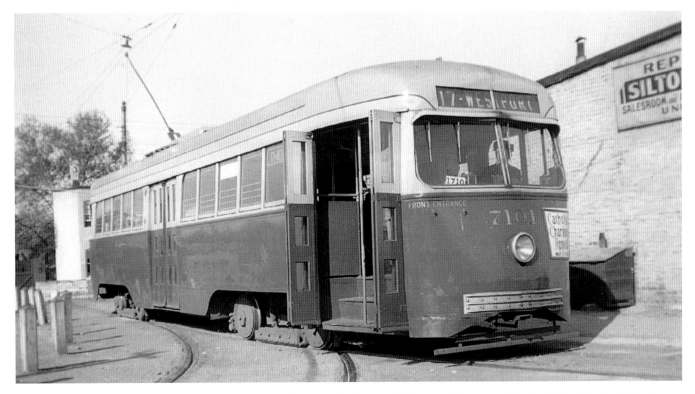

On May 10, 1947, BTC route 17 PCC car No. 7101 is at the terminal wye at Abbottston Street and Harford Road in the Coldstream-Homestead-Montebello neighborhood of northeastern Baltimore. This was one of 50 cars Nos. 7098-7147 built by the Pullman-Standard Car Manufacturing Company and delivered in April-July 1944. Powered by four General Electric type 1198 motors, each car weighed 36,000 pounds and seated 55. (C. R. Scholes collection.)

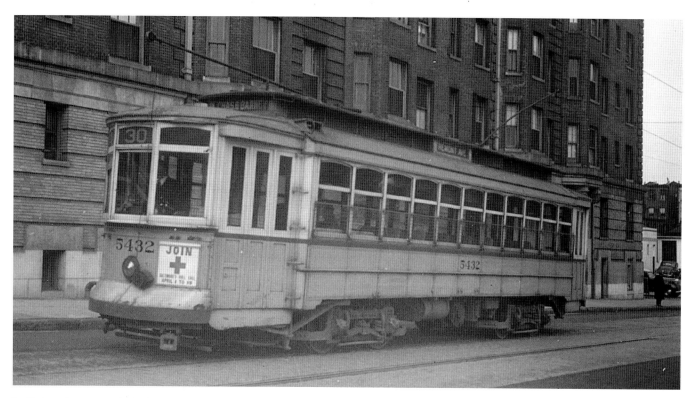

La Fayette Avenue and Charles Street is the location of BTC route 30 semi-convertible car No. 5432 (originally No. 153) in 1940. This was one of 60 cars Nos. 101-160 built by J. G. Brill Company in 1911, powered by four Westinghouse type 101B motors, and renumbered 5380-5439 in 1922. These were the first Pay As You Enter (PAYE) semi-convertible cars where the conductor was in a fixed location. For the first 380 semi-convertible cars, the conductor collected fares by moving through the car. (Bob Crockett photograph—C. R. Scholes collection.)

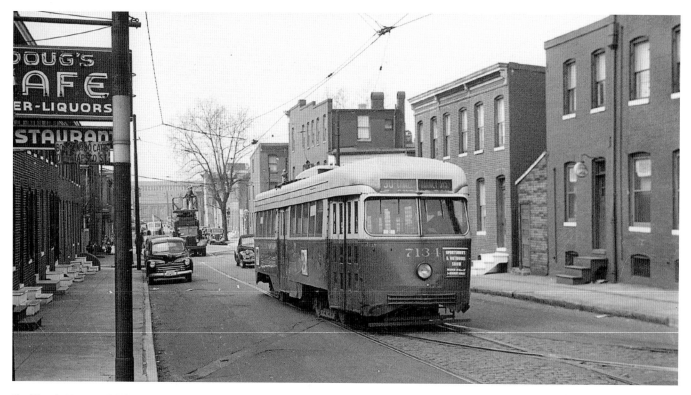

On March 20, 1949, BTC route 30 PCC car No. 7134 is at the Barney Street and Patapsco Street terminus in the Federal Hill neighborhood just south of the Baltimore central business district. Route 30 made sort of a half circle from Charles Street and North Avenue via McMechen Street, Division Street, Fremont Avenue, Hamburg Street, Charles Street, to Barney and Patapsco Streets. (Bob Crockett photograph—C. R. Scholes collection.)

Chapter 5

Routes 9 and 14

Since December 1, 1927, route 9 (Ellicott City) operated from Charles and Lexington Streets passing Rolling Road to Ellicott City, while route 14 (Rolling Road) was a short turn version operating along the same route, but ending at Rolling Road. West of Rolling Road, the line ran cross-country and crossed the Patapsco River over a steel truss bridge. Baltimore Transit Company (BTC) requested permission from the Public Service Commission (PSC) in 1941 to cut back route 14 to the city line at North Bend, which would allow the use of PCC cars on the city portion of the line, and operate a shuttle service with the older double ended semi-convertible cars on the remainder of the line. PCC cars required a loop, and it was not feasible to build a loop at Ellicott City. On May 20, 1941, the PSC decided that BTC would loop route 14 at Rolling Road instead of North Bend,

and during rush hours plus Saturdays the older route 9 cars would operate through to downtown Baltimore. During World War II, the Saturday through service was discontinued. On August 8, 1952, route 9 Ellicott City remaining through car service to downtown Baltimore was discontinued. Ellicott City passengers heading downtown had to transfer to either route 8 or route 14 streetcars at Catonsville Junction. On September 19, 1954, route 14 from Rolling Road to downtown Baltimore was replaced by extending bus route 23 (Middle River) to West Baltimore. Three semi-convertible streetcars, Nos. 5706, 5745, and 5748, maintained service on the now isolated route 9 between Catonsville Junction and Ellicott City. On June 20, 1955, route 9 was replaced by buses. The direct rail routing was replaced by a long winding bus routing which discouraged riding, and the bus route ended on February 1, 1957.

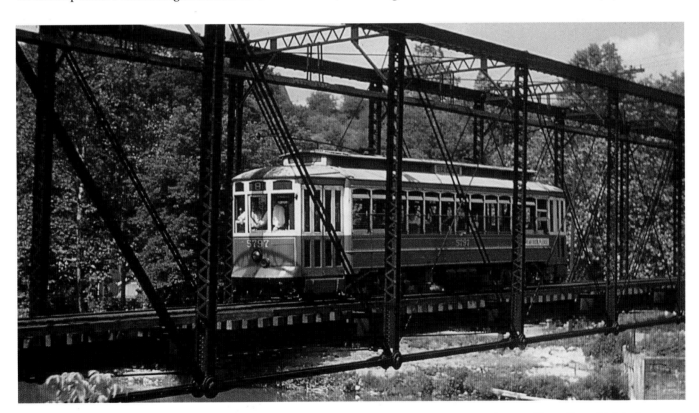

In 1946, BTC semi-convertible car No. 5797 is on the route 9 streetcar bridge over the Patapsco River at Ellicott City, which is the county seat of Howard County, Maryland. With the car showing route 8, it may have been a rail excursion. This car was built in 1918 by J. G. Brill Company as car No. 1553 and was renumbered 5797 in 1922. (C. R. Scholes collection.)

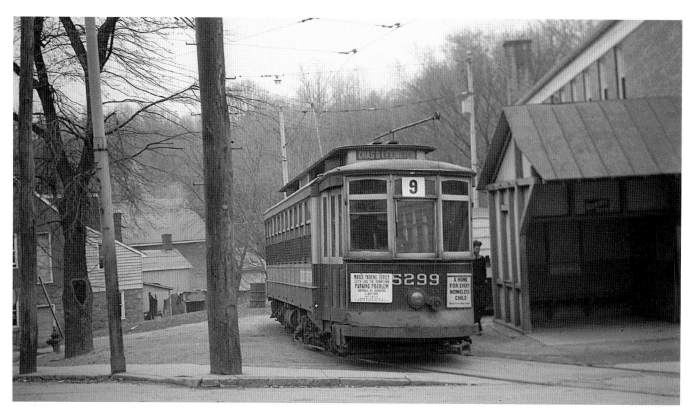

In March 1946, BTC route 9 semi-convertible car No. 5299 (originally No. 1406 in 1906, renumbered 1831 in 1910, and 5299 in 1922) is at the Ellicott City terminal. This was one of 100 cars built by J. G. Brill Company in 1906, and following several renumberings, became Nos. 5201-5300 in 1922. Each car was powered by four Westinghouse type 101B motors. (Bob Crockett photograph—C. R. Scholes collection.)

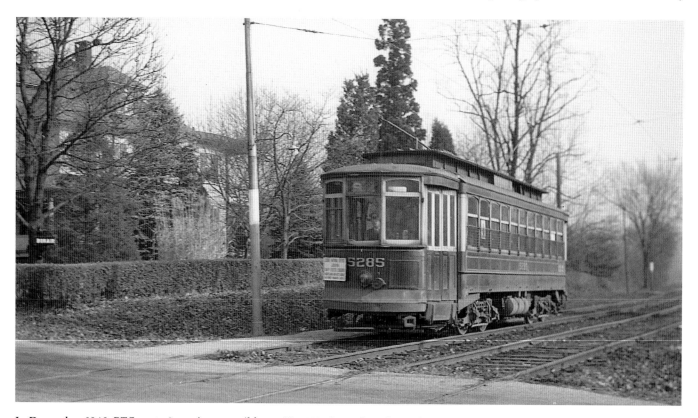

In December 1946, BTC route 9 semi-convertible car No. 5285 is on the Edmondson Avenue private right of way in this picturesque residential area westbound to Ellicott City. This car was originally No. 1717, built by J. G. Brill Company in 1906, renumbered No. 1817 in 1907, and became No. 5285 in 1922. (Bob Crockett photograph—C. R. Scholes collection.)

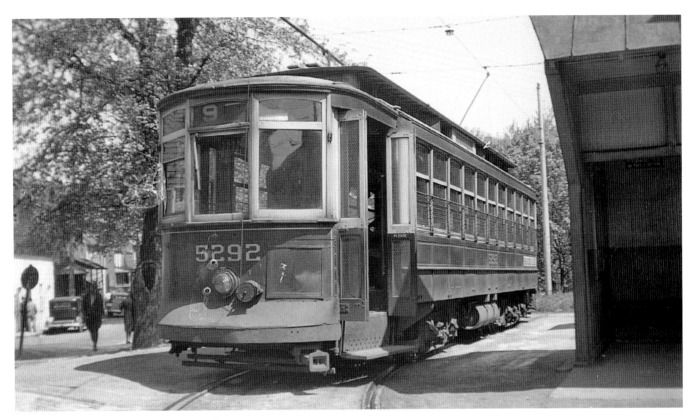

The Ellicott City terminal is the location of BTC route 9 semi-convertible car No. 5292, waiting for departure time on July 19, 1947. This car was originally No. 1724 built by J. G. Brill Company in 1906 and became No. 5292 in 1922. (C. R. Scholes collection.)

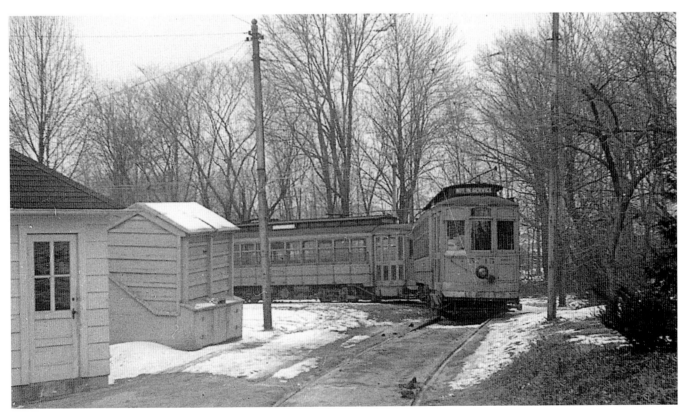

In 1950, BTC semi-convertible car No. 5745 is at the Rolling Road loop, which is the western route 14 terminus. This car was originally car No. 1501 built by J. G. Brill Company in 1918 and was renumbered 5745 in 1922. During World War II, BTC ridership peaked at 267,569,927 in 1943; however, by 1950 ridership dropped to 194,851,362, with a further decline to 91,749,867 in 1963. (C. R. Scholes collection.)

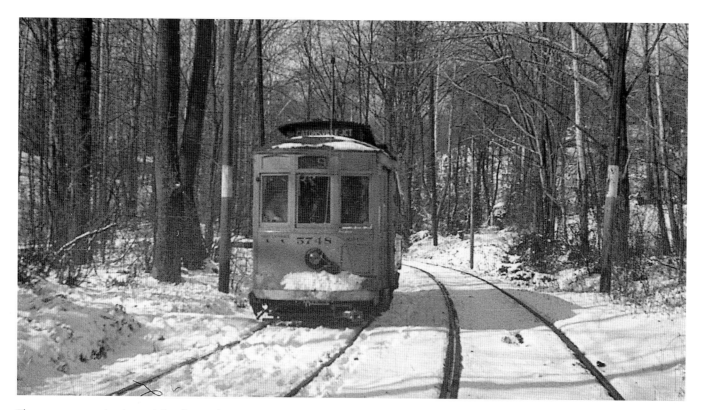

The snow-covered private right of way of BTC route 9 provides a scenic trip for riders of semi-convertible car No. 5748 in 1950. This car was originally No. 1504 built by J. G. Brill Company in 1918 and renumbered 5748 in 1922. It was acquired, without trucks, in 1957 from the founding group of today's Baltimore Streetcar Museum by the Seashore Trolley Museum in Kennebunkport, Maine. A pair of Montreal trucks, similar to the original trucks, has been obtained for the car's future restoration. (C. R. Scholes collection.)

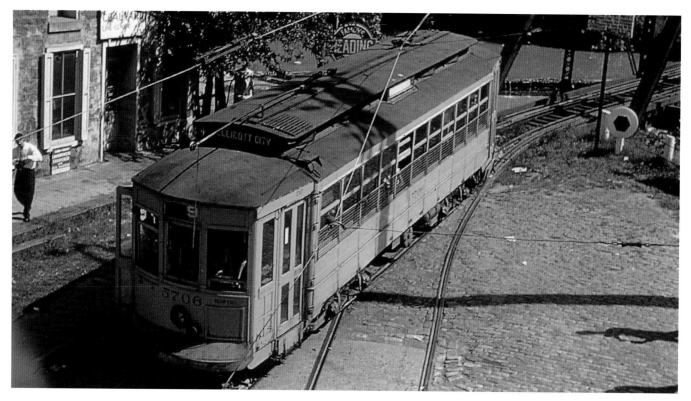

After crossing the Patapsco River on a long truss bridge over a gauntlet track (an arrangement in which the tracks are parallel and are overlapped such that only one pair of rails can be used at one time), BTC route 9 semi-convertible car No. 5706 is on Main Street in Ellicott City in 1954. This car was originally No. 3107 built by J. G. Brill Company in 1917, and was renumbered 5706 in 1922. (C. R. Scholes collection.)

Chapter 6

Routes 18 and 19

In 1945, route 18 (Pennsylvania Avenue) connected the Canton neighborhood in southeastern Baltimore via Toone Street, Clinton Street, Elliott Street, Kenwood Avenue, Fait Avenue, Essex Street, Eastern Avenue through downtown Baltimore on Lombard Street and to the northwestern part of Baltimore via Green Street, Pennsylvania Avenue, and Cumberland Street. Route 18, operating on one block of Baltimore Street between Greene and Paca Streets, was rerouted onto Saratoga Street on April 4, 1948. The Cumberland Street carhouse closed on May 15, 1949, and route 18 streetcars were transferred to be housed at Park Terminal. Because the repaving of Pennsylvania Avenue would have required major track rebuilding, on June 7, 1952, route 18 became a bus line resulting in the closure of the Park Terminal carhouse.

Route 19 (Harford Avenue) originated when the Baltimore & Hall's Springs Railway was chartered in 1870 and opened a horse car line which began at Holliday and Fayette Streets and used Fayette Street, Aisquith Street, Madison Street, Central Avenue, and Harford Road to Halls Springs. The northeastern end of route 19 between Parkville and Carney was replaced by bus route R on October 4, 1936, because of low ridership. In 1945, route 19 operated from Parkville northeast of Baltimore via Harford Avenue, Central Avenue, Madison Street, Aisquith Street to downtown Baltimore and south to its Sharp and Ostend Streets terminus. On May 9, 1948, route 19 was cutback to Hanover and Lombard. Route 19 was merged on October 13, 1952 with route 31. On June 17, 1956, route 19 streetcar service was replaced by buses, and the Montebello carhouse on Harford Road was converted into a bus garage.

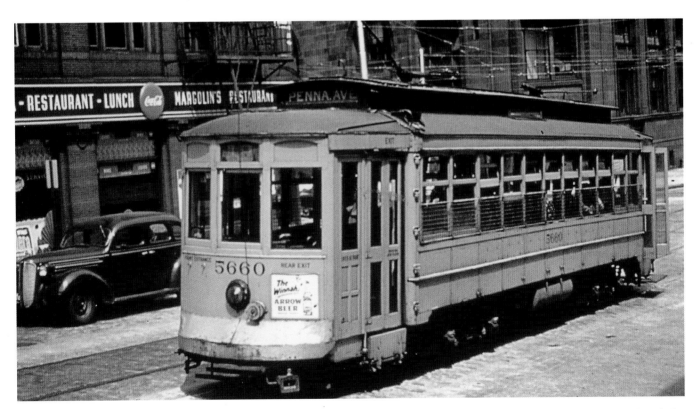

In 1946, BTC route 18 semi-convertible car No. 5660 (original number 1911) is on Lombard Street, originally an Italian neighborhood; the name came from the town Guardia Lombardi in Italy. This was one of 100 cars built by J. G. Brill Company in 1917 that were renumbered with the final car numbers 5645-5744 in 1922. These cars were each powered by four General Electric type 200-I motors. (C. R. Scholes collection.)

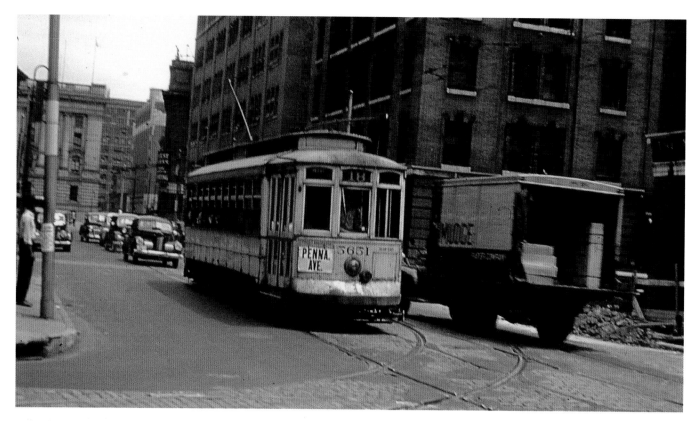

Lombard and Calvert Streets is the location of BTC Route 18 semi-convertible car No. 5651 in 1946. This car was originally car No. 1902, built by J. G. Brill Company in 1917, and became No. 5651 in 1922. (C. R. Scholes collection.)

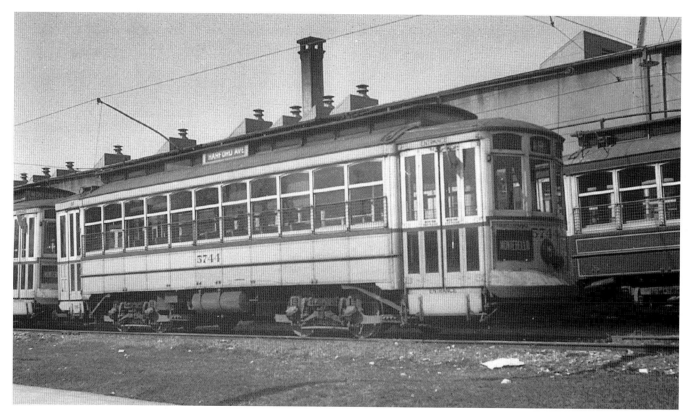

In 1946, BTC semi-convertible car No. 5744 is at the Montebello carhouse on Harford Road served by route 19. This car was originally No. 1945, built by J. G. Brill Company in 1917. It became No. 3145 in 1918, and No. 5744 in 1922. The Montebello carhouse opened in 1912 and was converted into a bus garage when route 19 was replaced by buses on June 17, 1956.

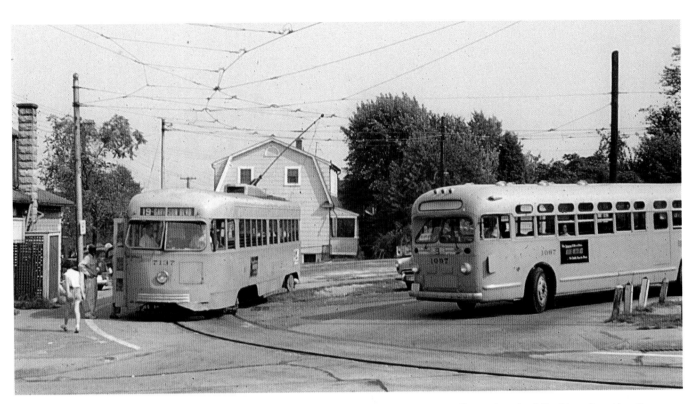

On August 27, 1955, BTC route 19 PCC car No. 7137 (one of 50 cars Nos. 7098-7147 built by Pullman-Standard Car Manufacturing Company in 1944) and model TD-4506 General Motors bus No. 1097 (one of five Nos. 1096-1100 built in 1945) are at the Parkville loop off Harford Road. For the bus, T = transit bus, D = diesel, 45 = seating capacity, 06 = the bus series. The route R (Carney) bus replaced the streetcar shuttle on Harford Road from Parkville loop to Carney on October 4, 1936. (C. Able photograph—C. R. Scholes collection.)

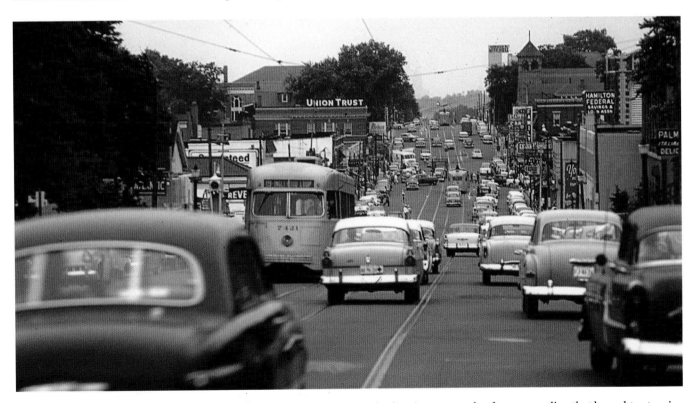

It is a busy Harford Road for route 19 PCC car No. 7421 on June 9, 1956. This line is an example of a streetcar line that brought extensive development which increased transit ridership until the growing popularity of the automobile resulted in a decline in ridership and increased traffic congestion, which reduced the transit line's operating speed, further impairing its ability to compete with the private automobile. (C. Able photograph—C. R. Scholes collection.)

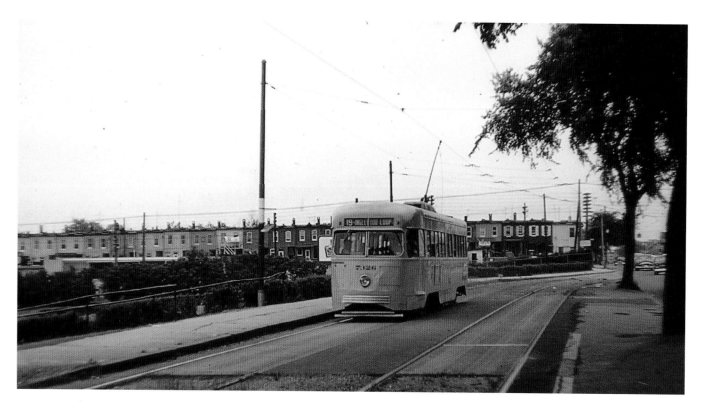

BTC route 19 PCC car No. 7326 is on the private right of way alongside Harford Road on June 9, 1956. This was one of 29 cars Nos. 7306-7334 built by Pullman-Standard Car Manufacturing Company and delivered in June 1939. Weighing 34,750 pounds, each car was powered by four Westinghouse type 1432 motors and seated 55 passengers. (C. Able photograph—C. R. Scholes collection.)

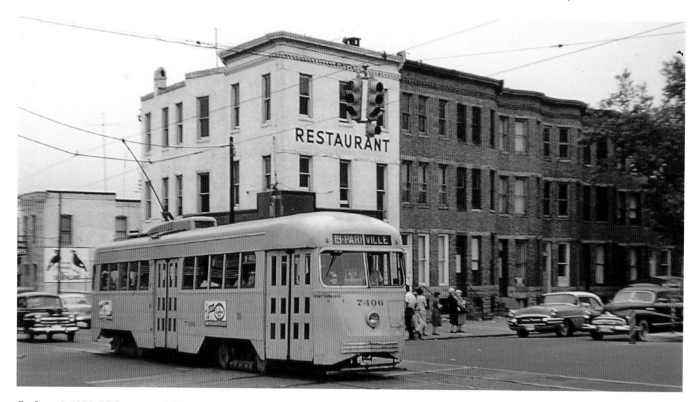

On June 9, 1956, BTC route 19 PCC car No. 7406 is on Central Avenue crossing the former route 27 streetcar line on Federal Street (with cross tracks still showing at the intersection). On the right of the streetcar are examples of row houses designed with swell fronts to break up the monotony and provide more room. Trackless trolleys replaced streetcars on route 27 (Federal Street) on January 1, 1939, and eventually route 27 became a bus line. Time was running out for route 19 streetcars with the streetcar service replaced by buses on June 17, 1956. (C. Able photograph—C. R. Scholes collection.)

Chapter 7

Routes 20 & 26

When route 10 (Roland Park-Highlandtown) was converted to trackless trolley operation on April 14, 1940, the section of route 10 that operated between Highlandtown and Point Breeze became streetcar route 20 (Point Breeze). On December 28, 1942, route 20 was extended from Highlandtown to downtown Baltimore City Hall to provide direct service from downtown to Point Breeze defense plants. Route 20 was cut back to its prewar operation between Highlandtown and Point Breeze on May 9, 1948. On July 24, 1948, the remaining portion of route 20 was converted to bus.

Route 26 (Sparrows Point-Bay Shore) was completed in 1903. Bay Shore Park (built by the United Railways & Electric Company, that included a roller coaster, dance hall, and a 208-foot-long streetcar station) opened on August 11, 1906, and was served by an extension of the Sparrows Point line. In 1945, route 26 operated from Sparrows Point via Dundalk to Highlandtown and used Fairmount Avenue, Wolfe Street, and Baltimore Street to enter downtown Baltimore, looping at Pearl and Fayette Streets. Semi-convertible cars such as the series 5825-5874 served the Sparrows Point shipyard on weekdays and handled the riders to Bay Shore Park on Sundays and holidays. The Bay Shore branch of route 26, where streetcar trackage passed under the roller coaster, closed on September 14, 1946. Effective July 30, 1950, route 26 streetcars no longer operated between Fayette and Pearl Streets in downtown Baltimore to Highlandtown. Route 26 streetcars only operated between Highlandtown (Pratt and Grundy Streets) and Sparrows Point. Bethlehem Steel funded the construction of a new loop at Sparrows Point during 1950, and PCC cars began replacing the older semi-convertible cars on route 26. On October 18, 1953, the Fort Howard shuttle operating between Sparrows Point and Fort Howard made its last streetcar run. Route 26 went through the Eastern Avenue underpass at Highlandtown. With the City of Baltimore planning to demolish a ramp at that underpass, BTC estimated that up to $120,000 would be required to relocate trackage, and permission was received to convert the line to bus operation. Route 26, mostly private right of way with a long bridge over Bear Creek on the remaining segment from Highlandtown to Sparrows Point, was replaced by buses on August 31, 1958.

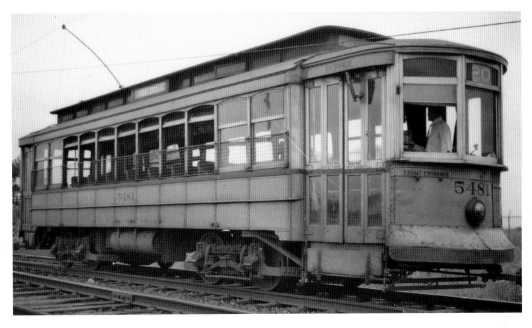

BTC route 20 semi-convertible car No. 5481 (originally 1541) is at the Keith Avenue loop in the Point Breeze neighborhood of Baltimore. This was one of 60 cars built by J. G. Brill Company in 1912 that went through renumbering, becoming 5440-5499 in 1922. Powered by four General Electric type 246 motors, these were the first cars to have the route number painted in the upper sanded front central window. (Bob Crockett photograph—C. R. Scholes collection.)

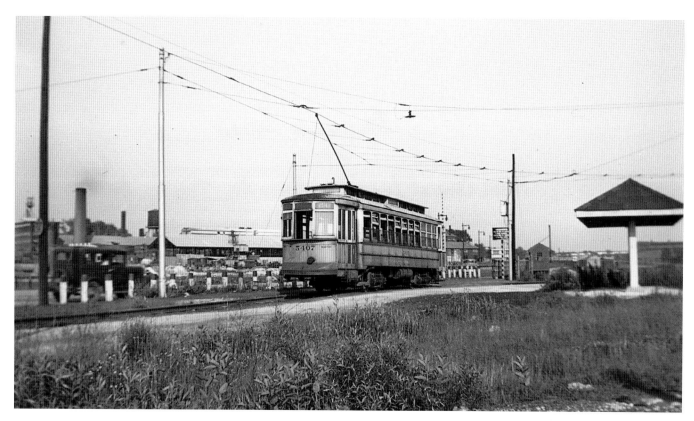

The Point Breeze loop off Keith Avenue is the location of BTC route 20 semi-convertible car No. 5407 (originally car No. 128 and became No. 5407 in 1922) in May 1946. (Bob Crockett photograph—C. R. Scholes collection.)

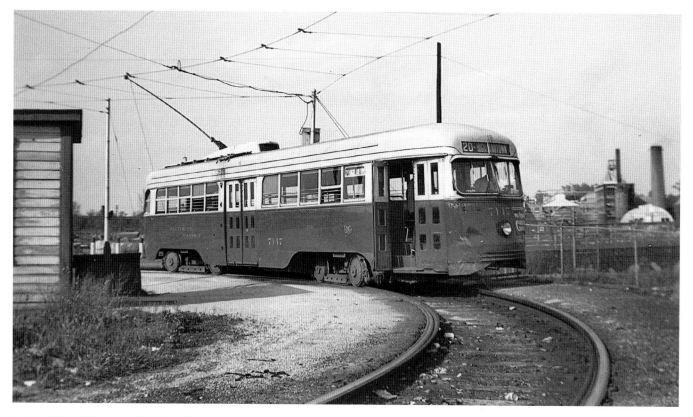

In May 1946, BTC route 20 PCC car No 7117 is at the Point Breeze loop off Keith Avenue, awaiting departure time. All of Baltimore's PCC cars were single ended, one person operated, and had front and center doors. PCC cars were designed for smooth riding and quiet operation. (Bob Crockett photograph—C. R. Scholes collection.)

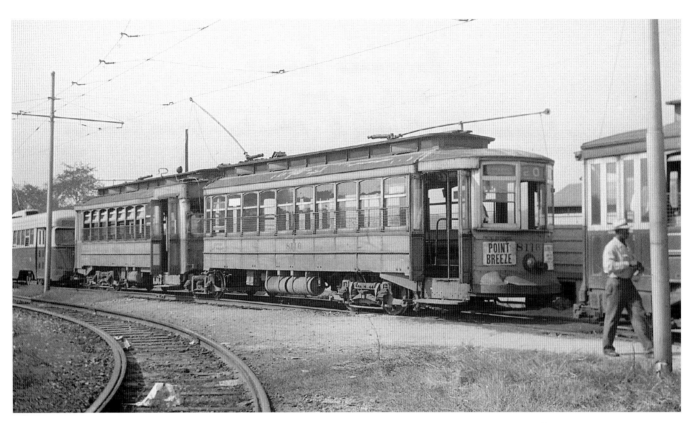

BTC route 20 articulated semi-convertible car No. 8116 (built from semi-convertible cars 5031 and 5032 in 1925) and a PCC car behind it are at the Point Breeze loop at Oldham Street and Keith Avenue on September 8, 1946. (Bob Crockett photograph—C. R. Scholes collection.)

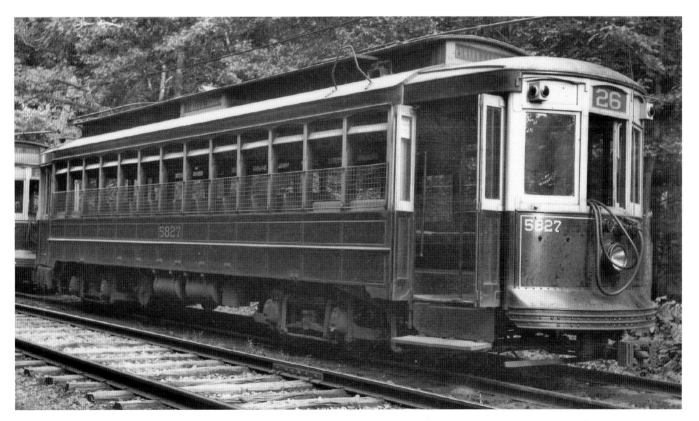

In 1938, BTC route 26 multiple unit semi-convertible cars 5827 (original number 2603) and 5866 (original number 2642) are at the Sparrows Point terminal. Both cars were built by J. G. Brill Company in 1919 for the United States Shipping Board Emergency Fleet Corporation and were renumbered in 1922. (Bob Hadley photograph—C. R. Scholes collection.)

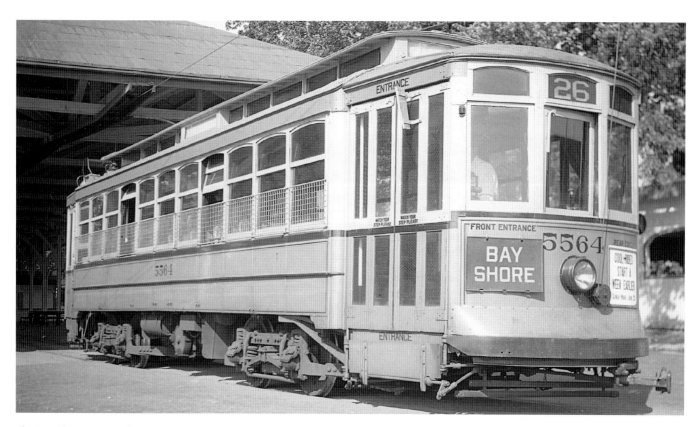

The Bay Shore terminal station is the location of BTC route 26 semi-convertible car No. 5564 in June 1940. This was originally car No. 305, built by J. G. Brill Company in 1914 and became 5564 in 1922. (Bob Crockett photograph—C. R. Scholes collection.)

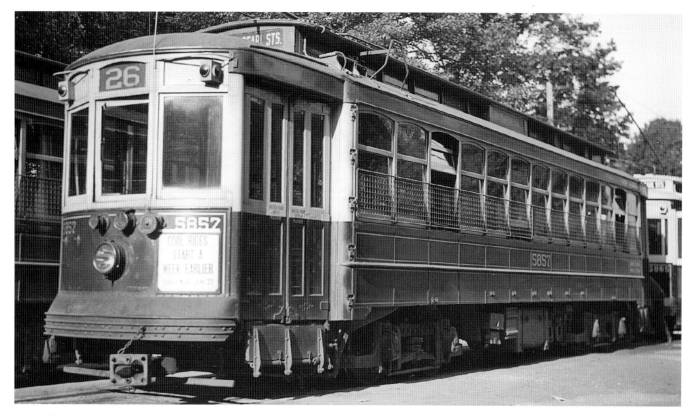

In June 1940, BTC route 26 semi-convertible multiple unit cars No. 5857 (originally No. 2633) and 5865 (originally No. 2641) are at the Sparrows Point terminal. Both cars were built by J. G. Brill Company in 1919 for the United States Shipping Board Emergency Fleet Corporation and were renumbered in 1922. (Bob Crockett photograph—C. R. Scholes collection.)

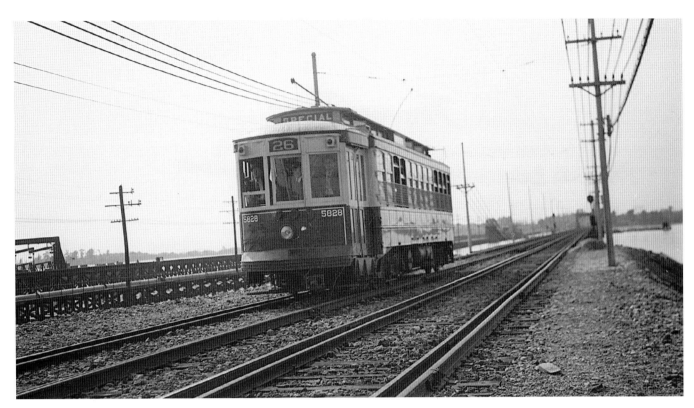

On May 30, 1941, BTC route 26 semi-convertible car No. 5828 (originally No. 2604) is on the Bear Creek causeway near the bridge. This car was built by J. G. Brill Company in 1919 and became No. 5828 in 1922. The 50 cars of this series, Nos. 5825-5874, were the first Baltimore cars equipped with anti-climbers (bumpers with ribbed surfaces that would lock together in a collision and prevent a car from overriding the other car). (Bob Crockett photograph—C. R. Scholes collection.)

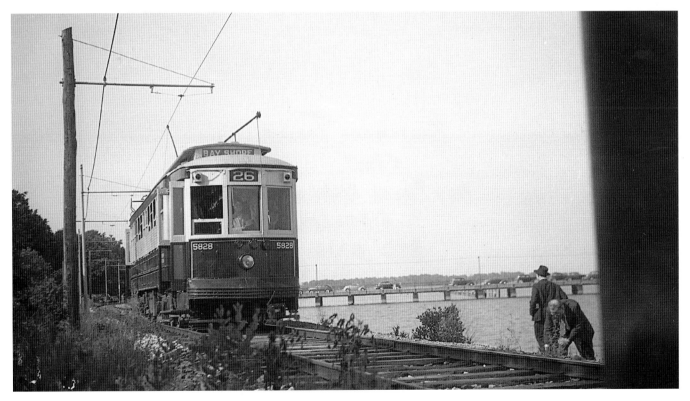

The Bay Shore branch of BTC route 26 along the Chesapeake Bay provides a nice photo spot for semi-convertible car No. 5828 on May 30, 1941. This series of cars, Nos. 5825-5874, served the Sparrows Point shipyard and steel mill on weekdays and carried crowds of riders to Bay Shore Park on Sundays and holidays. (Bob Crockett photograph—C. R. Scholes collection.)

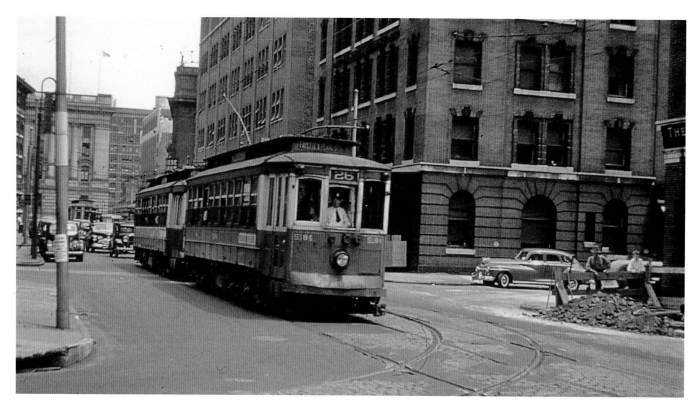

Lombard and Calvert Street in downtown Baltimore is the location of BTC route 26 semi-convertible car No. 5184 in multiple unit with another car in 1946. This car was built by J. G. Brill Company as No. 2413 in 1905, became No. 1713 in 1907, No. 1558 in 1914, No. 2483 in 1918, and No. 5184 in 1922. Before 1922, cars were numbered by their assigned route so that as an assigned route changed, the car number was changed. (Bob Crockett photograph—C. R. Scholes collection.)

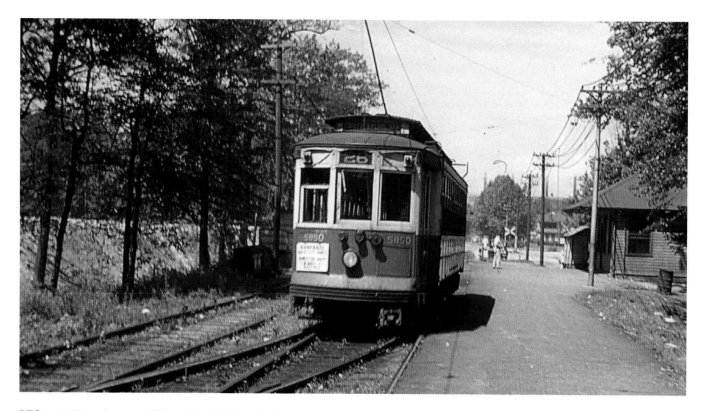

BTC route 26 semi-convertible car No. 5850 is at the Sparrows Point station in 1946. This car was built by J. G. Brill Company in 1919 as No. 2626 for the United States Shipping Board Emergency Fleet Corporation and became No. 5850 in 1922. (Bob Crockett photograph—C. R. Scholes collection.)

On September 8, 1946, BTC route 26 Peter Witt car No. 6075 is heading a lineup of streetcars at the Dundalk loop in the community of Dundalk (named after Dundalk, Ireland) in Baltimore County just east of Baltimore. This was one of 50 cars Nos. 6051-6100 built in 1930 by the Cincinnati Car Company. Powered by four General Electric type 301 motors, each car weighed 39,700 pounds. (Bob Crockett photograph—C. R. Scholes collection.)

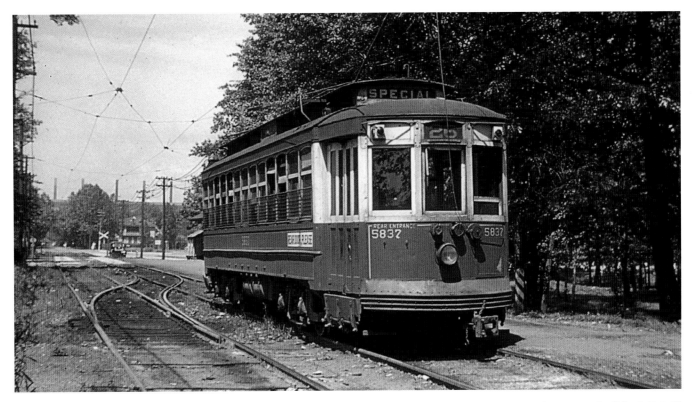

BTC route 26 semi-convertible car No. 5837 (originally No. 2613) is at the Sparrows Point terminal in 1946. This car was built by J. G. Brill Company in 1919 and became 5837 in 1922. Sparrows Point terminal was a transfer point for the streetcar to Bay Shore Park and the streetcar to Fort Howard. (Bob Crockett photograph—C. R. Scholes collection.)

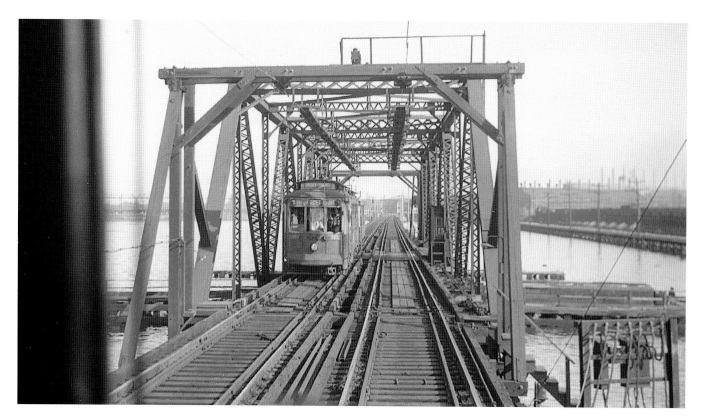

On September 8, 1946, BTC route 26 car No. 5652 (originally No. 1903) is on the Bear Creek trestle. This car was built by J. G. Brill Company in 1917 and became 5652 in 1922. (Bob Crockett photograph—C. R. Scholes collection.)

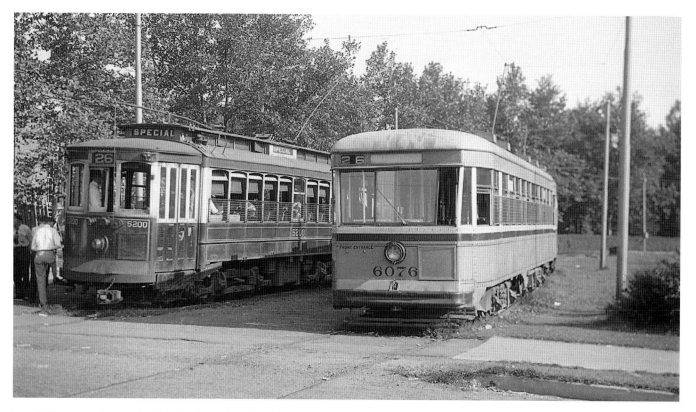

Dundalk loop on September 8, 1946, is the location of BTC route 26 Peter Witt car No. 6076 and semi-convertible car No. 5200, built as No. 1409 in 1905, renumbered 2434 in 1906, renumbered 1734 in 1907, renumbered 2914 in 1908, renumbered 1729 in 1912, renumbered 1574 in 1914, renumbered 2499 in 1918, and finally became No. 5200 in 1922. These renumberings occurred, because as a car was assigned to a different route, the car number would change. (Bob Crockett photograph—C. R. Scholes collection.)

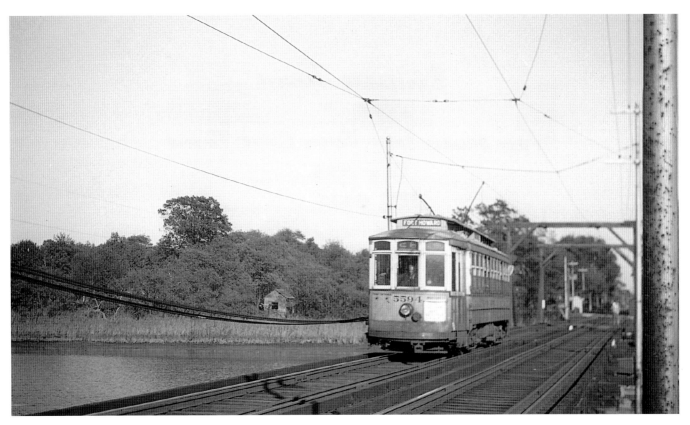

In October 1946, BTC semi-convertible car No. 5594 (originally No. 335) is over the Jones Creek trestle on the Fort Howard branch of route 26. This car was built by J. G. Brill Company in 1914 and became 5594 in 1922. (Bob Crockett photograph—C. R. Scholes collection.)

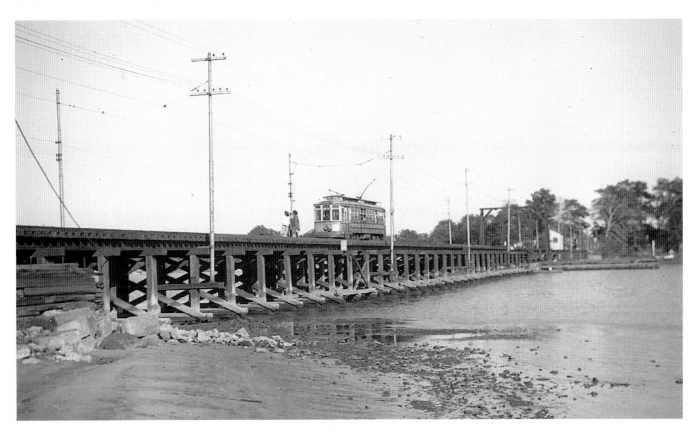

The Fort Howard North Point Channel trestle is the location of BTC semi-convertible car No. 5563 in October 1946. This car was built as No. 304 by J. G. Brill Company in 1914 and became No. 5563 in 1922. (Bob Crockett photograph—C. R. Scholes collection.)

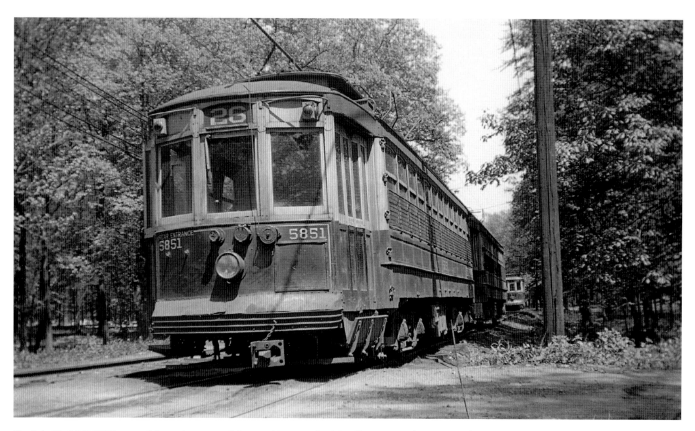

On July 19, 1947, BTC route 26 semi-convertible cars No. 5851 (originally No. 2627) and 5861 (originally No. 2637) are at Sparrows Point. Both cars were built by J. G. Brill Company in 1919. (C. R. Scholes collection.)

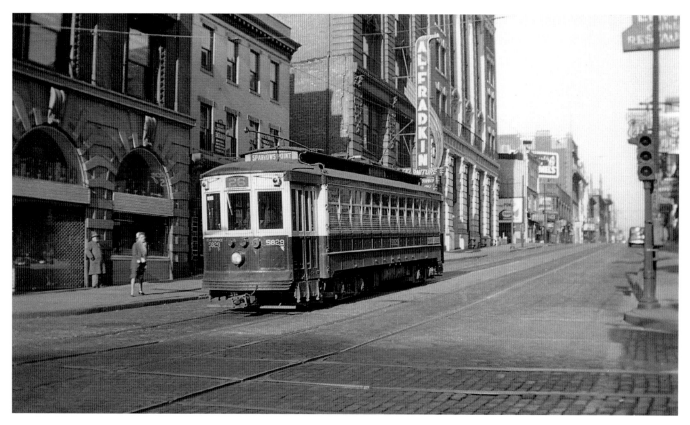

On a quiet July 19, 1947, BTC route 26 semi-convertible car No. 5829 (originally No. 2605) is on Fayette Street ready to cross routes 25 and 32 trackage on Park Avenue in downtown Baltimore. (C. R. Scholes collection.)

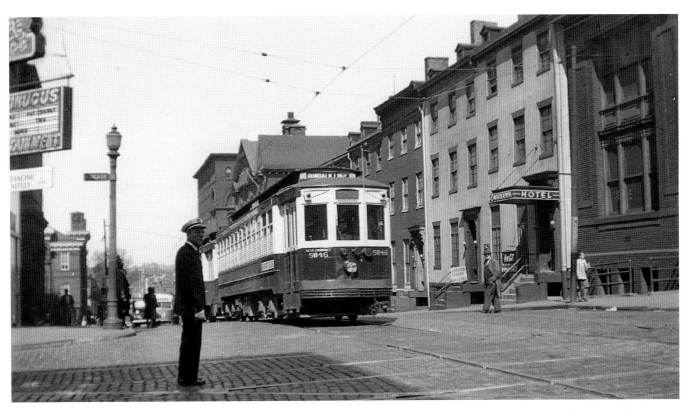

Fayette Street and Paca Street is the location of BTC route 26 semi-convertible cars Nos. 5846 (originally No. 2622) and 5835 (originally No. 2611) on July 19, 1947. Both cars were built by J. G. Brill Company in 1919. The homes on the right side of the streetcar are Federal style row homes characterized by dormers on the gabled roof. Baltimore has thousands of row homes, where there is a single wall between each home. (C. R. Scholes collection.)

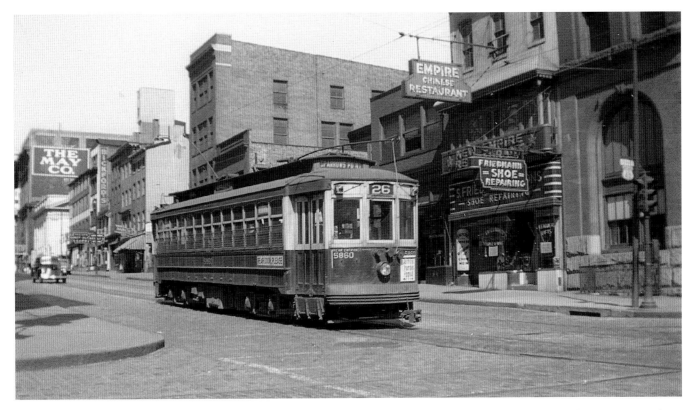

On July 19, 1947, BTC route 26 semi-convertible car No. 5860 (originally No. 2636), with Sparrows Point on the destination sign, is on Fayette Street and Paca Street. (C. R. Scholes collection.)

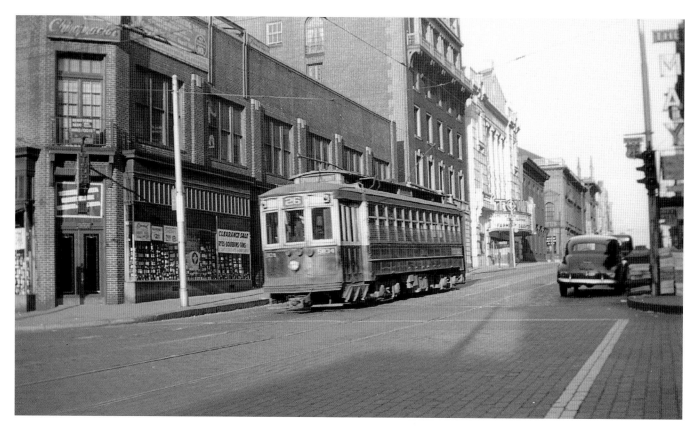

BTC route 26 semi-convertible car No. 5834 (originally No. 2610) is on Fayette Street at Howard Street on July 19, 1947. (C. R. Scholes collection.)

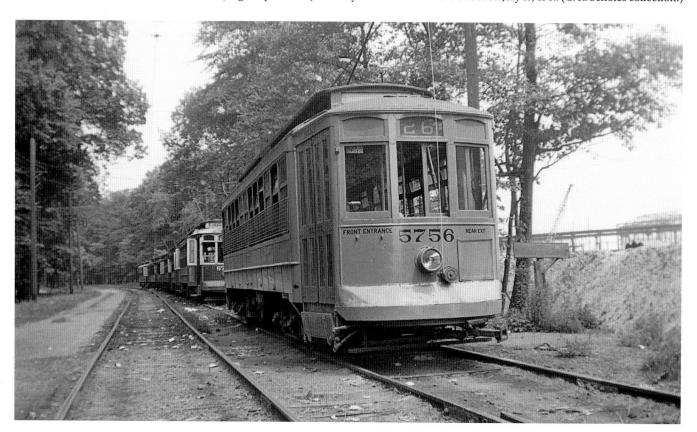

On July 29, 1948, BTC route 26 semi-convertible car No. 5756 (originally No. 1512) is heading a line of cars at Sparrows Point, waiting for departure time on July 29, 1948. This car does not have the cream paint scheme around the windows as noted on the streetcar behind it. (C. R. Scholes collection.)

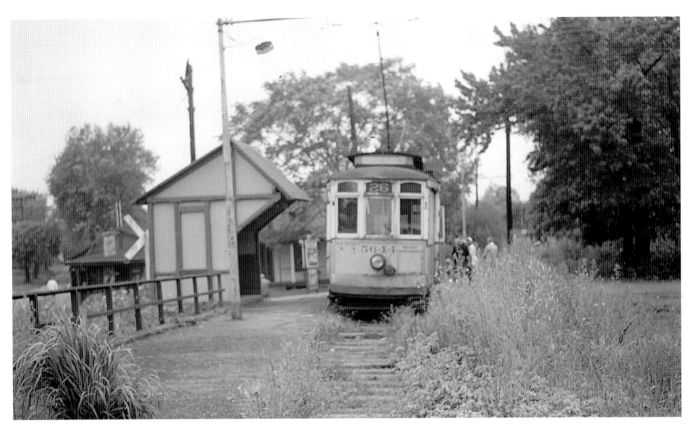

With vegetation taking over the right of way, BTC route 26 semi-convertible car No. 5644 (originally No. 1725) is at the Fort Howard terminal station on June 20, 1948. The Fort Howard to Sparrows Point shuttle made its last run on October 18, 1953. (C. R. Scholes collection.)

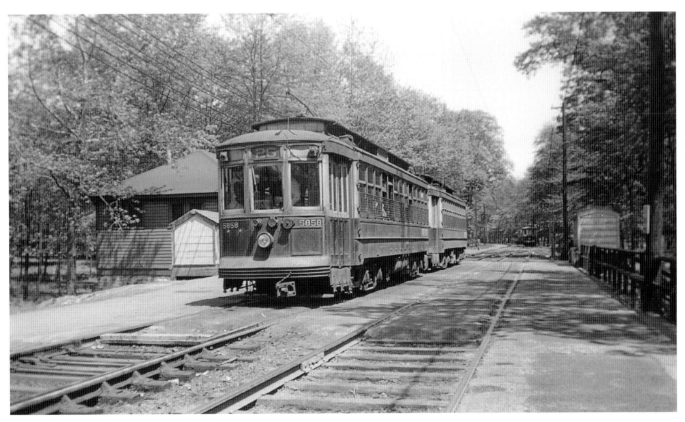

On July 20, 1947, a two-car train of BTC route 26 semi-convertible cars Nos. 5858 (originally No. 2634) and 5864 (originally No. 2640) are at the Sparrows Point terminal. (C. R. Scholes collection.)

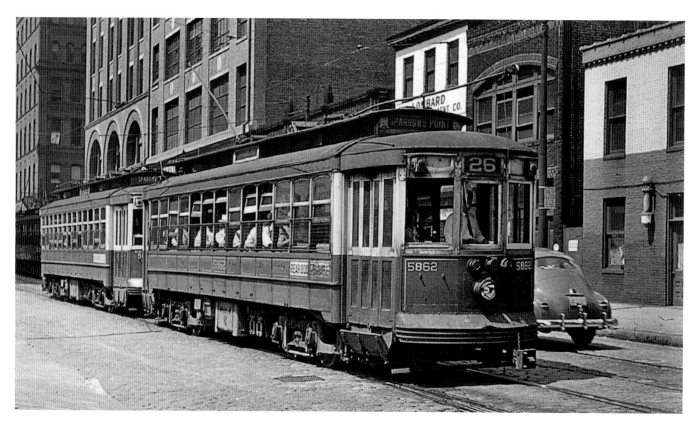

On August 12, 1948, BTC route 26 multiple unit semi-convertible cars Nos. 5862 (originally No. 2638) and No. 5858 (originally No. 2634) are on Fayette Street. Riding was heavy on this line to Dundalk, Sparrows Point, and up to September 14, 1946, when the Bay Shore branch line closed that served the company-owned bathing resort plus amusement park at Bay Shore Park. (Bob Crockett photograph—C. R. Scholes collection.)

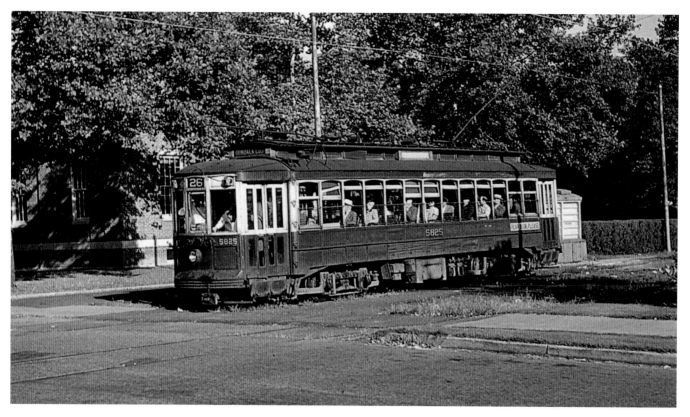

On August 30, 1950, BTC route 26 semi-convertible car No. 5825 (originally No. 2601) is on the private right of way at Dundalk. As noted by the open windows, people still dressed up when they went out in 1950. (Bob Crockett photograph—C. R. Scholes collection.)

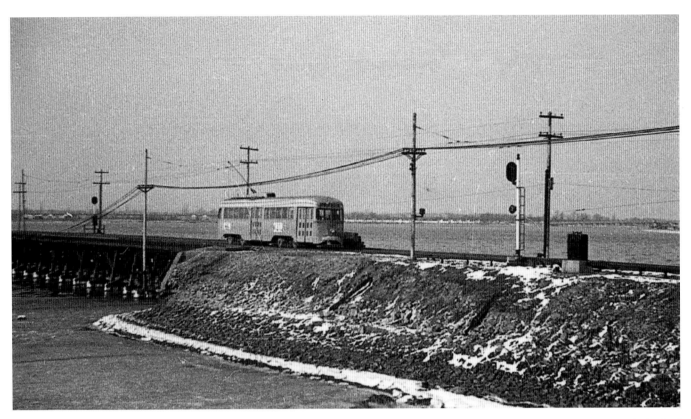

BTC route 26 PCC car No. 7115 has crossed the Bear Creek trestle and is on the causeway of the Sparrows Point line that had the look of a main line railroad in 1950. Much of route 26 was on private right of way, and the Bear Creek trestle was a highlight of the trip. (C. R. Scholes collection.)

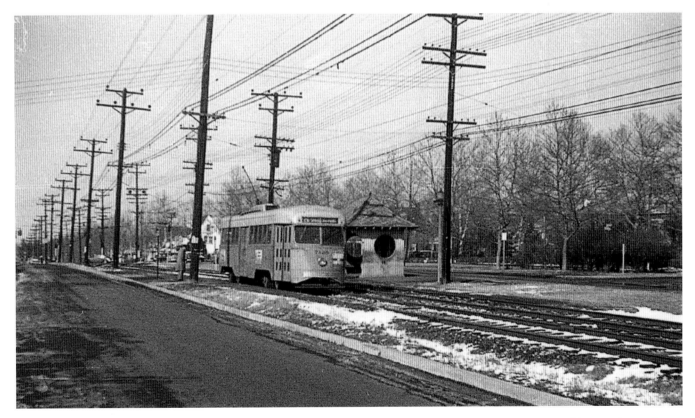

The private right of way along Dundalk Avenue provides a traffic-free route for BTC route 26 PCC car No. 7125 in this 1950 view at Center Place station. (C. R. Scholes collection.)

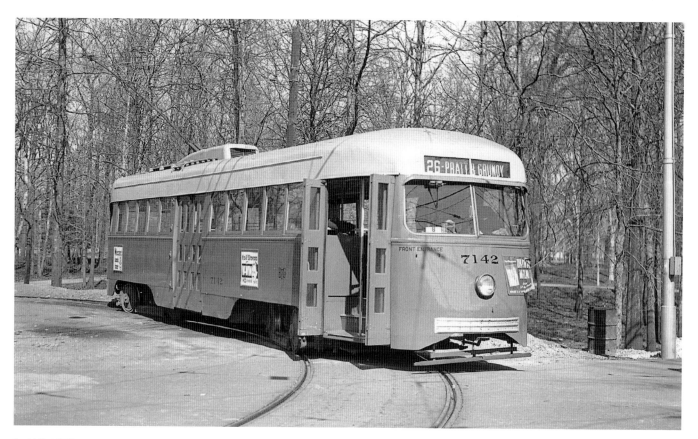

In 1951, BTC route 26 PCC car No. 7142 is at the Sparrows Point loop waiting for departure time. (C. R. Scholes collection.)

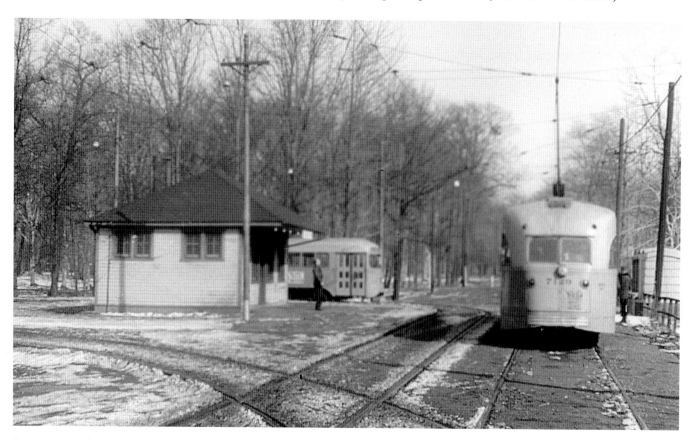

Sparrows Point loop is the location for BTC route 26 PCC car No. 7129 and another PCC car on February 12, 1955. (Bob Crockett photograph—C. R. Scholes collection.)

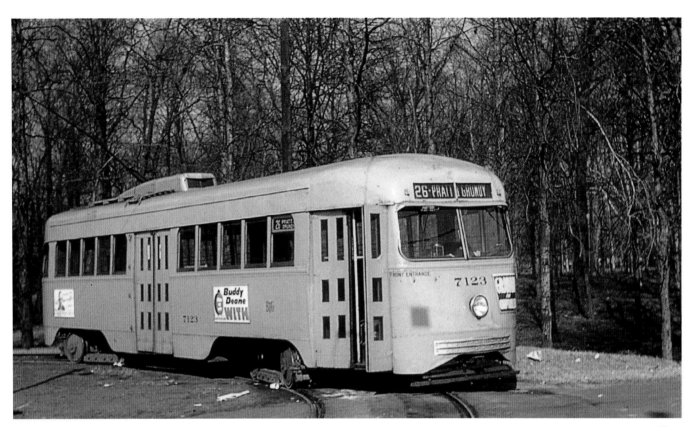

BTC route 26 PCC car No. 7123 had over 10 years of service and still had a well-maintained look in this scene at Sparrows Point loop in 1955. (Bob Crockett photograph—C. R. Scholes collection.)

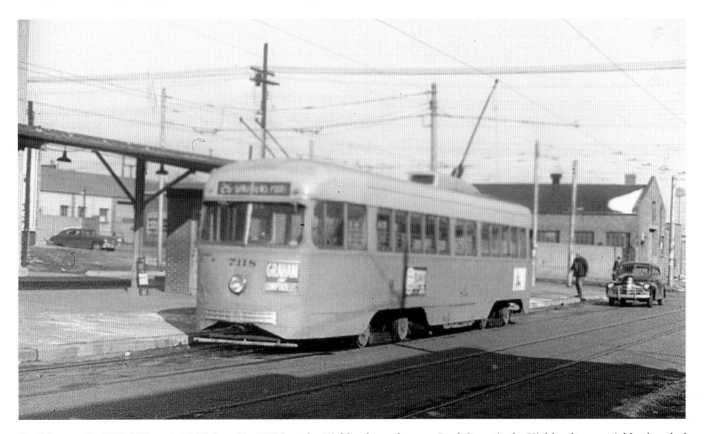

On February 13, 1955, BTC route 26 PCC car No. 7118 is at the Highlandtown loop on Bank Street in the Highlandtown neighborhood of Baltimore. (Bob Crockett photograph—C. R. Scholes collection.)

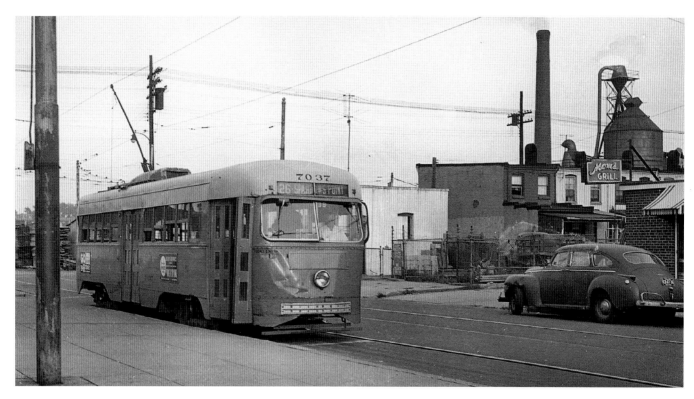

Time was running out for BTC route 26 in this 1958 scene of PCC car No. 7037 at Pratt and Haven Streets. This was one of 20 cars Nos. 7034-7053 built by Pullman-Standard Car Manufacturing Company and delivered between December 1940 and January 1941. Powered by four General Electric type 1198 motors, each car weighed 36,000 pounds and seated 55 passengers. On August 31, 1958, all of route 26 was running as a bus line. (C. R. Scholes collection.)

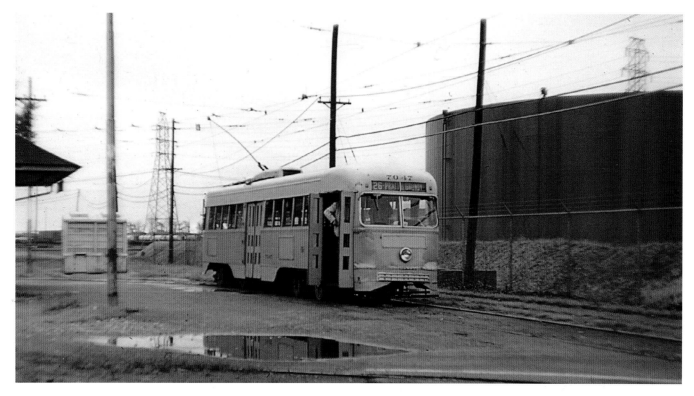

BTC route 26 PCC car No. 7047 is on a layover at the Sparrows Point loop on August 24, 1958. Named for Thomas Sparrow, landowner, the once rural area of Sparrows Point became the site of the world's largest steel plant. Operated by Bethlehem Steel, the four mile long steel plant once employed thousands of workers that contributed to heavy ridership for route 26 streetcars. The plant was sold in 2005, went through ownership changes, and closed in 2012. (C. Able photograph—C. R. Scholes collection.)

Chapter 8
Routes 13, 24, and 35

In 1945, route 13 (North Avenue) operated on North Avenue from Walbrook Junction on the west end, to Bel Air Road on the east end. This line did not enter downtown Baltimore. On October 13, 1946, the carhouse at North Avenue and Oak Street closed, and route 13 streetcars, which operated from that carhouse, were transferred to the Montebello carhouse on Harford Road. Some route 13 streetcars later operated from the Edmondson carhouse. BTC stated that route 13 required track reconstruction that would cost $211,178, and with the new city traffic director Henry Barnes testifying at the October 27, 1953 PSC hearing that buses would be safer than streetcars on North Avenue, the PSC permitted route 13 to become a bus line, which occurred on January 10, 1954.

When route 10 (Roland Park-Highlandtown) was converted to trackless trolley on April 14, 1940, route 24 (Lakeside) was extended southward on Roland Avenue from Upland Road to the Water Tower terminus of route 10. The 1945 BTC map showed that route 24 operated from the Roland Park Water Tower at Roland Avenue and University Parkway via Roland Avenue to Lakeside Park. On April 21, 1946, the Roland Park carhouse, which housed route 24 and route 29 streetcars, closed, and both streetcar routes were transferred to the Oak Street carhouse. Route 24 was terminated at Lake Avenue, separating it from the rest of the streetcar system on June 22, 1947, and car No. 5687 provided service on the now isolated line. On January 29, 1950, route 24 was replaced by the route 56 bus.

Route 35 (Lorraine), built as the Lorraine Electric Railway, began operation on August 20, 1907, from Lorraine Cemetery to Dickeyville, and began through service to Walbrook Junction on July 1, 1916. It leased cars and operators from United Railways & Electric Company and became part of the unified Baltimore system around 1930, making it the last independent streetcar company in Baltimore. West of Walbrook Junction, route 35 shared track with route 4 on Clifton Avenue to Windsor Hills. Beyond Windsor Hills the line was more rural to Dickeyville, while still within the Baltimore city limits. Buses replaced route 35 streetcars on February 27, 1954.

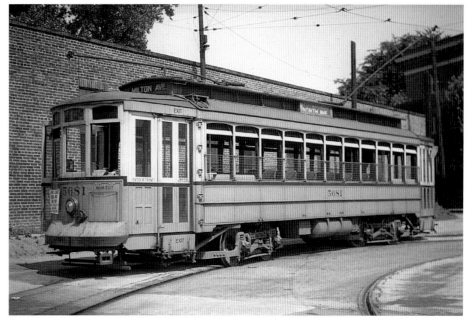

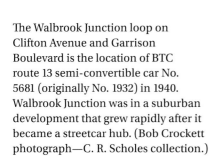

The Walbrook Junction loop on Clifton Avenue and Garrison Boulevard is the location of BTC route 13 semi-convertible car No. 5681 (originally No. 1932) in 1940. Walbrook Junction was in a suburban development that grew rapidly after it became a streetcar hub. (Bob Crockett photograph—C. R. Scholes collection.)

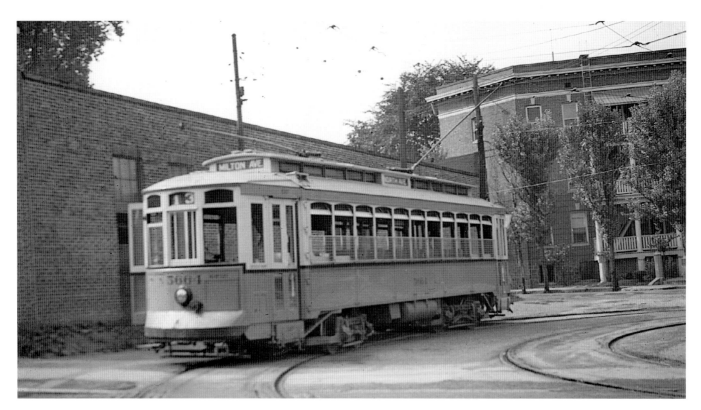

In August 1940, BTC route 13 semi-convertible car No. 5664 (originally 1915) is at the Walbrook Junction loop located at Clifton Avenue and Garrison Boulevard. At this time period, routes 13 and 35 terminated at the Walbrook Junction loop while routes 4 and 31 passed by the loop. (Bob Crockett photograph—C. R. Scholes collection.)

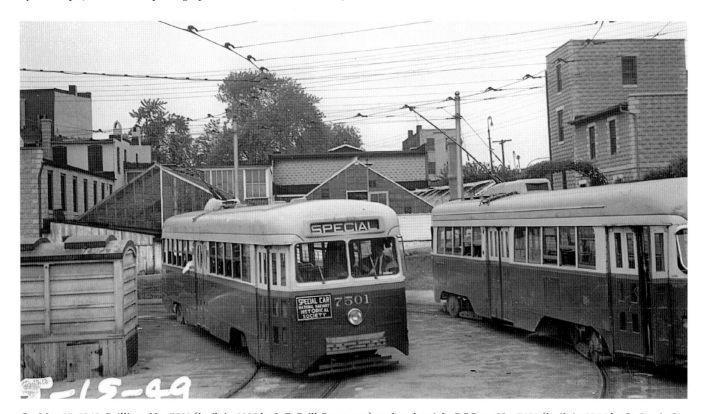

On May 15, 1949, Brilliner No. 7501 (built in 1939 by J. G. Brill Company) and to the right PCC car No. 7420 (built in 1944 by St. Louis Car Company) are at the Milton Avenue route 13 eastern terminus. Car No. 7501 was the only Brilliner purchased by BTC, and it was normally assigned to route 8. However, this car was being used for a rail excursion as noted by "Special" on the front roll sign and the lower left front sign "Special Car National Railway Historical Society." (Bob Crockett photograph—C. R. Scholes collection.)

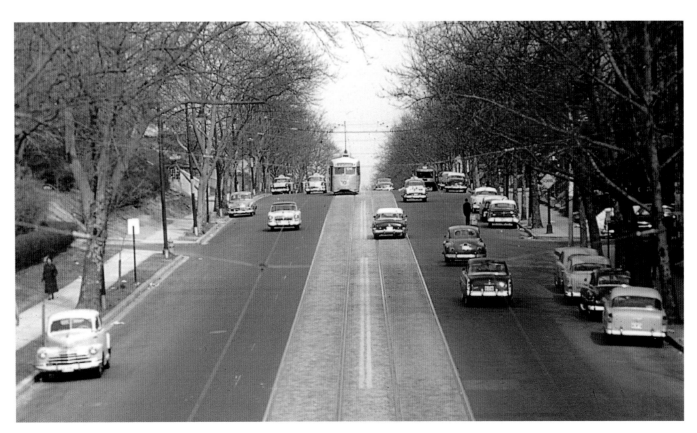

BTC route 13 PCC car No. 7377 is on North Avenue in this April 14, 1956 view. Route 13 was the only heavy ridership line that did not enter downtown Baltimore, but had heavy transfer service by crossing every major north-south route. (C. Able—C. R. Scholes collection.)

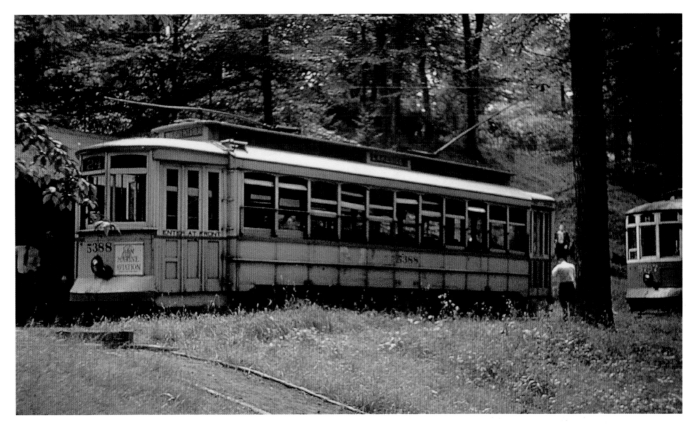

In 1946, BTC route 24 semi-convertible cars Nos. 5388 (originally No. 109) and 5797 (originally 1553) are at the Lakeside Terminal. (C. R. Scholes collection.)

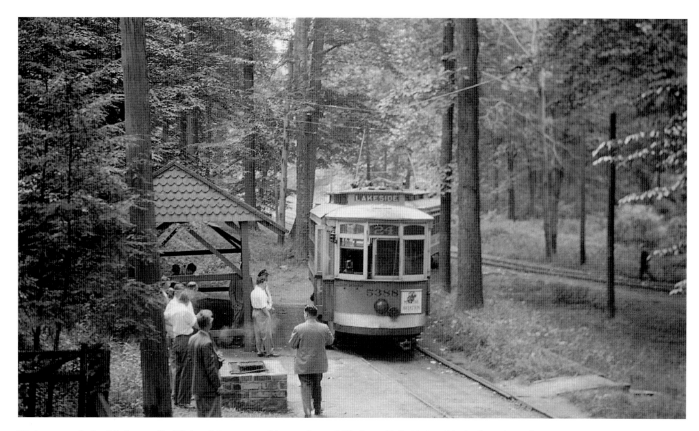

Picturesque Lakeside loop off of Roland Avenue and located on a hill above Lake Roland is the location of BTC route 24 semi-convertible car No. 5388 (originally No. 109) on July 7, 1946. (Bob Crockett photograph—C. R. Scholes collection.)

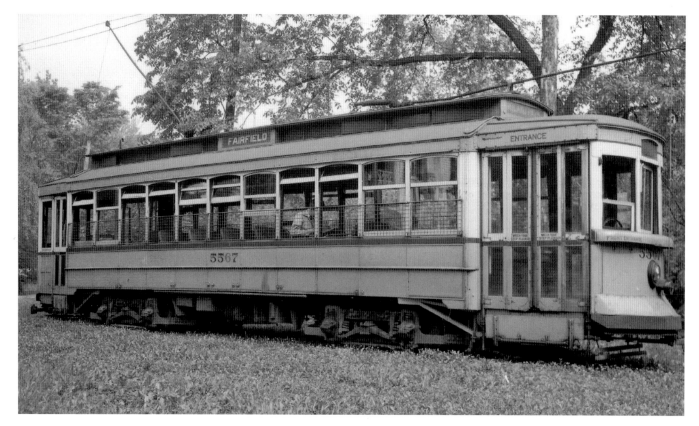

On April 24, 1949, BTC route 24 semi-convertible car No. 5567 (originally No. 308) is at the Lakeside Park terminal. This car lasted 35 years in service. The 85 cars of this series, Nos. 5560-5644, were in service from 33 to 36 years. (C. R. Scholes collection.)

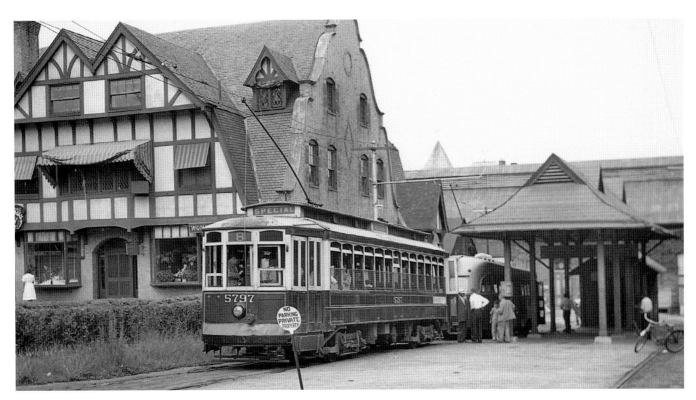

Roland Park loop, off Roland Avenue, is the location of BTC semi-convertible car No. 5797 (originally No. 1553) on a rail excursion behind a regular service route 29 PCC car at the Roland Park loop on July 7, 1946. This loop was used by route 29 cars while route 24 cars continued north to the Lakeside loop. The building on the left was one of the first shopping centers in the United States. Roland Park, named for Baltimore County landowner Roland Thornberry, began in 1890 as Baltimore's first planned residential development with deed restrictions and established responsibilities for maintenance of the area. (Bob Crockett photograph—C. R. Scholes collection.)

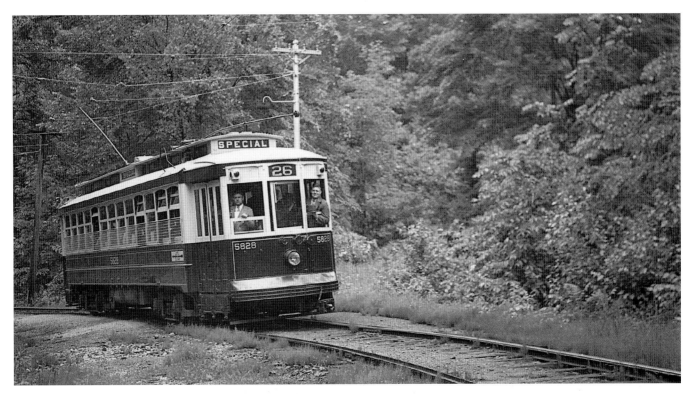

In May 1940, BTC semi-convertible car No. 5828 (originally No. 2604) is on a rail excursion over route 35 (Dickeyville) private right of way near Fairfax Road. At what appears to be a photo stop, 26 on the front roll sign should have been changed to 35. (Bob Crockett photograph—C. R. Scholes collection.)

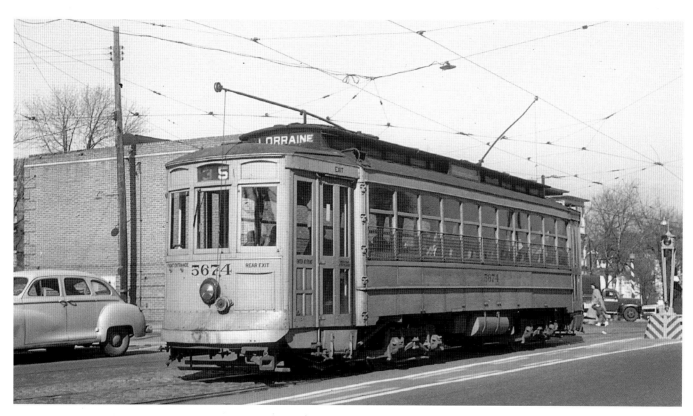

BTC route 35 semi-convertible car No. 5674 (originally No. 1925) is at Clifton Avenue and Garrison Boulevard at Walbrook Junction in the Walbrook neighborhood of Baltimore in 1940. Route 4 shared trackage with route 35 between Walbrook Junction and Windsor Hills. West of Windsor Hills, route 35 became a more rural line. (C. R. Scholes collection.)

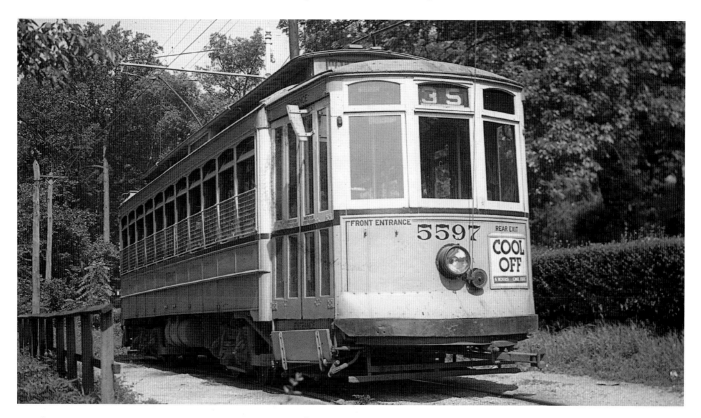

In July 1940, BTC route 35 semi-convertible car No. 5597 (originally No. 338) is at the Dickeyville end of the line. Dickeyville, named for mill owner William J. Dickey, was built in the 19th century for mill workers and families and was placed in the National Register of Historic Places in 1972. (Bob Crockett photograph—C. R. Scholes collection.)

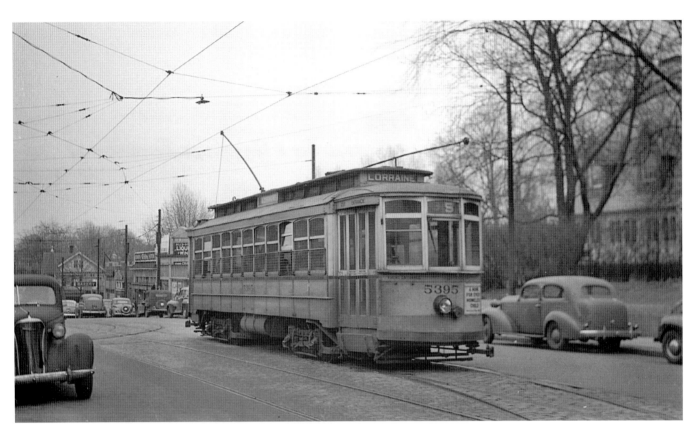

Clifton Avenue and Garrison Boulevard is the location of BTC route 35 semi-convertible car No. 5395 (originally No. 116) in October 1941. (Bob Crockett photograph—C. R. Scholes collection.)

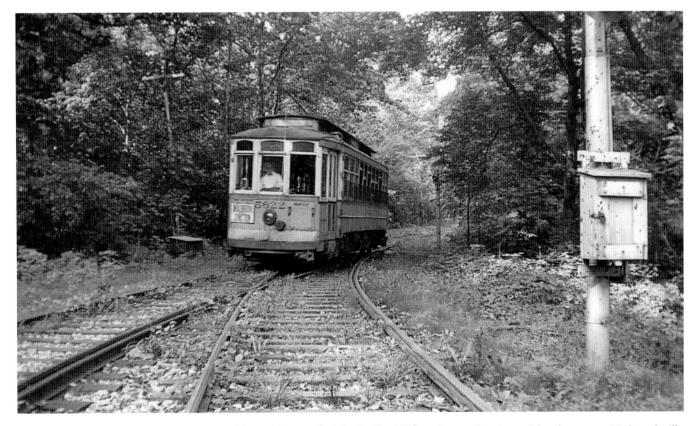

On July 19, 1947, BTC route 35 semi-convertible car No. 5622 (originally No. 1703) on the scenic private right of way near Wetheredsville Road. (C. R. Scholes collection.)

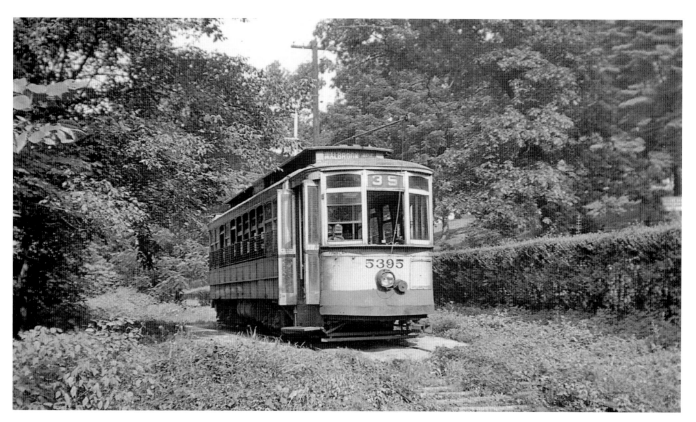

The scenic route 35 terminus at the village of Dickeyville, just inside the western edge of the city of Baltimore, is the location of BTC semi-convertible car No. 5395 (originally No. 116) on July 29, 1948. (C. R. Scholes collection.)

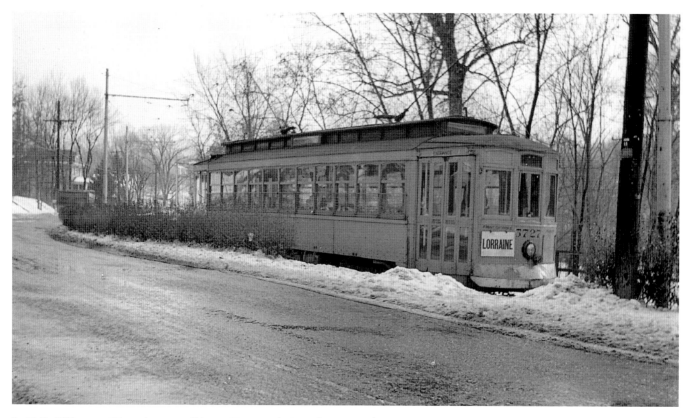

In 1948, BTC route 35 semi-convertible car No. 5727 (originally No. 3128) is on Dogwood Road at the Lorraine Cemetery, which was founded in 1872. This line traversed wooded areas, side of the road areas, and ended at a vintage village inside the city limits of Baltimore. (Bill Stevenson photograph—C. R. Scholes collection.)

Chapter 9

Routes 8 and 15

Route 8 (Catonsville-Towson), longest line on the system, operated from Catonsville west of Baltimore via Frederick Road and Lombard Street to downtown Baltimore and north to Towson via Greenmount Avenue and York Road. The northern terminus of route 8 was on Washington Street in front of the court house in Towson, the county seat of Baltimore County. Leaving the courthouse terminus, route 8 returned to York Road via Chesapeake Avenue. On April 27, 1893, the Baltimore Union Passenger Railway opened its York Road line connecting City Hall in Baltimore with Towson. Before Interstate 83 was built, York Road was the main road to York and Harrisburg, Pennsylvania. New PCC cars Nos. 7023-7033 and 7306-7334 purchased from Pullman-Standard Car Manufacturing Company provided base weekday and all weekend service on route 8 beginning July 2, 1939. Paradise loop was built in 1944. Route 8 was rerouted off Holliday Street, Hillen Street, Forrest Street, and Greenmount Avenue below North Avenue to the Guilford Avenue elevated line on June 22, 1947. Route 8 returned to its former Greenmount Avenue trackage on January 1, 1950. The

elevated structure was dismantled in May 1950. During 1951, the State Roads Commission paid the cost of relocating over a mile of track used by route 8 from the north side to the center of Frederick Road. PCC car No. 7084 made the last regularly scheduled route 8 trip coming into the Irvington carhouse at 5:25 a.m. followed by PCC car No. 7407, chartered by a group of rail enthusiasts at 6:34 a.m. Route 8 was replaced by buses on November 3, 1963.

Route 15 (Overlea) began receiving new PCC cars on December 25, 1940. On May 9, 1948, route 15 was cut back to Fayette and Pearl Streets. Streetcar route 15 was extended to take over streetcar route 4 (Edmondson Avenue) on September 19, 1954, by rerouting route 15 north of Eutaw Street to Saratoga Street and then over route 4 trackage to Windsor Hills. On June 19, 1956, route 19 buses replaced the Walbrook-Windsor Hills branch of streetcar route 15. However, Garrison Boulevard trackage was retained for route 15 streetcars to reach the Belvedere carhouse until February 14, 1960, when route 15 terminated at Walbrook Junction. Route 15 was replaced by buses on November 3, 1963.

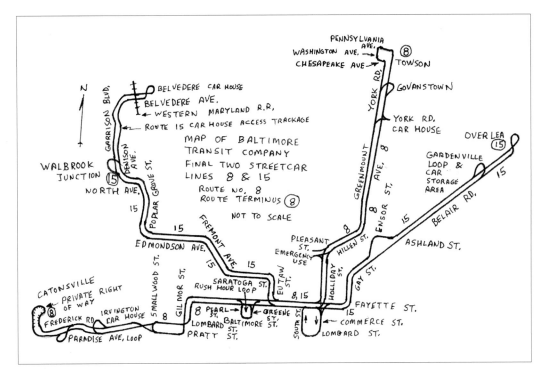

Map of Baltimore Transit Company routes 8 and 15 that shows trackage effective July 26, 1959.

BTC semi-convertible car No. 5502 (originally No. 403) is on the 0.67-mile-long Guilford Avenue, elevated in June 1940, which was used by BTC routes 1, 8, and 11. This was one of 60 cars, Nos. 401-460, built by J. G. Brill Company in 1913 and renumbered 5500-5559 in 1922. Each car was powered by four General Electric type 246 motors. On May 3, 1893, the first streetcar operated over the elevated structure (the first time a car had operated by electric power on an elevated structure in America). New York City's first elevated line opened in May 1885 with coaches hauled by steam locomotives. On July 3, 1899, the Brooklyn Rapid Transit Corporation opened its first electrified service on the 5th Avenue Elevated. Baltimore's route 8 used the Guilford Avenue elevated until January 1, 1950, when it was returned to its former Greenmount Avenue routing. (Bob Crockett photograph—C. R. Scholes collection.)

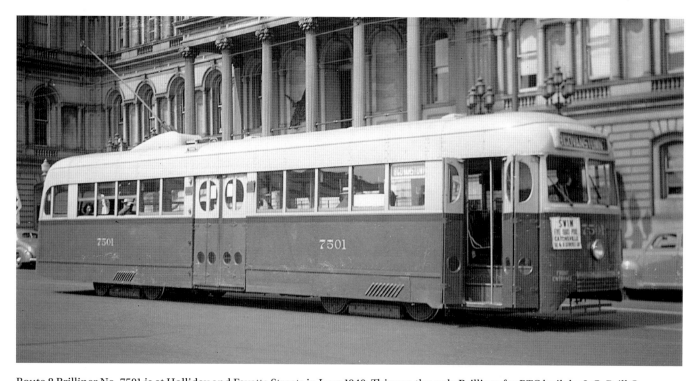

Route 8 Brilliner No. 7501 is at Holliday and Fayette Streets in June 1940. This car, the only Brilliner for BTC built by J. G. Brill Company, had doors with circular windows in the upper section and small windows in the lower portion of the door. These doors were later replaced by doors with rectangular windows. The car skirting partially covered the trucks, was later removed to improve access for maintenance. (Bob Crockett photograph—C. R. Scholes collection.)

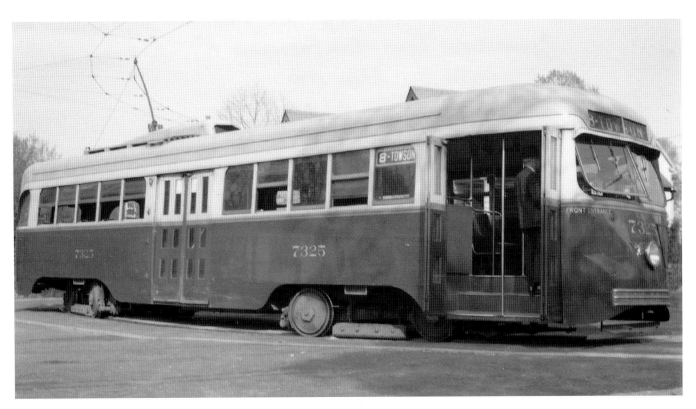

In April 1941, BTC route 8 PCC car No. 7325 is at the Catonsville loop waiting for departure time. Beginning July 2, 1939, PCC cars began providing base service on route 8. (Bob Crockett photograph—C. R. Scholes collection.)

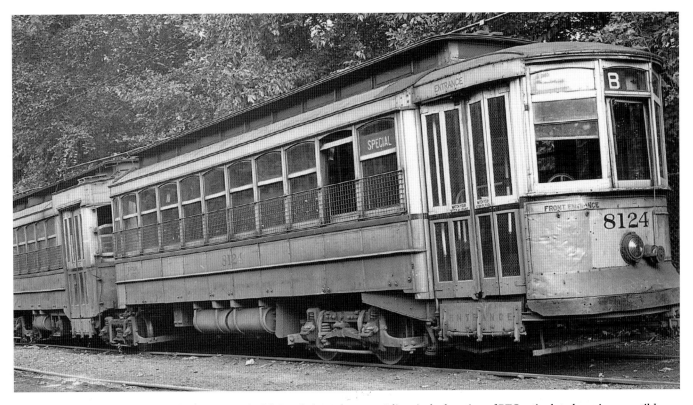

On August 24, 1946, Irvington carhouse, on Frederick Road along the route 8 line, is the location of BTC articulated semi-convertible car No. 8124 (home built from cars Nos. 5103 and 5104 in 1931). This type of car was a creative, low cost way of handling rush hour crowds of riders. The Baltimore, Catonsville, and Ellicott's Mills Passenger Railway (BC&EMPR) opened a horse car line on Frederick Road on August 5, 1862, connecting Catonsville with Baltimore. BC&EMPR opened Baltimore's first trolley amusement park at Frederick Road and Paradise Avenue in 1865. (C. R. Scholes collection.)

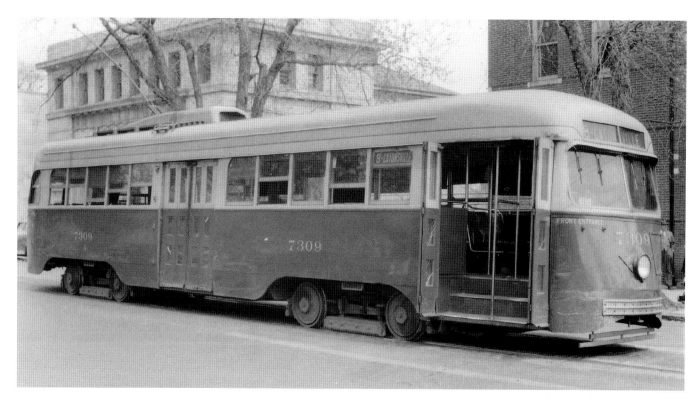

BTC route 8 PCC car No. 7309 is at the northern end of the line on Washington Avenue at Chesapeake Avenue in Towson in July 1946. The Baltimore & Yorktown Turnpike Company began operating double deck horse cars between Baltimore's City Hall and Towsontown (later named Towson) on August 20, 1863. Electric streetcar operation between Baltimore and Towson began on April 2, 1893. (C. R. Scholes collection.)

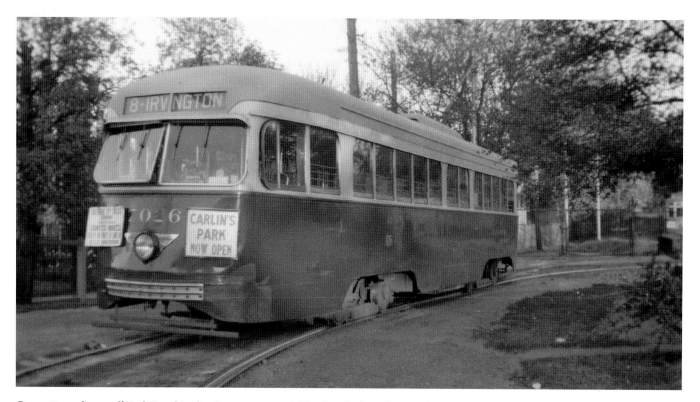

Govanstown loop, off York Road in the Govanstown neighborhood of northern Baltimore, is the location of BTC route 8 PCC car No. 7026 on July 20, 1947. Until January 1, 1931, route 7 (a short turn version of route 8) operated between Govanstown loop and Irvington loop, after which cars opreating betweeen those loops were designated as route 8. (C. R. Scholes collection.)

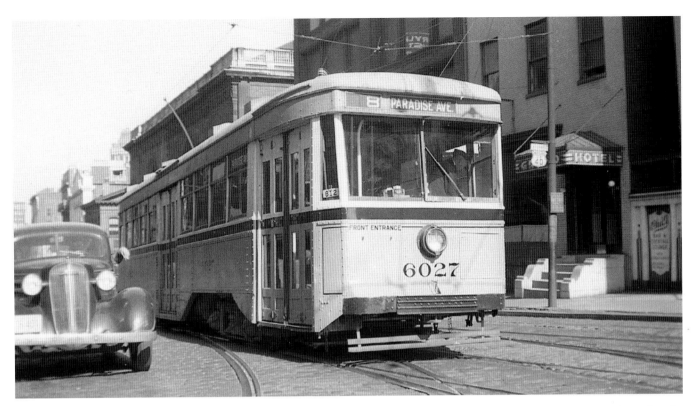

On July 20, 1947, BTC route 8 Peter Witt car No. 6027 is at Fayette and Paca Streets in downtown Baltimore, heading westbound to the Paradise loop, a cutback loop for route 8. Downtown Baltimore was a maze of streetcar tracks. The streetcar was a positive influence in the development of Baltimore, linking outlying areas to center city. (C. R. Scholes collection.)

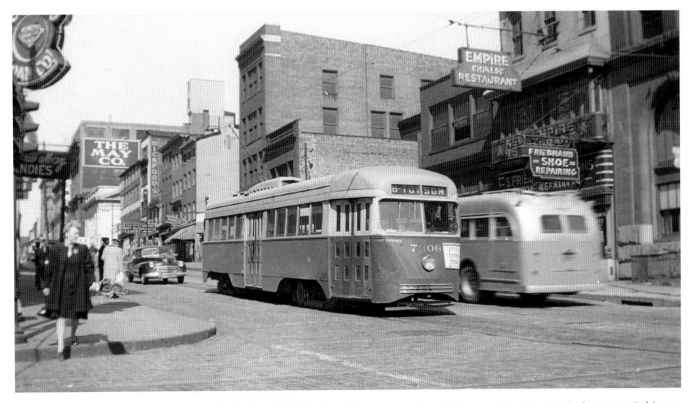

BTC route 8 PCC car No. 7306 is passing a bus built by FitzJohn Coach Company on Fayette Street and Park Avenue in downtown Baltimore on July 19, 1947. Initially buses for the most part were feeder routes to the streetcar lines; however, the major conversion to bus operation in Baltimore began on June 22, 1947, even though the PCC car was Baltimore's newest streetcar and was the finest streetcar design from a maintenance standpoint in the United States. (C. R. Scholes collection.)

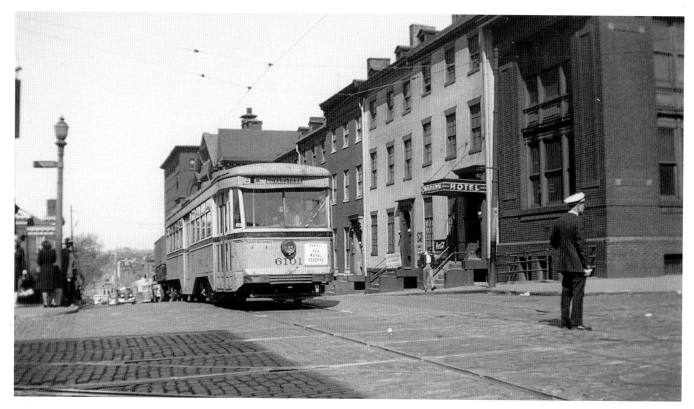

On May 10, 1947, BTC route 8 Peter Witt car No. 6101 is on Fayette and Paca Streets, heading for Govanstown with a policeman directing traffic at the intersection. (C. R. Scholes collection.)

BTC articulated semi-convertible cars Nos. 8123 (built in 1930 from No. 5101 and 5102) and 8128 (built in 1931 from 5111 and 5112) are parked at the York Road carhouse on July 10, 1947. Recycling old cars into an articulated car was a practical solution to handle rush hour ridership needs. Articulated streetcars were not popular in the 1930s; however, in 2017, they are used on light rail systems around the world, including Baltimore's Central Light Rail Line. The York Road carhouse opened on February 24, 1908. (C. R. Scholes collection.)

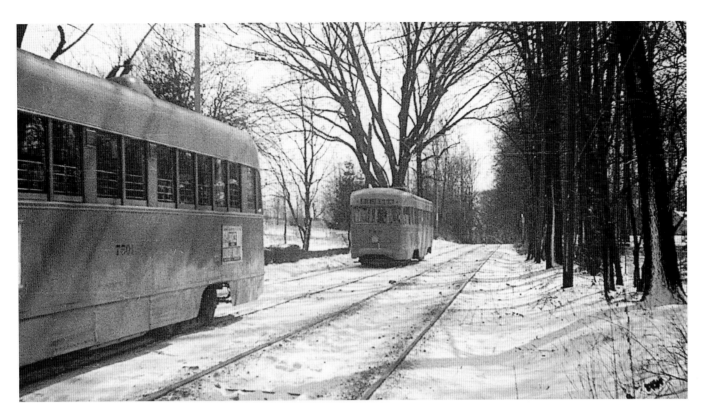

Brilliner No. 7501 followed by PCC car No. 7137 are on the snow covered private right of way at the Catonsville end of route 8 in 1950. (C. R. Scholes collection.)

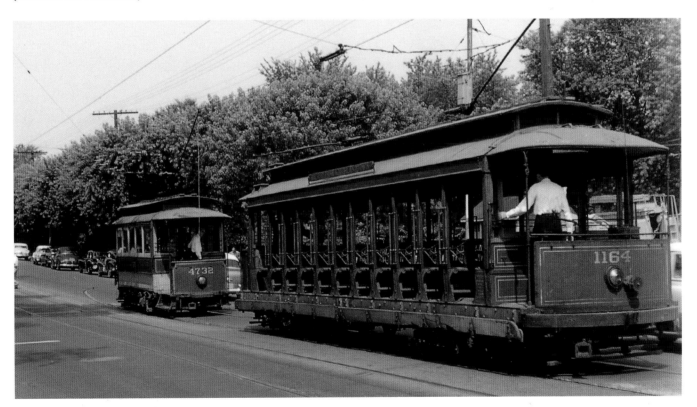

On July 11, 1954, former United Railways and Electric Company (UR&EC) double end open car No. 1164 (built by J. G. Brill Company in 1902) and former UR&EC car No. 4732 (believed built as horse car no. 417 in 1885 by the Baltimore City Passenger Railway Company, electrified by UR&EC as No. 427 in 1895, and later became No. 4732) are on BTC route 8 on Frederick Road at Irvington loop. The cars were paraded from Irvington carhouse to Irvington loop, marking the BTC donation of its historic streetcar collection to the Maryland Historical Society. Both of these cars are preserved at the Baltimore Streetcar Museum. (Bob Crockett photograph—C. R. Scholes collection.)

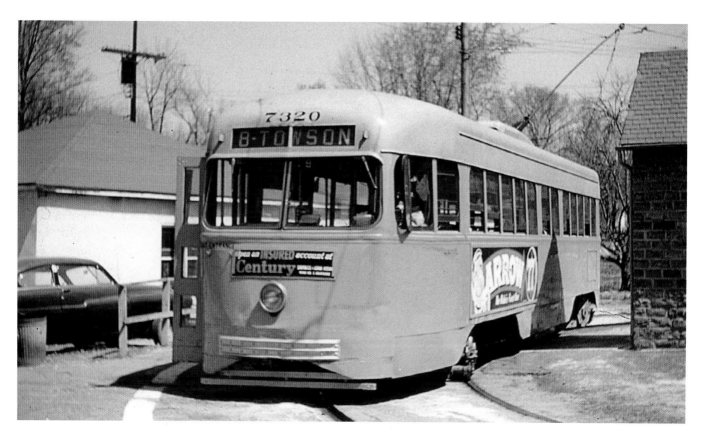

Well maintained BTC route 8 PCC car No. 7320 is ready for passengers at the Catonsville loop in 1954. (Bob Crockett photograph—C. R. Scholes collection.)

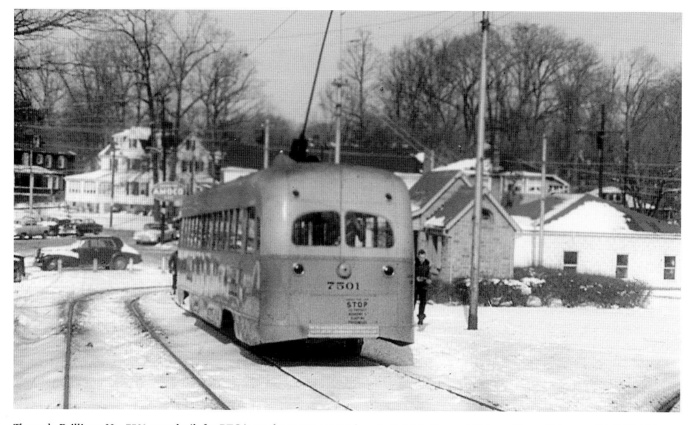

The only Brilliner, No. 7501, ever built for BTC is on the snow-covered route 8 right of way at Catonsville on February 13, 1955. This car was scrapped in 1956. (Bob Crockett photograph—C. R. Scholes collection.)

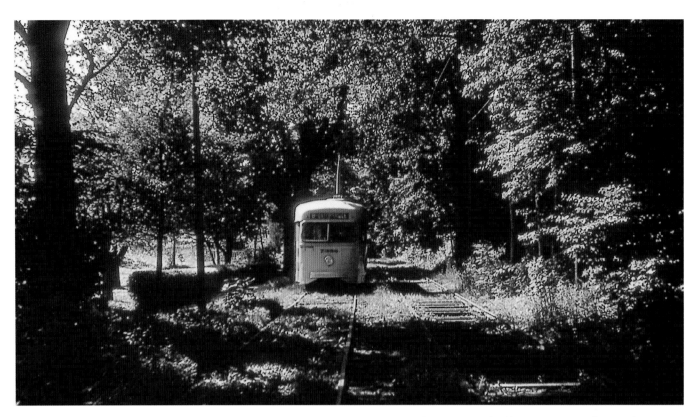

Surrounded by trees, BTC route 8 PCC car No. 7102 carefully makes its way along the private right of way at Catonsville on July 14, 1956. This 0.75 mile section extending north from Frederick Road near Montrose Avenue to Catonsville Junction was the last genuine through the woods streetcar private right of way in Baltimore. There was a very short stretch of private right of way on route 15 at Ashland Avenue in a very urban area near downtown Baltimore. (C. Able—C. R. Scholes collection.)

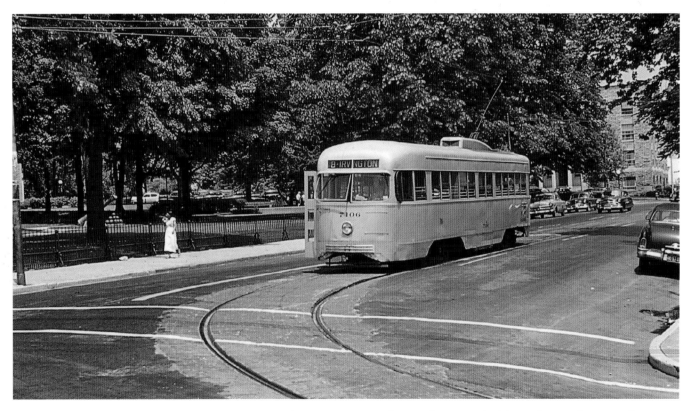

On June 20, 1953, BTC route 8 PCC car No. 7106 is on Washington Avenue at Chesapeake Avenue in this scenic area of Towson, the county seat of Baltimore County, waiting for departure time. (Bob Crockett photograph—C. R. Scholes collection.)

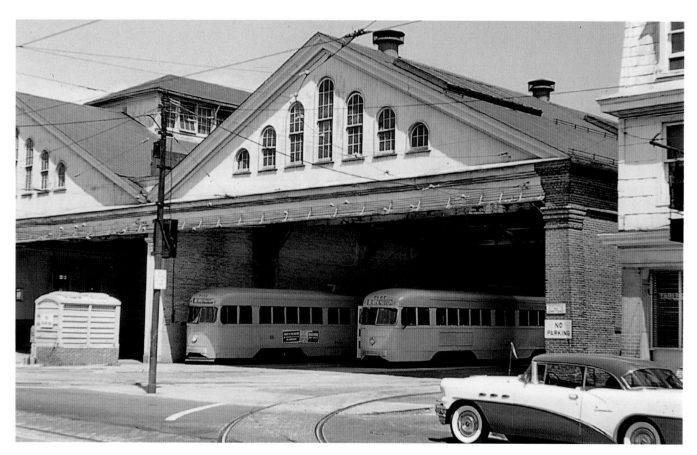

PCC cars Nos. 7125 and 7127 are at the Irvington carhouse (built in 1893) on Frederick Road at Collins Avenue waiting for the next assignment on July 14, 1956. (C. Able—C. R. Scholes collection.)

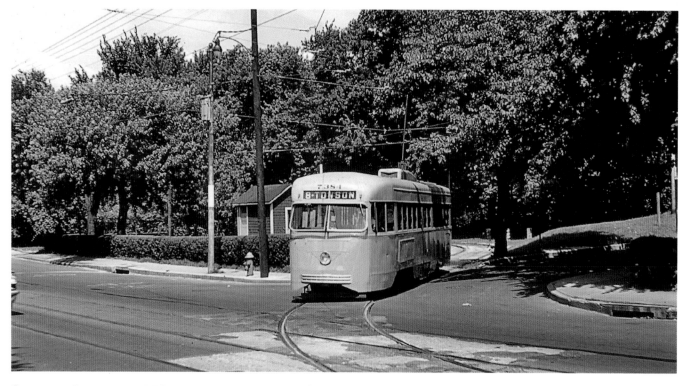

On a sunny June 14, 1956, BTC route 8 PCC car No. 7384 is leaving Irvington loop and turning onto Frederick Road in the Irvington neighborhood of southwestern Baltimore for a trip to Towson. Irvington loop was about three blocks west of the Irvington carhouse. (C. Able—C. R. Scholes collection.)

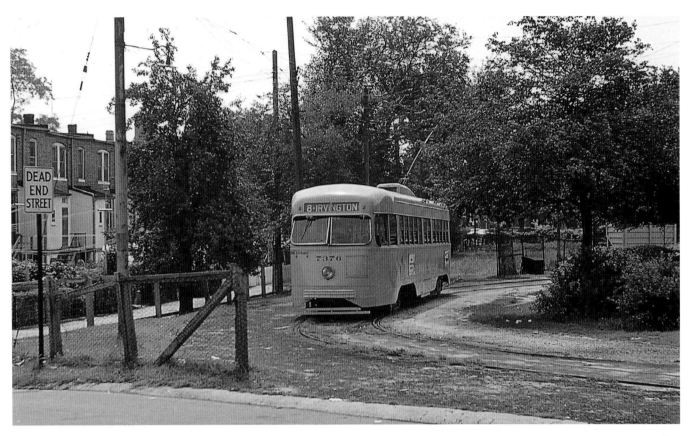

Govanstown loop off York Road is the location of BTC route 8 PCC car No. 7376 on June 20, 1956. (C. Able—C. R. Scholes collection.)

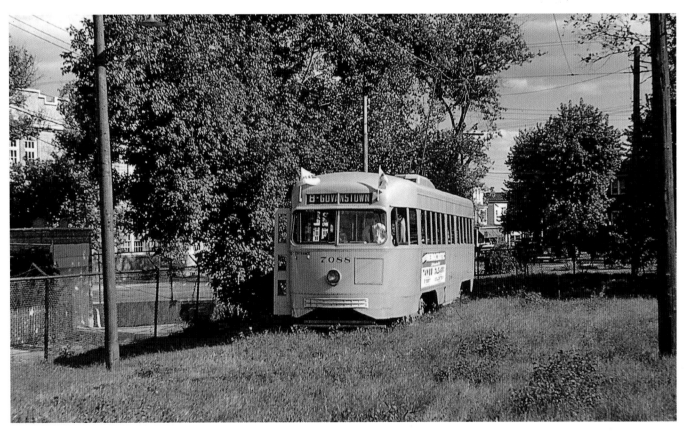

Govanstown loop off York Road makes a pleasant photo stop with BTC repainted "Transportation Orange" paint scheme PCC car No. 7088 for what is probably a rail excursion in this September 28, 1958 scene. (C. Able—C. R. Scholes collection.)

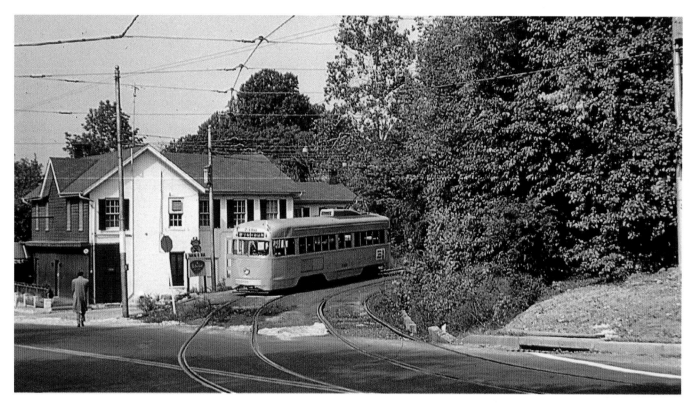

In 1959, BTC route 8 PCC car No. 7390 is at a passenger stop on the Catonsville private right of way in Baltimore County and is signed for Towson, which involves turning onto Frederick Road for the long trip through the city of Baltimore, and ending in another part of Baltimore County. (Bob Crockett photograph—C. R. Scholes collection.)

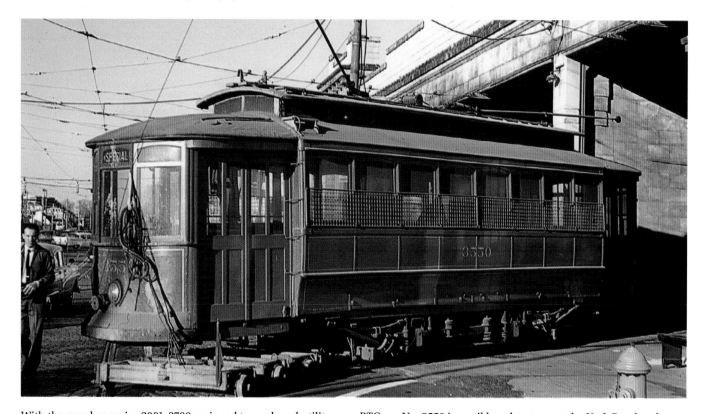

With the number series 3001-3799 assigned to work and utility cars, BTC car No. 3550 is a rail bond test car at the York Road carhouse on November 22, 1959. This car was originally No. 4533, a two-man car, built in 1904 by J. G. Brill Company for UR&EC. It was rebuilt by UR&EC as a one-man safety car in 1924. BTC rebuilt the car as rail bond testing car No. 3550, and it remained in service until the system was converted to bus operation on November 3, 1963. (C. Able—C. R. Scholes collection.)

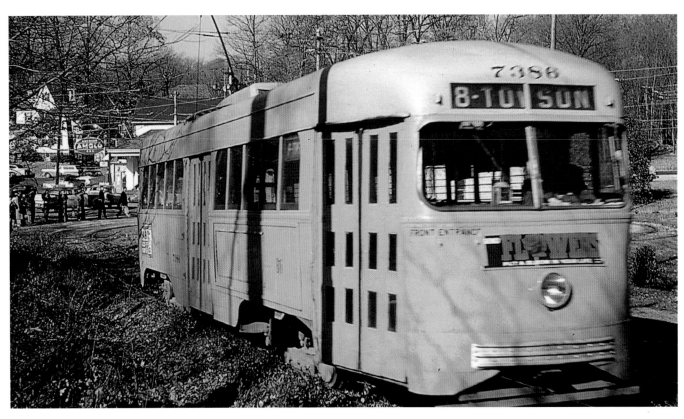

BTC route 8 PCC car No. 7386 is at the Catonsville end of the line on November 22, 1959. (C. Able—C. R. Scholes collection.)

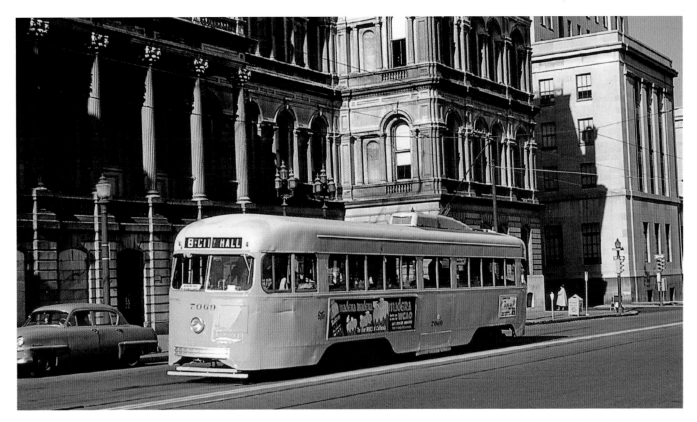

On October 22, 1959, BTC route 8 PCC car No. 7069 is on Holliday near Fayette Streets, passing by the Baltimore City Hall with its exterior walls faced with Baltimore County marble, obtained from the John B. Quarries near Cockeysville, Maryland. This building, an example of the architecturally significant structures in Baltimore, was designed by architect George Aloysius Frederick and officially dedicated on October 22, 1875. (Bob Crockett photograph—C. R. Scholes collection.)

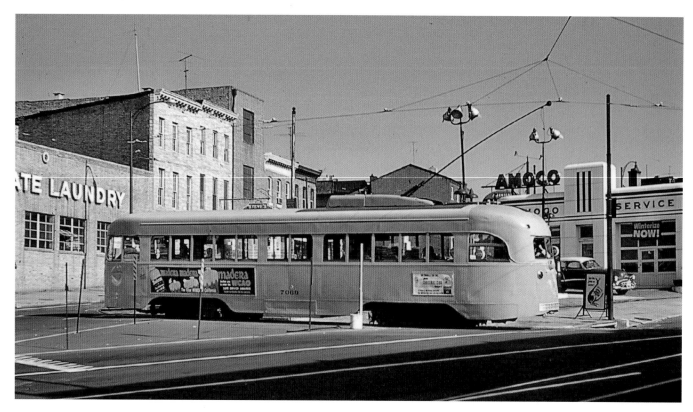

Smallwood Street loop between Lombard and Pratt Streets in the Carrollton Ridge neighborhood of Baltimore is the location of BTC route 8 PCC car No. 7089 on November 22, 1959. This was one of 20 cars Nos. 7078-7097 built by Pullman-Standard Car Manufacturing Company and delivered between August and October 1941. Powered by four General Electric type 1198 motors, each car weighed 36,000 pounds and seated 55 passengers. The loop was used by route 21 until it was converted to trackless trolley operation and rerouted in March 5, 1938. The loop was retained for emergency cutback purposes. (C. Able—C. R. Scholes collection.)

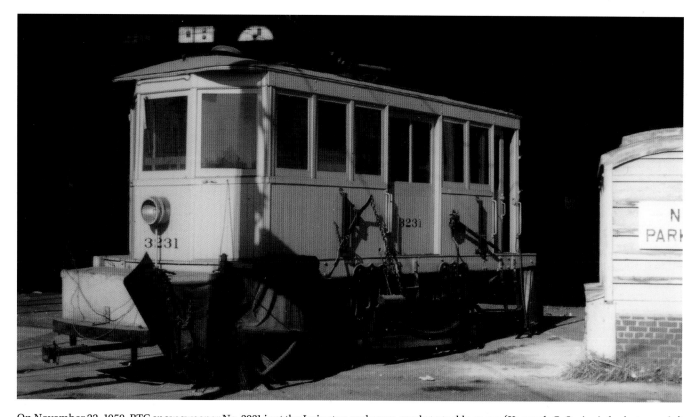

On November 22, 1959, BTC snow sweeper No. 3231 is at the Irvington carhouse, ready to tackle snow. (Kenneth C. Springirth photograph.)

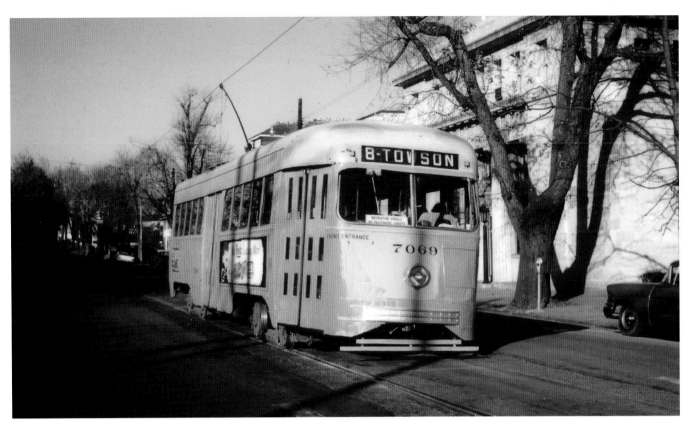

On a sunny November 22, 1959, PCC car No. 7069 is on Washington Avenue near Chesapeake Avenue in Towson for a rail excursion photo stop. (Kenneth C. Springirth photograph.)

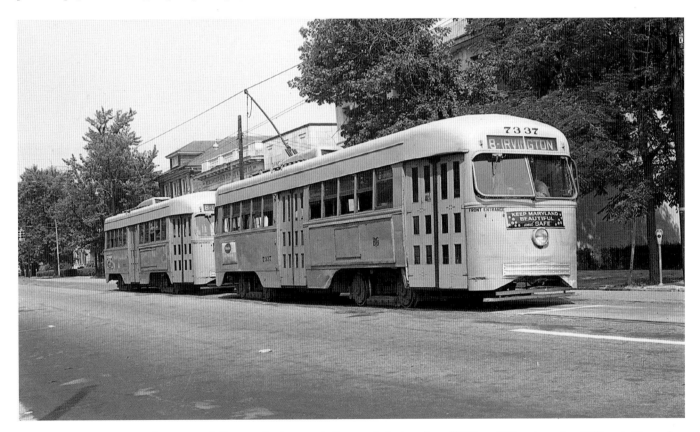

BTC route 8 terminal at Washington and Chesapeake Avenues in Towson is the location of PCC car 7337 and another PCC car in December 1960. (C. R. Scholes collection.)

On November 5, 1961, BTC single truck rail grinder No. 3738 is at the classic looking Irvington carhouse on Frederick Road. (Bob Crockett photograph—C. R. Scholes collection.)

BTC line car No. 3506 is at the Irvington carhouse on Frederick Road on November 5, 1961. (Bob Crockett photograph—C. R. Scholes collection.)

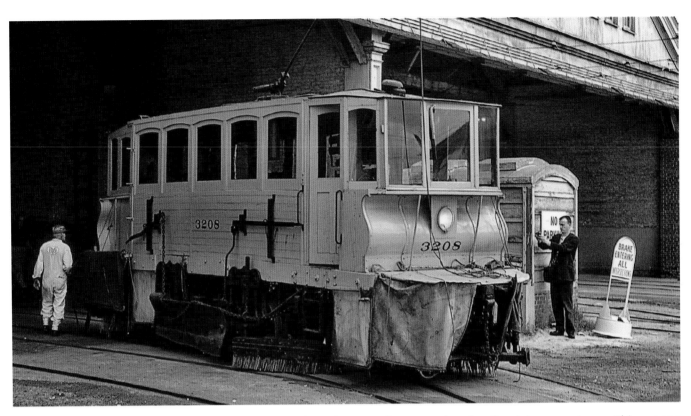

On November 5, 1961, BTC snow sweeper No. 3208 is at the Irvington carhouse, ready to handle winter snow storms. This was one of several snow sweepers along with rail grinder No. 3738, rail test car No. 3550, and line car No. 3506 stored at Irvington carhouse. (Bob Crockett photograph—C. R. Scholes collection.)

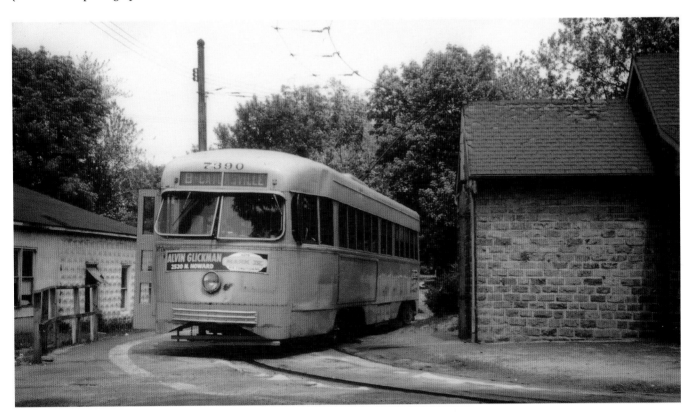

On May 20, 1962, BTC route 8 PCC car No. 7390 is at the Catonsville terminus. This was one of 25 cars Nos. 7379-7403 built by Pullman-Standard Car Manufacturing Company and delivered between November 1941 and February 1942. Powered by four Westinghouse type 1432 motors, each car weighed 36,000 pounds and seated 55 passengers. (Kenneth C. Springirth photograph.)

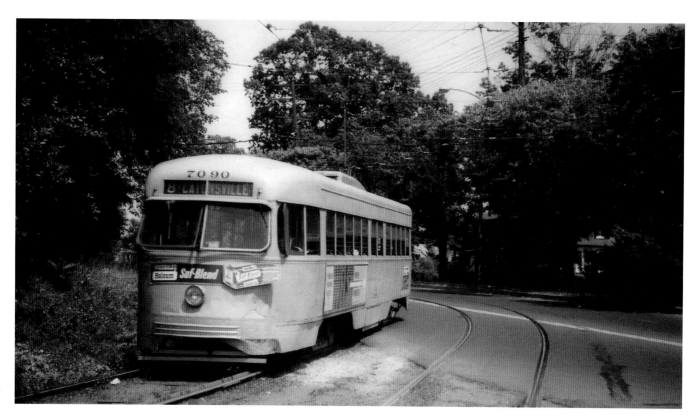

BTC route 8 PCC car #7090 is turning from Frederick Road and entering the private right of way heading north to Catonsville on May 20, 1962. (Kenneth C. Springirth photograph.)

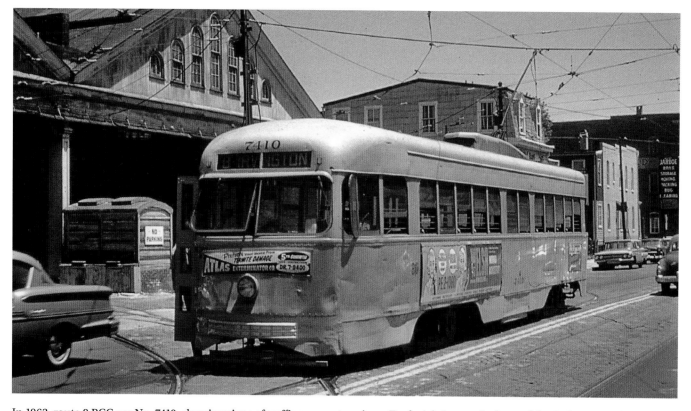

In 1963, route 8 PCC car No. 7410, showing signs of traffic encounters, is on Frederick Avenue in front of the Irvington carhouse. This carhouse operated 28 scheduled streetcars in the late 1950s for route 8. After trackage on Washington Boulevard leading to the Carroll Park repair shop was abandoned, Irvington carhouse, in the final streetcar years, became the main streetcar repair shop. (Bob Crockett photograph—C. R. Scholes collection.)

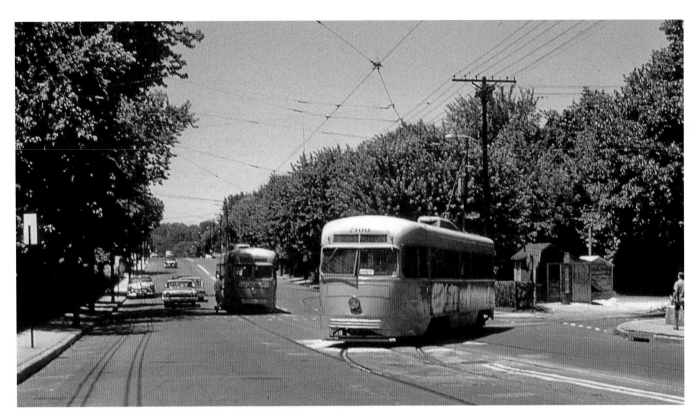

BTC route 8 PCC car No. 7100 has left Irvington loop on tree-lined Frederick Road, and behind is PCC car No. 7146 at a passenger stop in 1963. As early as 1887, the Baltimore, Catonsville, and Ellicott's Mills Passenger Railway allowed its trackage on the city section of Frederick Road to be moved to the center of the road for a wider roadway. As automobile traffic increased, streetcar speeds were reduced. (Bob Crockett photograph—C. R. Scholes collection.)

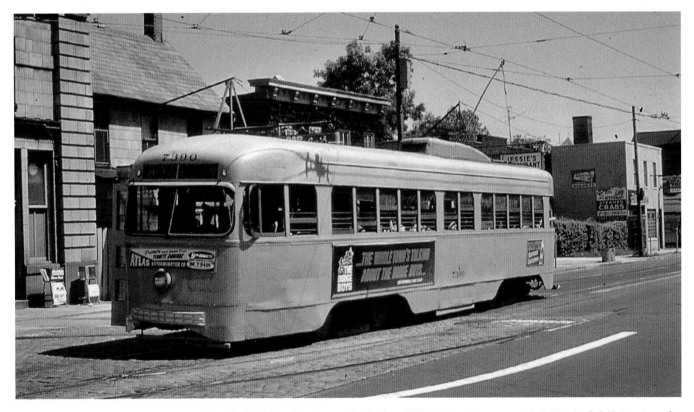

In 1963, BTC route 8 PCC car No. 7390 is at the York Road carhouse. In the late 1950s, this carhouse supplied 27 scheduled streetcars for route 8. (Bob Crockett photograph—C. R. Scholes collection.)

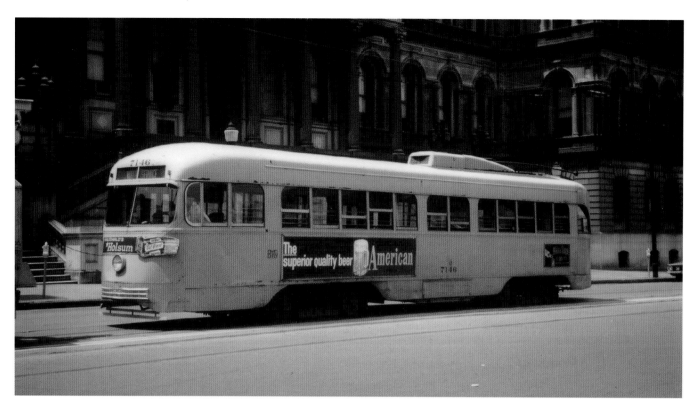

Disabled BTC route 8 PCC car No. 7146 is being pulled with the trolley pole down on Holliday Street approaching Fayette Street past the Baltimore City Hall on June 1, 1963. Time had taken its toll on the streetcar system. BTC and the City of Baltimore had financial negotiations which included the city taking over all paving obligations resulting from conversion from streetcar to bus operation. (Kenneth C. Springirth photograph.)

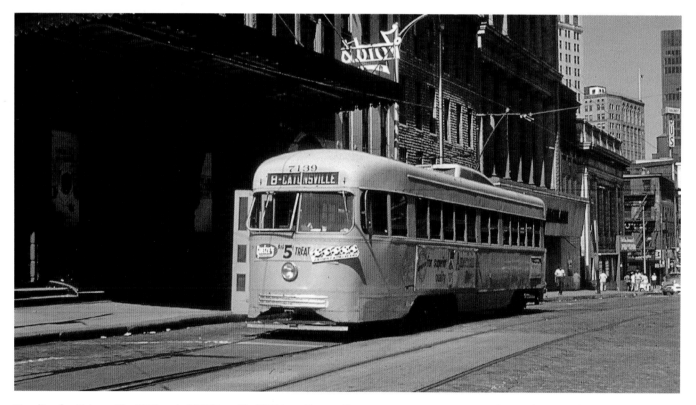

Heading for Catonsville, BTC route 8 PCC car No. 7139 is on Fayette Street at a passenger stop near Eutaw Street in downtown Baltimore in 1963. This PCC car seated 55 passengers. Assuming an average of 1.5 passengers per automobile, it would take 36 automobiles to handle the same number of commuters. (Bob Crockett photograph—C. R. Scholes collection.)

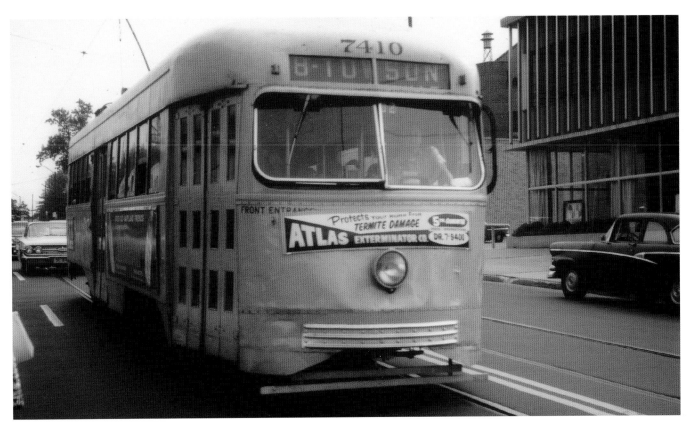

York Road at Belvedere Avenue in the Govanstown neighborhood of Baltimore is the location of BTC route 8 PCC car No. 7410 on June 1, 1963. (Kenneth C. Springirth photograph.)

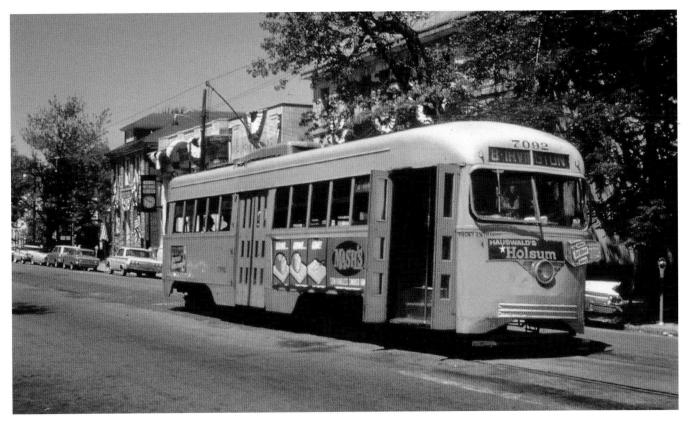

Washington Avenue, just north of Chesapeake Avenue in Towson, is the location of BTC route 8 PCC car No. 7092 in 1963. (Bob Crockett photograph—C. R. Scholes collection.)

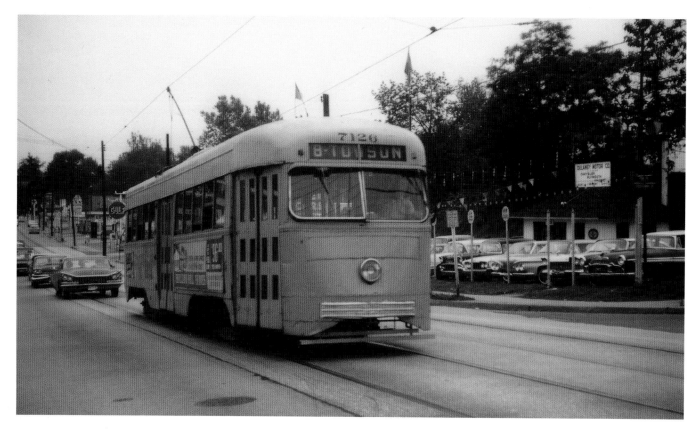

On June 1, 1963, BTC route 8 PCC car No. 7126 is on York Road in Towson. Before Interstate 83, York Road was the main road between Baltimore, Maryland, and York, Pennsylvania. In its early years, route 8 connected Baltimore, passing by large estates, to the county seat at Towson. Over the years, York Road became a commercial roadway. (Kenneth C. Springirth photograph.)

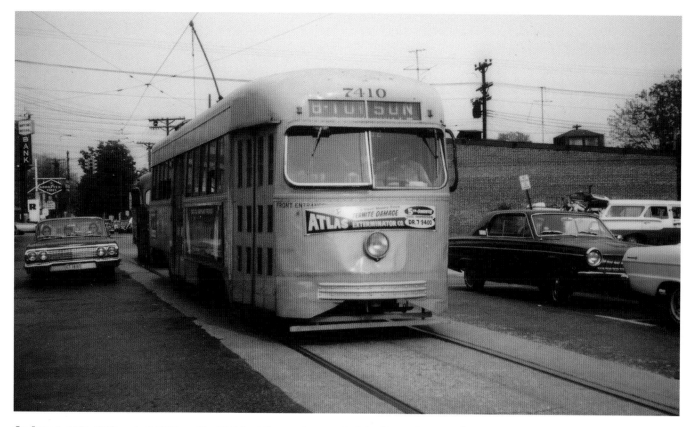

On June 1, 1963, BTC route 8 PCC car No. 7410 is at the northern end of the line at Towson. (Kenneth C. Springirth photograph.)

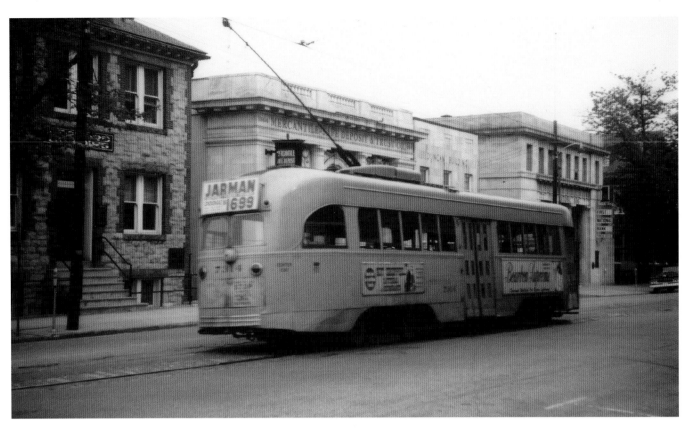

BTC route 8 PCC car No. 7314 is passing by the Mercantile Deposit & Trust Company in Towson on June 1, 1963. (Kenneth C. Springirth photograph.)

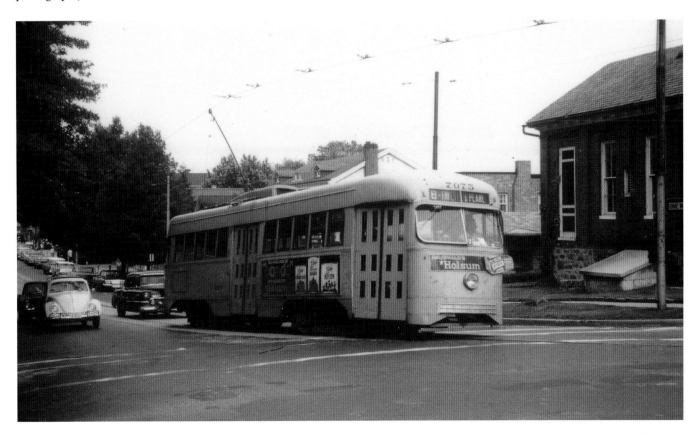

On June 1, 1963, BTC route 8 PCC car No. 7075 is leaving Towson for a trip to Fayette and Pearl Streets in downtown Baltimore. (Kenneth C. Springirth photograph.)

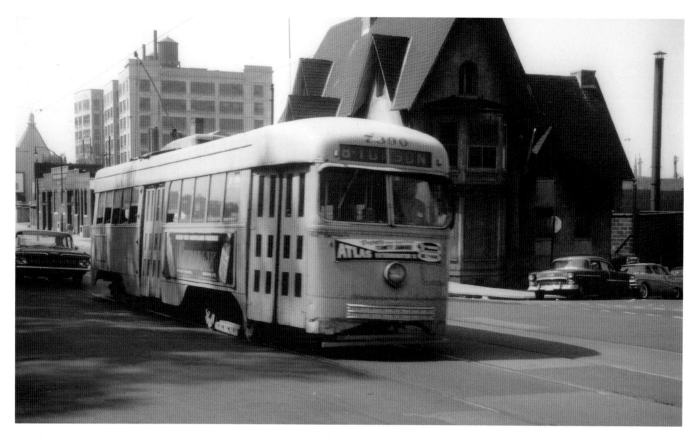

BTC route 8 PCC car No. 7390 is northbound on Greenmount Avenue, crossing E. Lanvale Street in the Greenmount West neighborhood of Baltimore on June 1, 1963. (Kenneth C. Springirth photograph.)

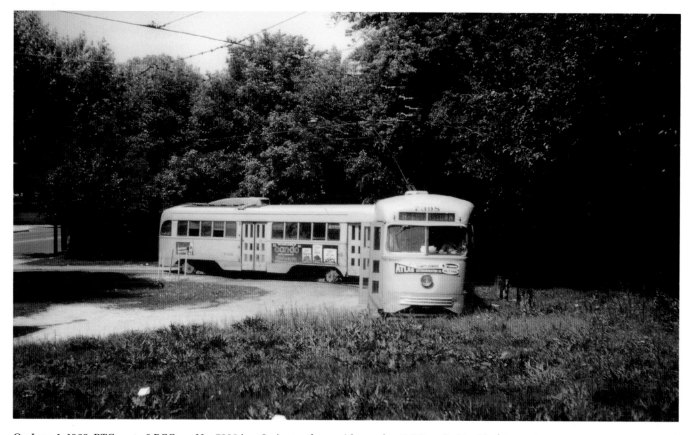

On June 1, 1963, BTC route 8 PCC car No. 7398 is at Irvington loop with another PCC car behind it. (Kenneth C. Springirth photograph.)

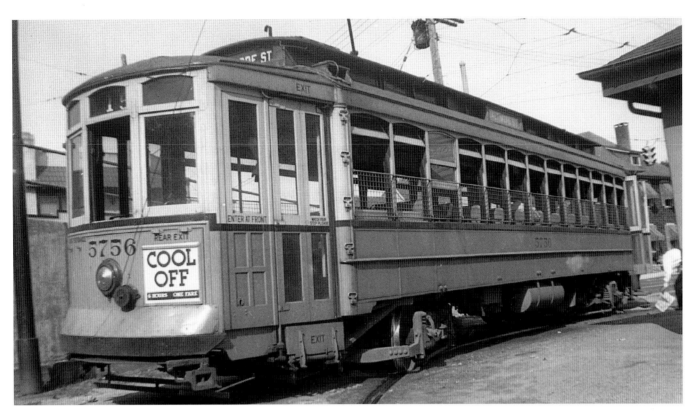

Overlea loop off Belair Road is the location of BTC route 15 semi-convertible car No. 5756 (originally No. 1512) on July 2, 1939. Route 15 began when the Baltimore City Passenger Railway incorporated on February 13, 1862, and established horse car service from Baltimore Street in downtown Baltimore to Gay Street, ending at North Avenue at the Baltimore Cemetery. (C. R. Scholes collection.)

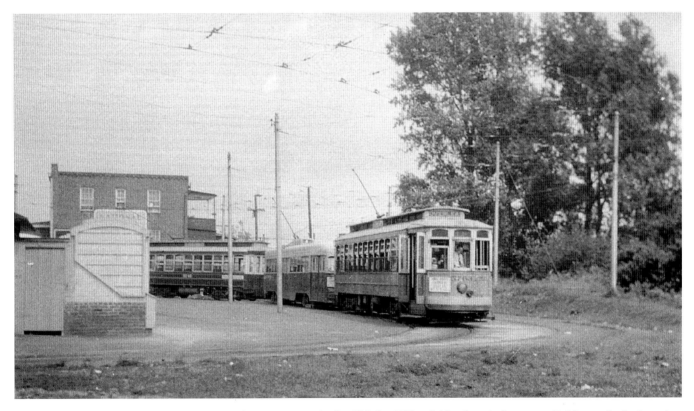

The BTC route 15 Kinsey Avenue loop at Baltimore Street in the Shipley Hill neighborhood of western Baltimore is the location of semi-convertible car No. 5763 (originally No. 1519), a PCC car, and another semi-convertible car in August 1946. (Bob Crockett photograph—C. R. Scholes collection.)

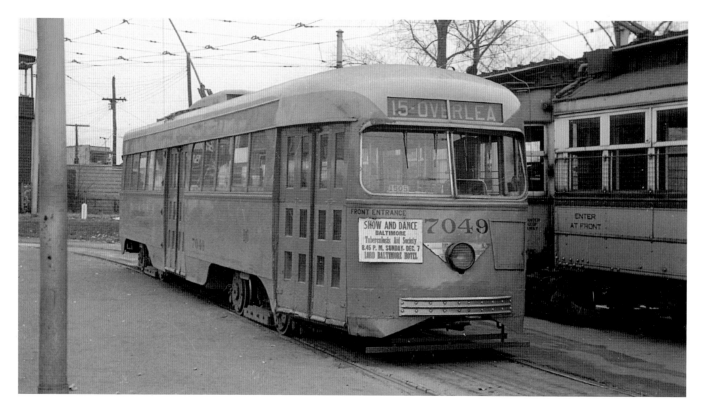

In this December 7, 1947 scene at the BTC route 15 Overlea loop terminus off Belair Road, PCC car No. 7049, alongside an articulated semi-convertible car, is waiting for the next assignment. (Bob Crockett photograph—C. R. Scholes collection.)

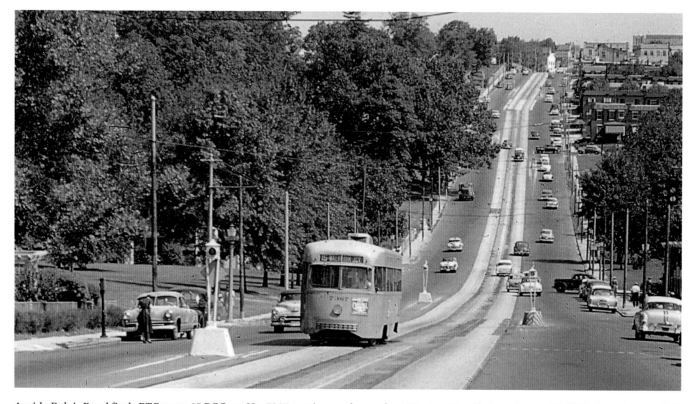

A wide Belair Road finds BTC route 15 PCC car No. 7367 coming up the grade at Herring Run Park on August 27, 1955. Operating on "T" rail track in paved concrete with an extra wide clearance in the center between tracks provides a nice transportation artery for both motor vehicles and public transit. However, as motor vehicle traffic increases, it can slow up the transit service. This line was originally on a side of the road private right of way that weas relocated to the center of the road for a street widening project. (Bob Crockett photograph—C. R. Scholes collection.)

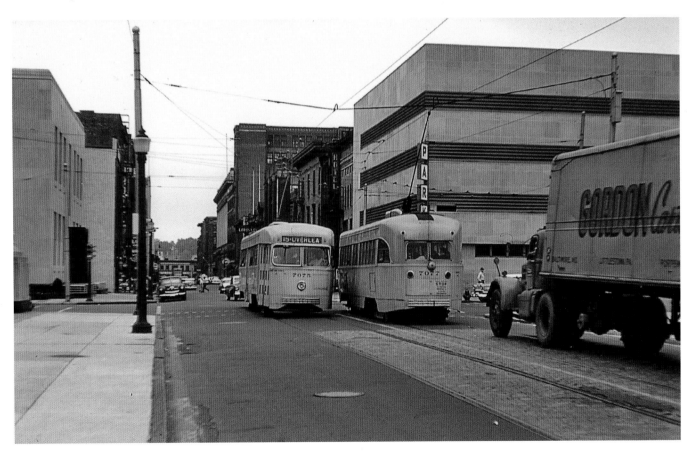

With the Shot Tower just ahead, BTC route 15 PCC car No. 7074 is on Fayette Street ready to turn onto Gay Street in this July 14, 1956 scene. The 234.25 foot Shot Tower produced lead shot from 1828 to 1892. Molten lead was dropped from the tower top through a sieve and into cold water in a vat at the bottom of the tower. The hardened, dried, and polished shot was used for pistols and rifles. On November 11, 1971, the tower was designated a National Historic Landmark. (C. Able—C. R. Scholes collection.)

On an overcast June 9, 1956, BTC route 15 PCC car No. 7075, heading for Overlea, is passing PCC car No. 7077 on Baltimore Street at Gay Street in downtown Baltimore. (C. Able—C. R. Scholes collection.)

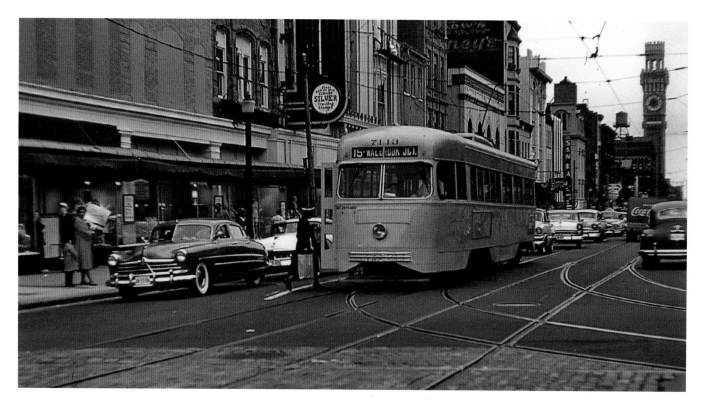

BTC route 15 PCC car No. 7113 is boarding a passenger on Baltimore and Paca Streets in downtown Baltimore on June 9, 1956. Baltimore Street divides the city's north and south sections. Baltimore was the first city to have a commercial electric streetcar line, which opened on August 15, 1885, even though later it had to go back to animal power, and the first city to have an electric streetcar operating on an elevated structure over Guilford Avenue on May 3, 1893. In 1919, Milwaukee Electric pioneered a two body three truck articulated streetcar and Baltimore followed with numerous articulated streetcars beginning in 1924. At that time, articulated streetcars were not widely used in the United States; however in 2017, they are widely used around the world. (C. Able—C. R. Scholes collection.)

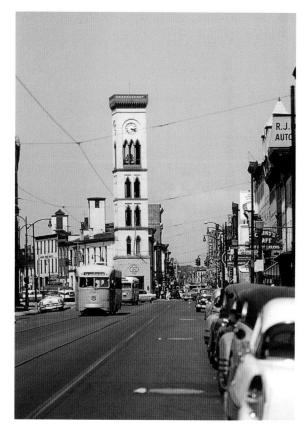

With the Engine House No. 6 Clock Tower in the background, BTC route 15 PCC car No. 7083, followed by a General Motors bus, is on Gay Street at Orleans Street in the Old Town neighborhood of Baltimore on July 14, 1956. Designed by Baltimore architects Reasin and Weatherald, the historic 103-foot brick Italian-Gothic style Engine House No. 6 Clock Tower was built in 1853-1854 and was added to the National Register of Historic Places on June 18, 1973. (C. Able—C. R. Scholes collection.)

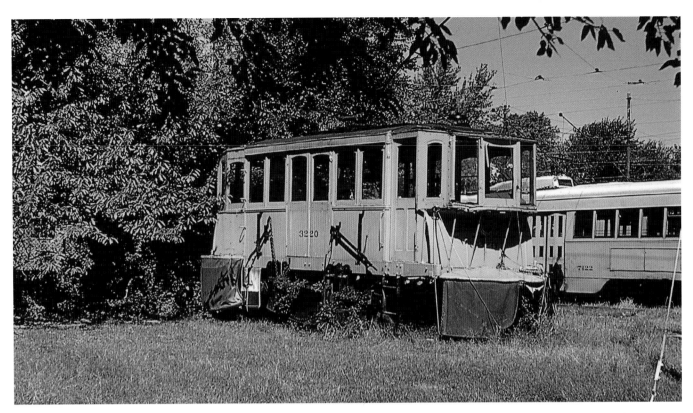

On a beautiful September 26, 1958, BTC snow sweeper No. 3220 and PCC car No. 7122 are at the Gardenville car yard on Belair Road, traversed by route 15 in northeastern Baltimore. Gardenville was an outdoor car storage area with an inspection pit, plus a small combination office and shop. It also served as a cutback loop for trips not going to Overlea. (Bob Crockett photograph—C. R. Scholes collection.)

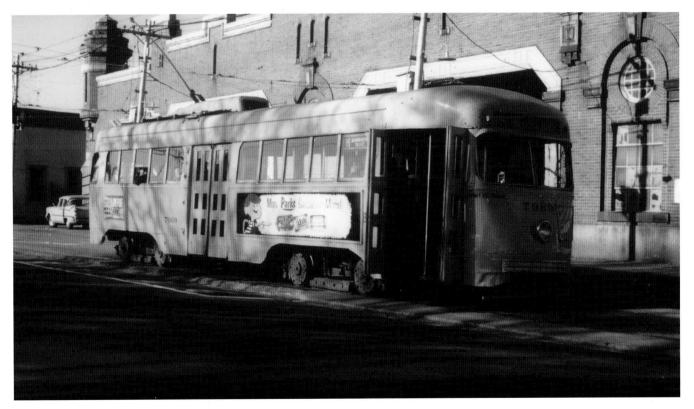

Repainted PCC car No. 7069 is in front of the well-built BTC Belvedere carhouse in the Woodmere neighborhood of Western Baltimore on a November 22, 1959 rail excursion. Route 15 was the only remaining streetcar line housed at Belvedere carhouse, which opened on November 30, 1907, and closed in February 1960. (Kenneth C. Springirth photograph.)

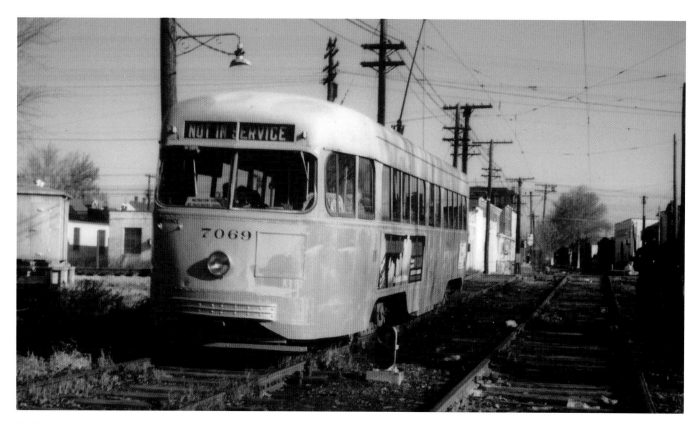

On November 22, 1959, PCC car No. 7069 is just south of the Western Maryland Railroad track crossing on a rail excursion photo stop. This trackage was used by route 31, which was merged with route 19 on October 13, 1952. Buses replaced route 19 streetcars on June 17, 1956, and this trackage was retained for route 15 cars to reach Belvedere carhouse. On February 14, 1960, route 15 was cut back to Walbrook Junction and trackage between Walbrook Junction and Belvedere carhouse was abandoned. (Kenneth C. Springirth photograph.)

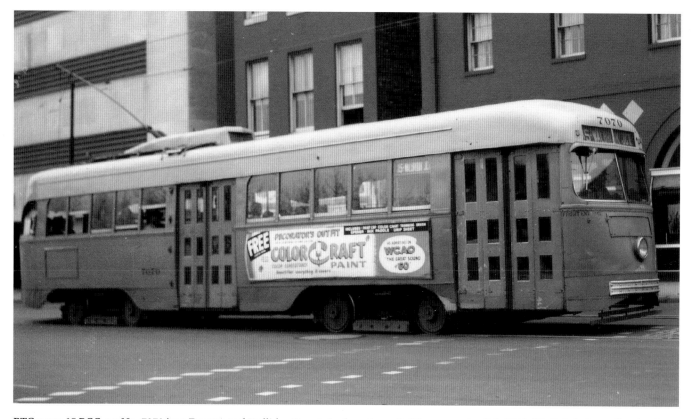

BTC route 15 PCC car No. 7070 is at Fayette and Holliday Streets in downtown Baltimore on April 4, 1960. (C. R. Scholes collection.)

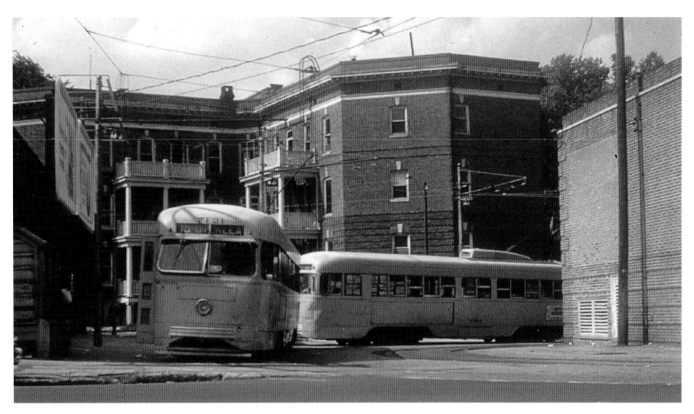

In June 1960, BTC route 15 PCC cars Nos. 7121 and 7056 are at the Walbrook Junction loop off Clifton Avenue. In earlier years route 13 (North Avenue) and route 35 (Lorraine) streetcars used this loop. Route 15 was extended to take over streetcar route 4 (Edmondson Avenue) on September 19, 1954 to Windsor Hills. On June 17, 1956, route 19 buses replaced the Walbrook-Windsor Hills branch of streetcar route 15, and route 15 terminated at Walbrook Junction with certain trips extended to Belvedere carhouse. (Bob Crockett photograph—C. R. Scholes collection.)

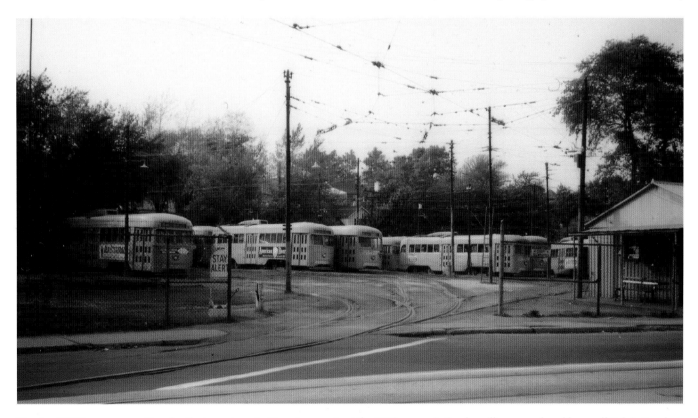

Plenty of PCC cars are waiting for their next route 15 assignments at the BTC open air Gardenville car yard and loop off Belair Road on May 20, 1962. In the late 1950s, Gardenville yard supplied 28 scheduled streetcars for route 15. (Kenneth C. Springirth photograph.)

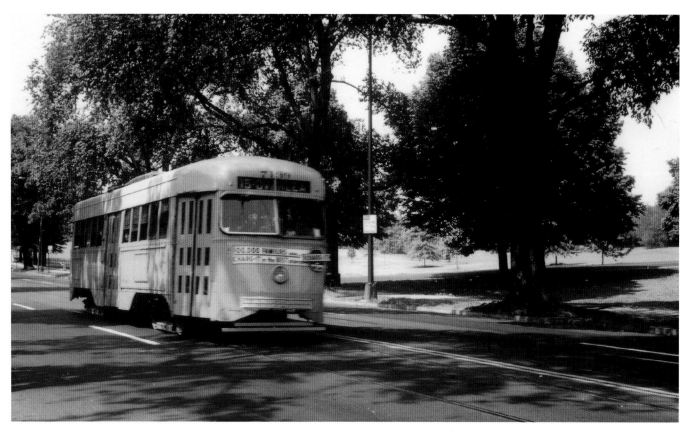

On May 30, 1962, BTC route 15 PCC car No. 7139 is passing by a tree lined section of Belair Road. (Kenneth C. Springirth photograph.)

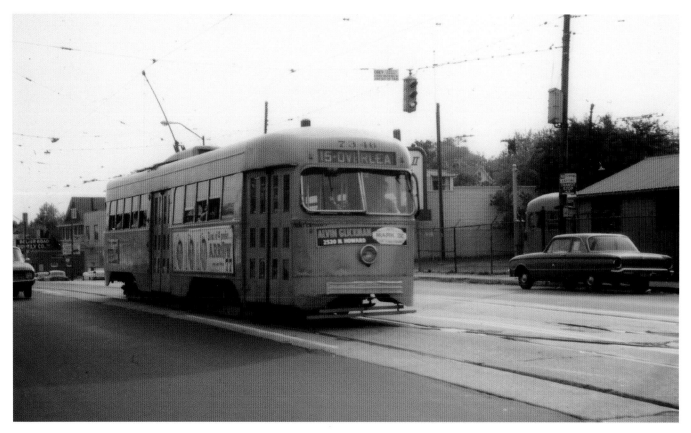

BTC route 15 PCC car No. 7346 is on Belair Road passing by the Gardenville loop and open car yard on May 20, 1962. (Kenneth C. Springirth photograph.)

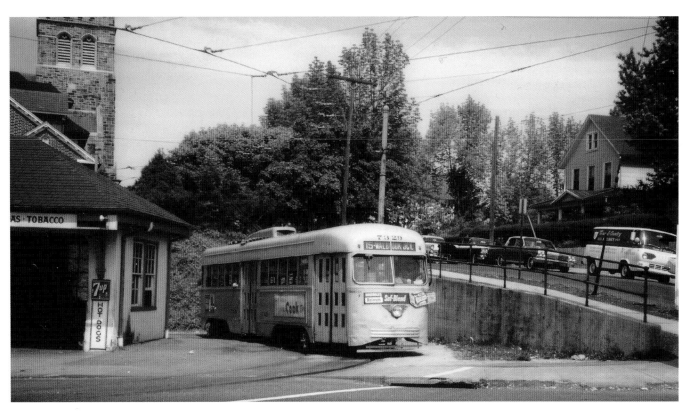

On May 30, 1962, BTC route 15 PCC car No. 7329 is at the Overlea loop waiting departure time for a trip to Walbrook Junction. (Kenneth C. Springirth photograph.)

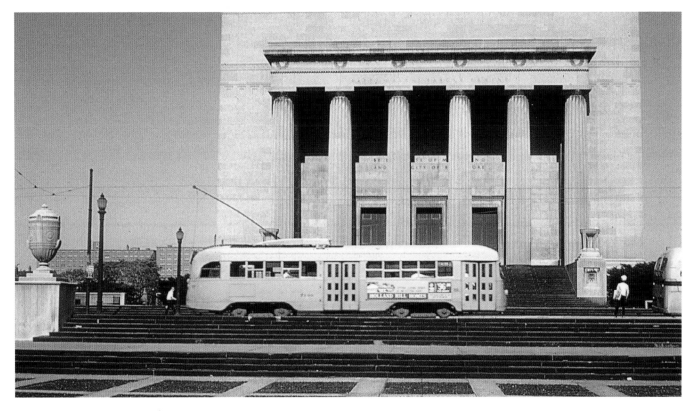

BTC route 15 PCC car No. 7146 is passing the Baltimore War Memorial Building at 101 North Gay Street in 1963. Designed by Baltimore architect Lawrence Hall Fowler, the Greek Revival style building with its six columns across the front was dedicated on April 25, 1925. It serves as a remembrance for fallen soldiers and as an administrative office for veteran's outreach organizations. (Bob Crockett photograph—C. R. Scholes collection.)

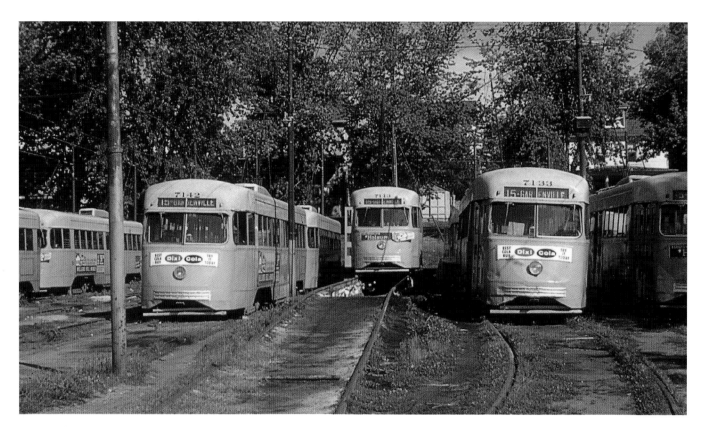

With abandonment just around the corner, PCC cars Nos. 7142, 7143, 7133, and others at the Gardenville car yard, are waiting for their next route 15 assignment in the summer of 1963. Car No. 7143 is over an open inspection pit. They still look presentable even with some body dents. (Bob Crockett photograph—C. R. Scholes collection.)

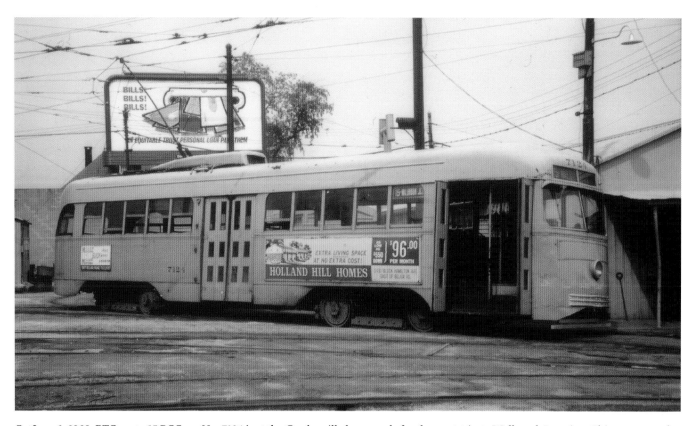

On June 1, 1963, BTC route 15 PCC car No. 7124 is at the Gardenville loop ready for the next trip to Walbrook Junction. This was a regular service loop as well as an open streetcar storage area. (Kenneth C. Springirth photograph.)

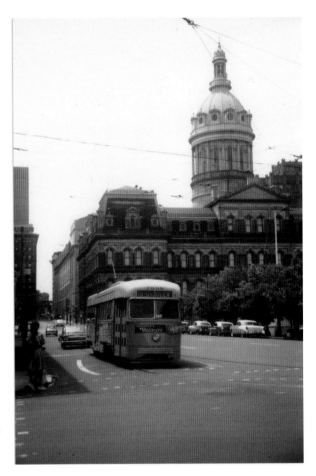

With the Baltimore City Hall in the background, BTC route 15 PCC car No. 7098 is on Fayette Street ready to turn north on Gay Street for a trip to Overlea on June 1, 1963. Representing an example of French Renaissance Revival architecture, the Baltimore City Hall features an elaborate center dome flanked by a Mansard roof on each side wing. The building was added to the National Register of Historic Places on May 8, 1973. (Kenneth C. Springirth photograph.)

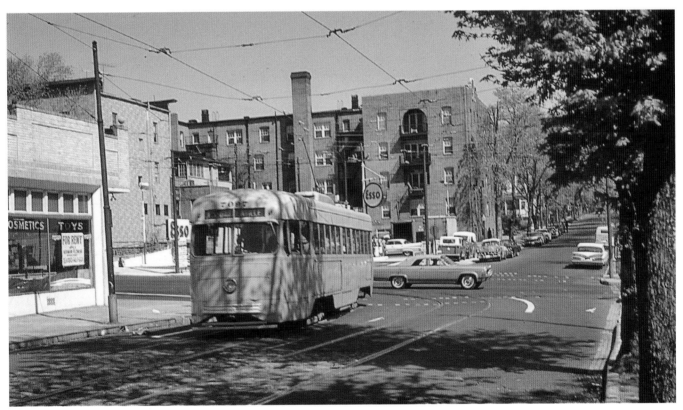

Denison Street and Clifton Avenue is the location of BTC route 15 PCC car No. 7097 on April 20, 1963, in the Walbrook neighborhood of western Baltimore. (W. Hoffman photograph—C. R. Scholes collection.)

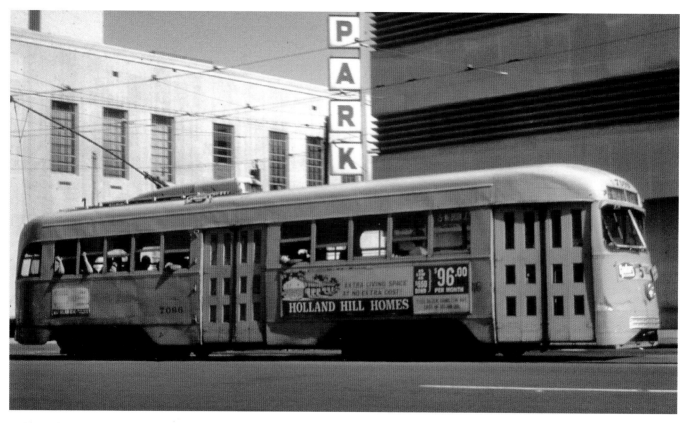

In 1963, BTC route 15 PCC car No. 7096 is on Eutaw and Fayette Streets in downtown Baltimore. (Bob Crockett photograph—C. R. Scholes collection.)

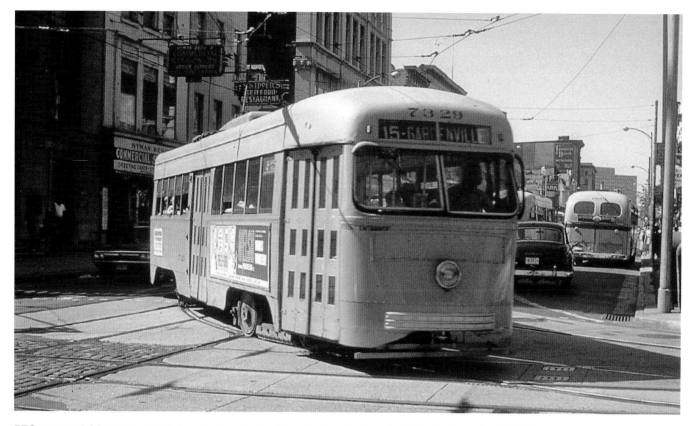

BTC route 15 PCC car No. 7329 is turning from Eutaw Street to Fayette Street in 1963. On the right is BTC bus No. 1855 which was one of 45 model TDH-5105 buses built by General Motors in 1955. (Bob Crockett photograph—C. R. Scholes collection.)

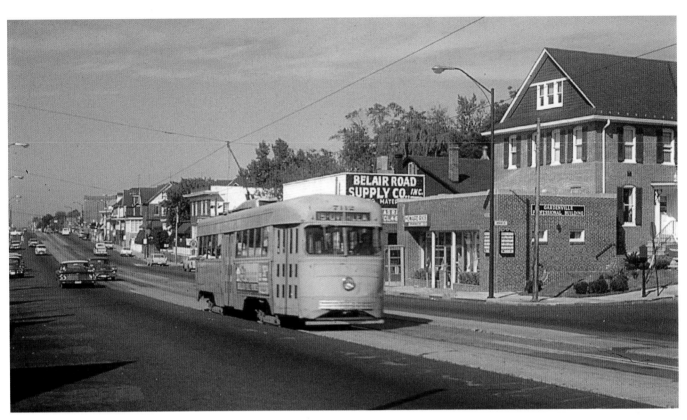

In 1963, BTC route 15 PCC car No. 7112 is on Belair Road passing by the Gardenville Professional Building in the northeastern part of Baltimore on its trip to Overlea. Over the years, Belair Road has changed from a semi-rural area to a residential and commercial area. (Bob Crockett photograph—C. R. Scholes collection.)

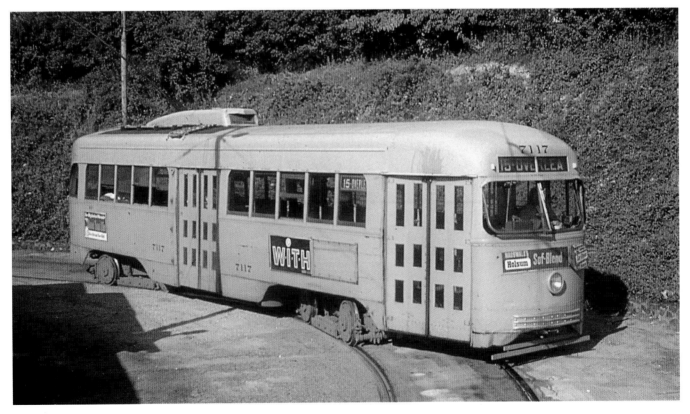

Overlea loop is the location of BTC route 15 PCC car No. 7117 in 1963 on an operator layover. (Bob Crockett photograph—C. R. Scholes collection.)

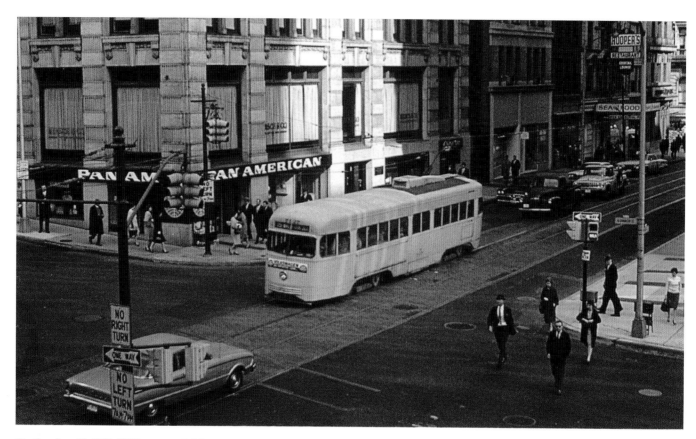

On October 31, 1963, BTC route 15 PCC car No. 7127 is on Fayette Street at Charles Street in downtown Baltimore. The sound of streetcars ended on Fayette Street as buses took over on November 3, 1963. All of the male pedestrians were well dressed in this scene. (C. Able—C. R. Scholes collection.)

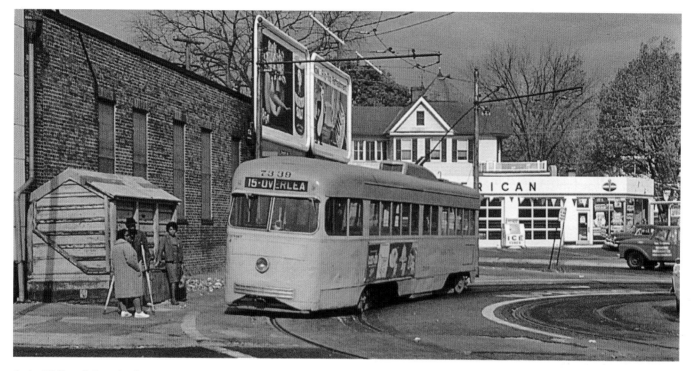

At the Walbrook Junction loop, passengers are waiting to board BTC route 15 PCC car No. 7339 on October 31, 1963. Over the years streetcars were phased out of most United States cities and Baltimore joined the ranks of converting entirely to bus operation on November 3, 1963. Fortunately, in 1992 modern electric rail service returned to Baltimore with the opening of the first part of the Central Light Rail Line. (Bob Crockett photograph—C. R. Scholes collection.)

Chapter 10

Baltimore Trackless Trolleys

United Railways & Electric Company (UR&EC) opened a 6.6-mile trackless trolley line from Gwynn Oak Junction to a new subdivision in Randallstown on November 1, 1922, using three Brill RailLess vehicles. Buses replaced trackless trolley service on August 31, 1931. UR&EC became Baltimore Transit Company (BTC). The important 7.2-mile route 21 (Caroline Street-Preston Street) streetcar line needed extensive track repairs in 1937. Eliminating the expense of repairing track, BTC replaced the line with trackless trolleys on March 6, 1938. In the first two years of trackless trolley operation, route 21 ridership increased 43.5 percent, and the trackless trolleys were 5.6 percent faster than the streetcars. On January 1, 1939, the route 27 (Federal Street) streetcar line was converted to trackless trolley operation. Federal expressway construction necessitated conversion of streetcar route 10 (Roland Park) to trackless trolley operation on April 14, 1940, because the United States Bureau of Public Roads would not pay for the relocation of "fixed route vehicles" but did pay part of the trackless trolley costs. The route 1 (Gilmore Street) streetcar line was converted to trackless trolley operation on August 1, 1948, followed by route 2 (Carey Street-Fort Avenue) on December 12, 1948, and route 30 (Fremont Avenue) on March 26, 1950. Trackless trolleys used the streetcar system's electric facilities and maintenance facilities. The streetcar maintenance shops had the facilities and tools needed to overhaul electric motors and maintain the overhead wire. Trackless trolleys were reliable. By the mid-1950s, transit riding had a significant decline, motorbus reliability had improved, and the need to upgrade electrical distribution systems meant that the trackless trolley was less beneficial in reducing transit costs. On June 23, 1957, trackless trolley routes 21 and 27 were converted to bus operation. To avoid the expense of relocating the overhead wire due to the construction of the Jones Falls expressway, buses replaced route 30 trackless trolleys on August 31, 1958. Buses replaced Baltimore's last trackless trolley routes 1, 2, and 10 on June 21, 1959 with routes 1 and 2 combined into a single bus route 1 (Fulton Avenue-Fort Avenue).

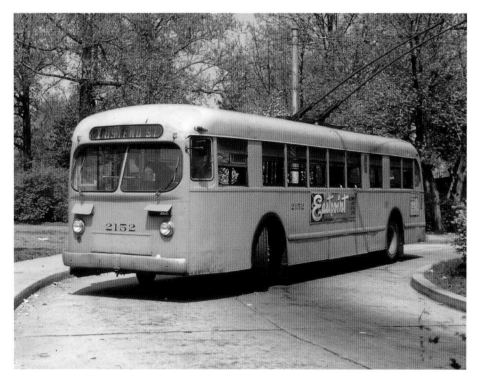

On April 27, 1957, BTC route 1 trackless trolley No. 2152 is at the Fulton and Druid Avenues loop. This was one of 63 model TC44 trackless trolleys, Nos. 2128-2190, built in 1948 by A.C.F.-Brill Motors Company (a June 19, 1944 merger of American Car & Foundry Motors Company and Brill Corporation) seating 44 passengers. (C. Able photograph—C. R. Scholes collection.)

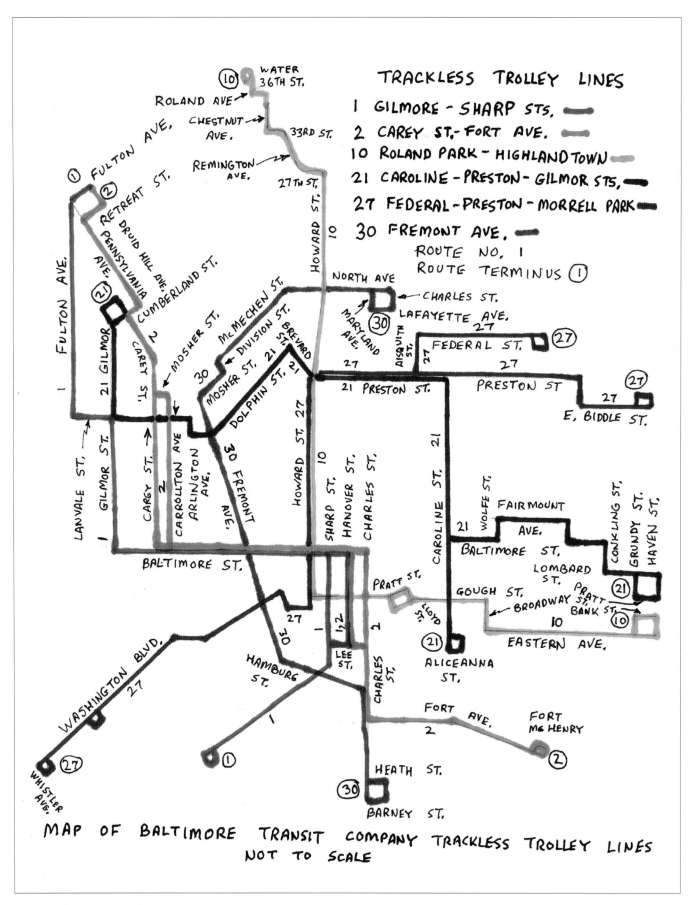

At its height of trackless trolley operation, Baltimore Transit Company operated 190 trackless trolleys on six lines.

The Highlandtown loop on Banks and Grundy Streets is the location of BTC route 10 trackless trolley No. 2071 on April 27, 1957. This was one of 40 trackless trolleys, Nos. 2052-2091, built in 1940 by Pullman-Standard Car Manufacturing Company, seating 44 passengers. (C. Able photograph—C. R. Scholes collection.)

On June 1, 1957, BTC route 21 trackless trolley No. 2158 (built in 1948 by A.C.F.-Brill Motors Company) is at the Bank and Grundy Streets terminal. Trackless trolleys were smooth, quiet, and pleasant to ride where the pavement was smooth. (C. Able photograph—C. R. Scholes collection.)

On April 27, 1957, BTC route 27 trackless trolley No. 2120 is at the Morris Park terminal located on Washington Boulevard at Whistler Avenue. This was one of 30 trackless trolleys, Nos. 2092-2121, built in 1942 by Pullman-Standard Car Manufacturing Company, seating 44 passengers. (C. Able photograph—C. R. Scholes collection.)

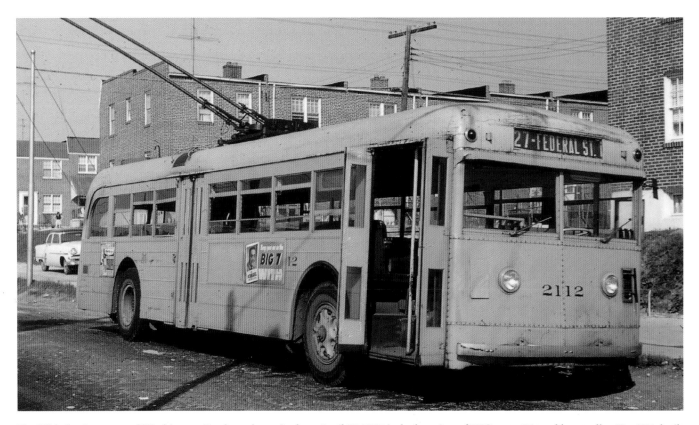

The Whistler Avenue and Washington Boulevard terminal, on April 27, 1957, is the location of BTC route 27 trackless trolley No. 2112, built in 1942 by Pullman-Standard Car Manufacturing Company. (C. Able photograph—C. R. Scholes collection.)

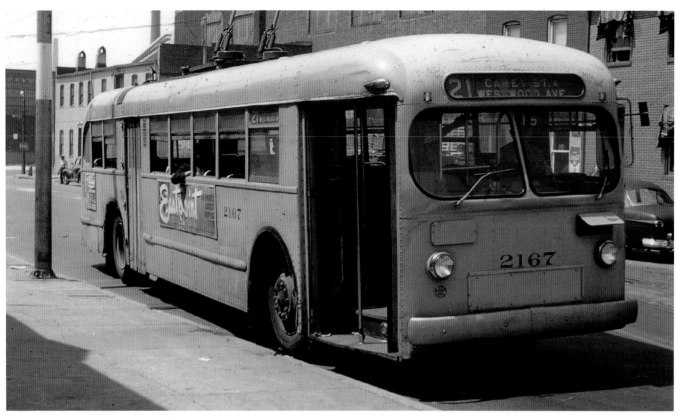

BTC route 21 trackless trolley No. 2167, built in 1948 by A.C.F.-Brill Motors Company, is at the Caroline Street and Alicianna Street terminus in the Fell's Point neighborhood of Baltimore on April 27, 1957. (C. Able photograph—C. R. Scholes collection.)

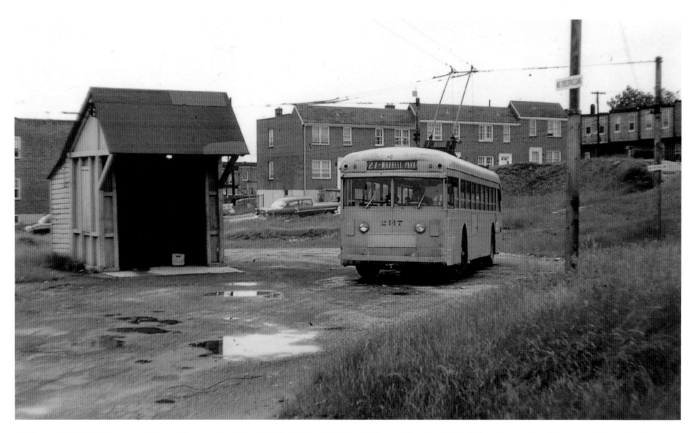

On June 1, 1957, BTC route 27 trackless trolley No. 2117 (built in 1942 by Pullman-Standard Car Manufacturing Company) is at the Luzerne Avenue terminal off Federal Street. (C. Able photograph—C. R. Scholes collection.)

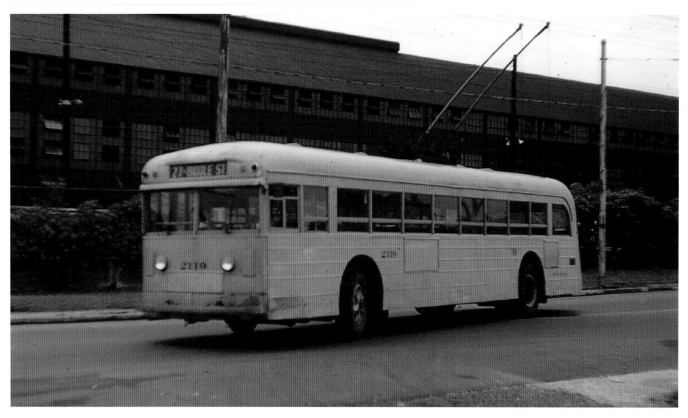

BTC route 27 trackless trolley No. 2119 (built in 1942 by Pullman-Standard Car Manufacturing Company) is at the Biddle Street loop on June 1, 1957. (C. Able photograph—C. R. Scholes collection.)

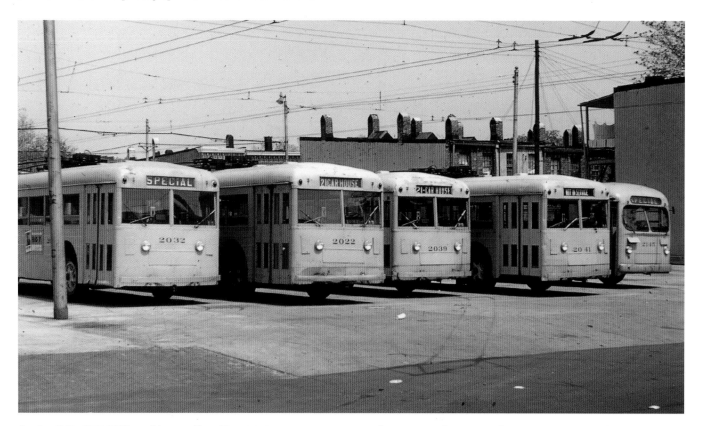

On April 27, 1957, BTC trackless trolleys Nos. 2032, 2022, 2039, 2041, and 2145 part of a group of 30, Nos. 2022-2051, built in 1939 by Pullman-Standard Car Manufacturing Company, plus the more rounded front No. 2145 built in 1948 by A.C.F.-Brill Motors Company, are waiting for the next assignment at the Traction Street yard. (C. Able photograph—C. R. Scholes collection.)

Chapter 11

Baltimore Central Light Rail Line

On June 1, 1961, the state General Assembly of Maryland created the Metropolitan Transportation Authority (MTA) to regulate routes, rates and services of public transit operations in the Baltimore metropolitan area. The MTA, later given power to purchase and operate bus companies, acquired the Baltimore Transit Company in 1970. Maryland took over the state's rail commuter services. Renamed, the Mass Transit Administration (MTA) became responsible for commuter operations. On December 18, 1987, Maryland Governor William Donald Schaefer announced a 29-mile light rail line would be built from the Hunt Valley office/industrial park/shopping mall area through downtown Baltimore to Glen Burnie with a 2.5-mile branch line to BWI Airport. On May 2, 1988, Governor Schaefer signed the bill allowing the state to begin construction of the light rail line. Over 18 miles of the 22 miles between Timonium and Glen Burnie were once home to three separate rail systems as follows:

The first 11 miles southward from Timonium to North Avenue for the new line started out as the Baltimore & Susquehanna Railroad (B&S) line from Baltimore via York to Harrisburg that was completed in 1851. Facing financial problems, the B&S reorganized as the Northern Central Railroad on January 1, 1855, which became part of the Pennsylvania Railroad. Before 1930, the Pennsylvania Railroad diverted most of its through trains through Perryville, Maryland. By 1971, passenger service ended.

Howard Street, to be used for 1.3 miles of the new line, had railroad track built around 1837 from the Baltimore & Ohio Railroad Pratt Street line north to Franklin Street. Around 1838, the B&S built south from its Bolton Depot to meet this line.

The southernmost 6 miles of the new line began on March 9, 1887, as the steam locomotive operated Annapolis & Baltimore Short Line Railroad handling freight and passengers between Annapolis and Baltimore. Facing financial problems, it was foreclosed and became the Baltimore & Annapolis Short Line in 1894, with electrification completed in 1908. The Washington, Baltimore & Annapolis Electric Railway was completed in 1908. Both lines were parallel for 3.5 miles between Linthicum and Clifford and merged on February 21, 1921. The rail service was replaced by buses on February 5, 1950.

There were two gaps. The first was a 0.7-mile section from the end of the Northern Central Railroad right of way at North Avenue to Howard Street. The second was a section 2.7-miles long south of Camden Station to the north end of Baltimore & Annapolis right of way near Patapsco Avenue. To handle the first gap, the line crossed Mt. Royal Avenue at Dolphin Street, went one block on Dolphin Street to Howard Street, and went alongside Howard Street on reserved track to Martin Luther King Jr. Boulevard, where it went into the center of Howard Street. The second gap was handled by building a 3,760-foot-long concrete viaduct south of Camden station over CSX Transportation tracks at Ostend Street, and curving across the Middle Branch landing north of Clair Street where it paralleled Kloman Street southward to Westport station. Heading south, the line rose on a bridge over CSX Transportation's South Baltimore branch and came down to cross Waterview Avenue at grade. From that point south, the Baltimore & Annapolis Railroad right of way was used.

In December 1989, a restudy of the project estimated the cost would be $469 million, which was 62 percent higher than the original $292 million. Some of the ways the project cost was reduced included having more single instead of double track sections and eliminating the Timonium Road bridge. The first rails were laid near the Timonium fairgrounds on September 28, 1990. During construction, provision was made for Conrail to use the track at night.

The new 4 foot 8.5 inches standard gauge light rail line opened on April 3, 1992, from Timonium to Camden Station to serve an exhibition game at the new Oriole Park at Camden Yards. Initially service was only for ball games. Full regular revenue service began on May 17, 1992, between Timonium and Camden Station in Baltimore. On August 30, 1992, the line was opened 3.2 miles south from Camden Station to Patapsco Avenue. The line was extended from Patapsco Avenue to Linthicum on April 2, 1993, and opened to Cromwell-Glen Burnie on June 20, 1993, with 35 new light rail vehicles (LRVs) Nos. 5001-5035, supplied by Asea Brown Boveri Traction Inc. (ABB). A 4.5-mile extension north to Hunt Valley opened on September 9, 1997. When the 2-mile spur to Baltimore Washington International Airport and 0.25-mile spur to Penn Station both opened on December 5, 1997, the light rail system totaled 29.3 miles. An additional 18 LRVs Nos. 5036-5053, ordered from Adtranz (successor to ABB) identical to the first 35 cars, were received in 1997-1998.

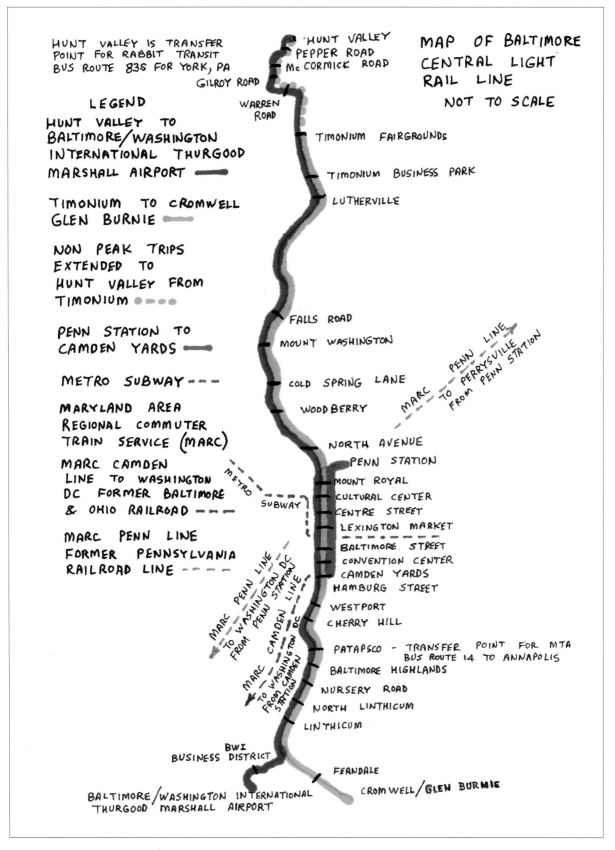

The 2017 map of the 29.3-mile Maryland Transit Administration (MTA) Central Light Rail Line shows three services: Hunt Valley to BWI Airport, Timonium (non-peak trips extended to Hunt Valley from Timonium) to Cromwell Station/Glen Burnie, and Penn Station to Camden Yards. From 1961-1971 the MTA was known as the Metropolitan Transit Authority, renamed Mass Transit Administration from 1971- 2001, and since 2001 is the Maryland Transit Administration.

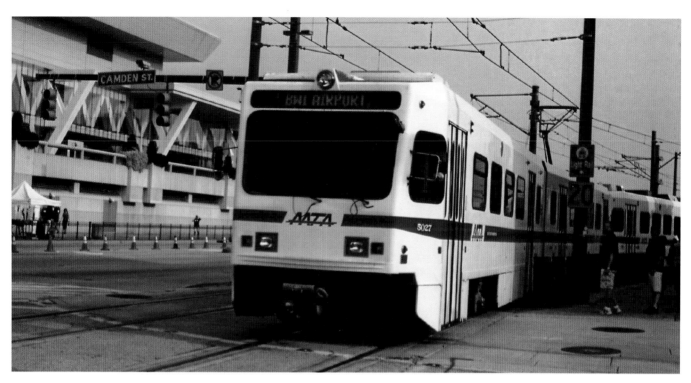

MTA light rail vehicle No. 5027 is part of a two train at Camden Street on July 28, 2007. The line initially opened with 35 vehicles, Nos. 5001-5035, built by Asea Brown Boveri (ABB) Traction Inc. For extra strength, the corrosion resistant steel car body has the roof and underframe linked by wall columns. Car bodies were built in Denmark, electrical equipment came from Sweden, and the final assembly was done in the United States. Car length over the couplers is 95 feet. Line voltage is 750 volts dc, and the maximum speed is 50 miles per hour. (Kenneth C. Springirth photograph.)

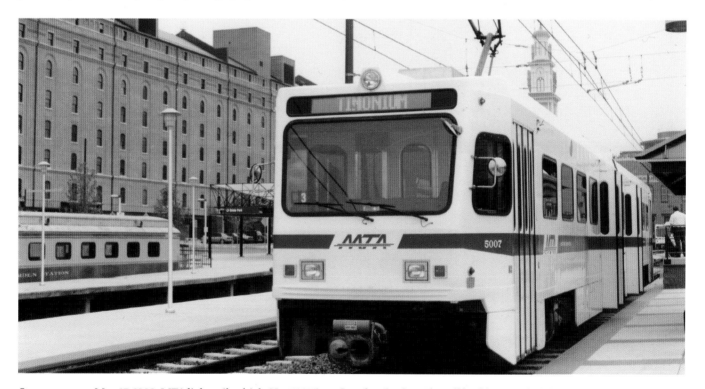

On an overcast May 17, 1992, MTA light rail vehicle No. 5007 is at Camden Station. The tall building on the left was the former Baltimore & Ohio Railroad Warehouse completed in 1905, used by the railroad until the 1960s, and is now used by the Baltimore Orioles. On the other side of the warehouse is the Baltimore Orioles Baseball Park at Camden Yards. When the line opened on April 3, 1992 to serve the new baseball park, nine two-car trains brought 4,400 people to the first game. During April 1992, the line only operated for baseball games from three hours before start to two hours after the end of the game. (Kenneth C. Springirth photograph.)

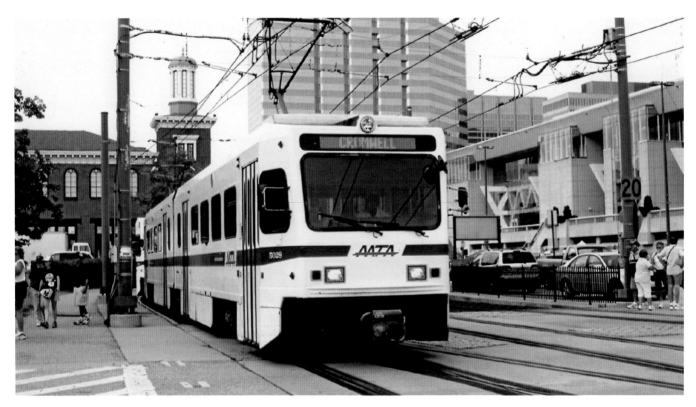

Southbound two-car train headed by light rail vehicle No. 5028 is at Camden Yards on July 28, 2007. The first revenue light rail service to Camden Yards carried 4,400 fans for the April 3, 1992 Baltimore Orioles' exhibition game with the New York Mets and 4,543 travelled on light rail on April 6, 1992 to watch the Orioles play the Cleveland Indians. (Kenneth C. Springirth photograph.)

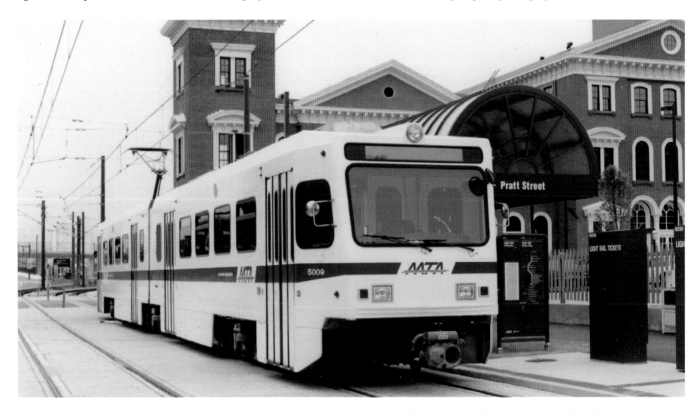

On May 17, 1992, light rail vehicle No. 5009 is at Howard and Pratt Streets. Each vehicle has four doors on each side, weighs 106,000 pounds, and has four 750-volt AC motors with power supplied by an overhead wire. The six-axle single articulated car seats 84 passengers with standing room for 88, making the total capacity 172 persons. Cars can be operated in a three-car train with one operator. (Kenneth C. Springirth photograph.)

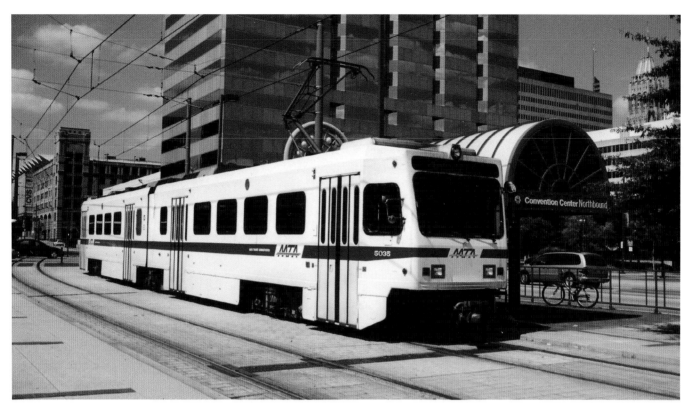

Under a bright sunny sky, Convention Center station (originally called Pratt Street station) is the location of northbound light rail vehicle No. 5035, ready to cross Pratt Street on July 5, 1998. This station, at the corner of Pratt and Howard Streets, is close to the Baltimore Convention Center that opened in August 1979. (Kenneth C. Springirth photograph.)

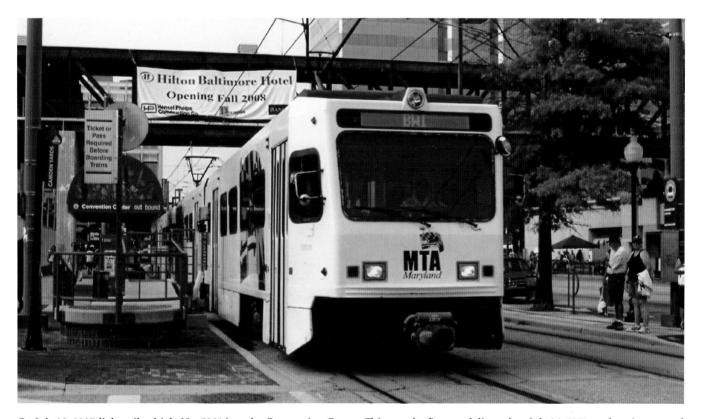

On July 28, 1907, light rail vehicle No. 5001 is at the Convention Center. This was the first car delivered on July 24, 1991, and testing started on about a two-mile section between North and Union Avenues in Baltimore. The second car, No. 5002, arrived on October 10, 1991. (Kenneth C. Springirth photograph.)

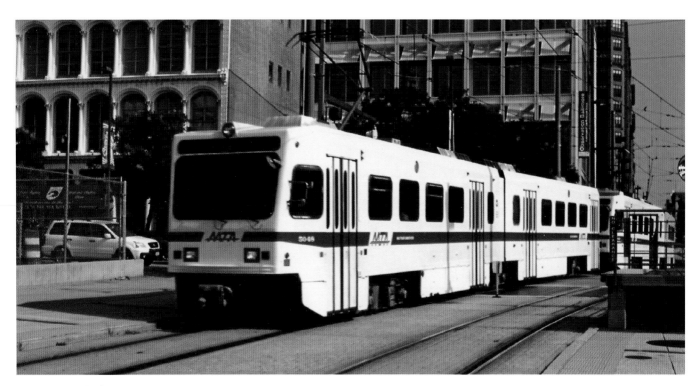

Howard Street at Pratt Street is the location of light rail vehicle No. 5048 on July 28, 2007. Howard Street has had a long history of rail transportation. In 1838, track was laid in Howard Street to connect the Baltimore & Ohio Railroad with the Buffalo & Susquehanna Railroad. By 1872, the railroad trackage was removed. Horsecar companies began using Howard Street, laying track from Cathedral Street south to Conway Street, by 1882. (Kenneth C. Springirth photograph.)

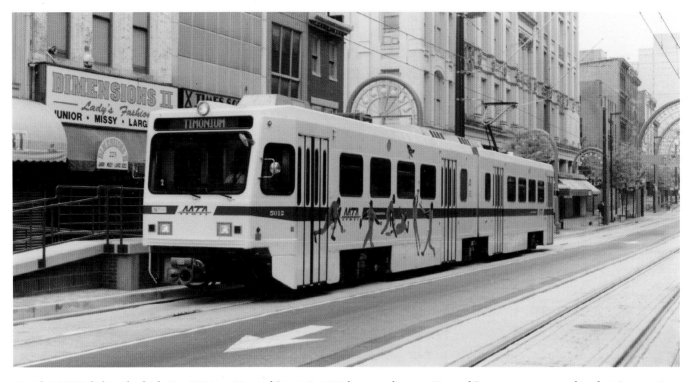

On July 17, 1992, light rail vehicle No. 5012 is on Howard Street. By 1893, horsecar lines on Howard Street were converted to electric operation. After the January 25, 1899 consolidation of Baltimore's streetcar companies into the United Railways & Electric Company (UR&EC), more streetcar routes used Howard Street including 10, 12, 23, 25, 26, and 32 by 1923. On July 3, 1941, streetcars no longer operated on Howard Street north of Baltimore Street. With the September 4, 1955 conversion of route 32 to bus operation, all streetcars were removed from Howard Street. However, 37 years later, on April 3, 1992, rail service returned to Howard Street. This once-major retail district, with a number of historic buildings, has been struggling in recent years. (Kenneth C. Springirth photograph.)

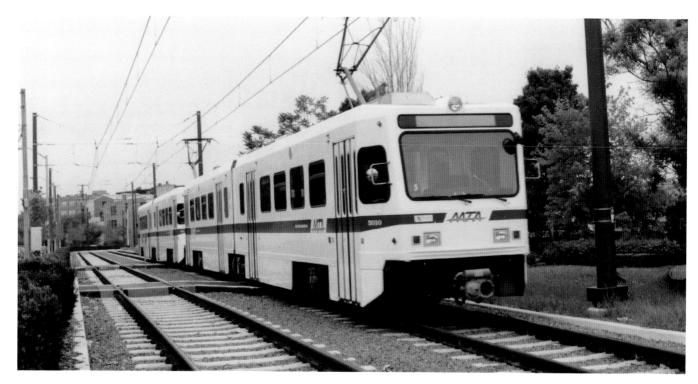

Light rail vehicle No. 5010 is part of a two-car train at Preston Street, which is north of the Cultural Center station on May 17, 1992. (Kenneth C. Springirth photograph.)

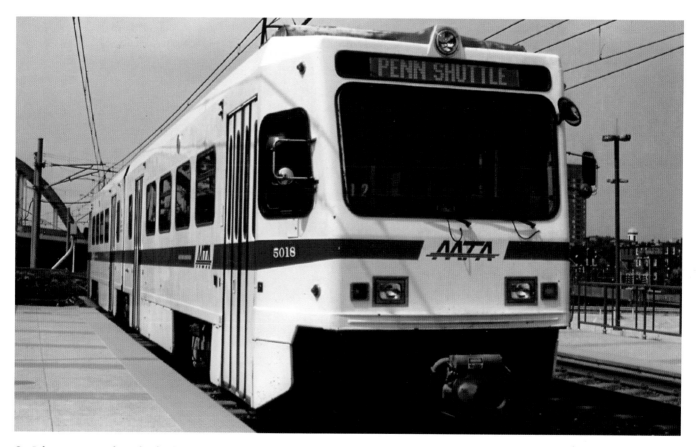

On July 28, 2007, Light rail vehicle No. 5018 is at the North Avenue station, which is one of the 33 stations on the Baltimore Central Light Rail line. Certain trips originate and end at this station. In April 1990, Consolidated Rail Corporation (Conrail) received $17.5 million for the 14.2 miles of the Northern Central Railroad line between North Avenue and Cockeysville, plus 34 acres north of North Avenue for the new car and storage yard which became the major light rail maintenance facility. (Kenneth C. Springirth photograph.)

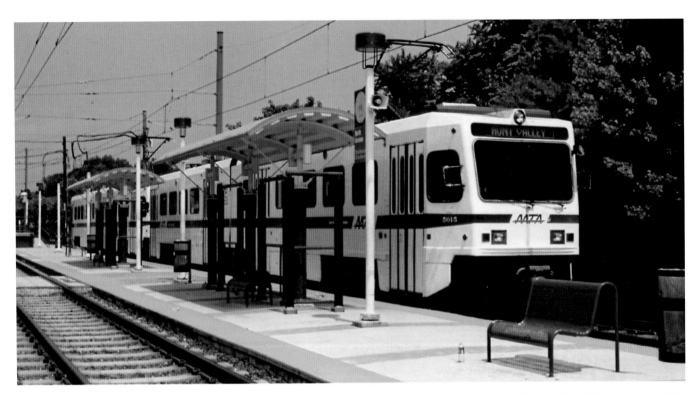

North Avenue is the location of a two-car train with light rail vehicle No. 5015 at the rear on July 28, 2007. Double tracking of the south end of the light rail line was completed on December 5, 2004. The section between North Avenue and Timonium was completed on December 4, 2005. To complete the double tracking project, it was necessary to shut down the line from Timonium to Hunt Valley. On February 26, 2006, service was restored, marking the completion of the 9.4 miles of double track project that began in early 2005. (Kenneth C. Springirth photograph.)

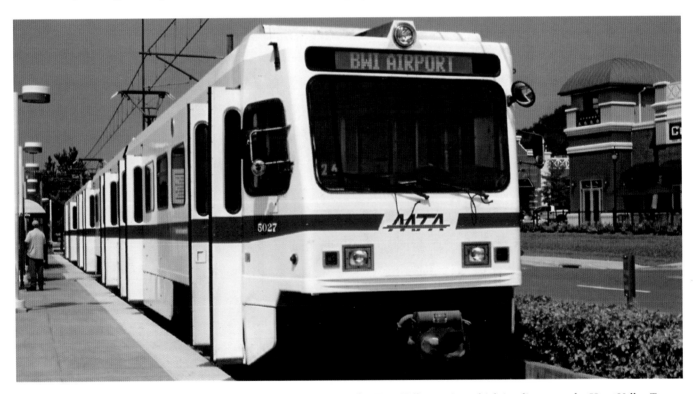

On July 28, 2007, light rail vehicle No. 5027 is part of a two-car train at the Hunt Valley station which is adjacent to the Hunt Valley Towne Center Shopping Center. The 4.5-mile extension from Timonium to Hunt Valley opened on September 9, 1997, with light rail vehicle No. 5036 used for the ribbon cutting ceremony. LRV #5036, the first of 18 additional LRVs from Adtranz (successor to ABB), identical to the first 35 cars, arrived on July 17, 1997. Damaged in route, it was sent back to Adtranz's Elmira, New York plant on July 24, 1997 for repair and was returned on August 7, 1997. (Kenneth C. Springirth photograph.)

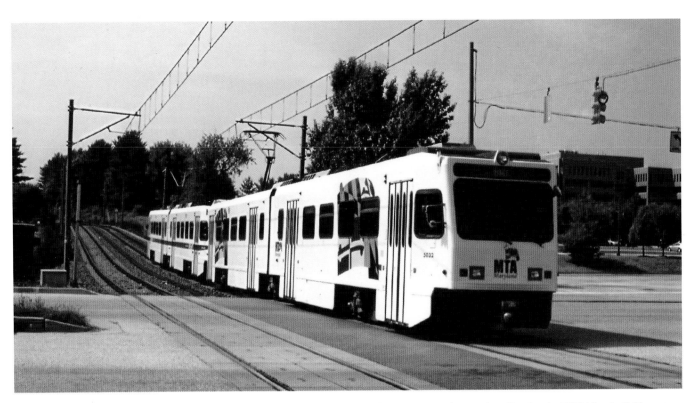

Southbound from Hunt Valley station is a two-car train with light rail vehicle No. 5032 in the rear heading for the BWI Marshall Airport on July 28, 2007. The Maryland Transit Administration 2014 Annual Report stated that light rail weekday ridership was 25,183, and the annual light rail ridership was 8,105,743. (Kenneth C. Springirth photograph.)

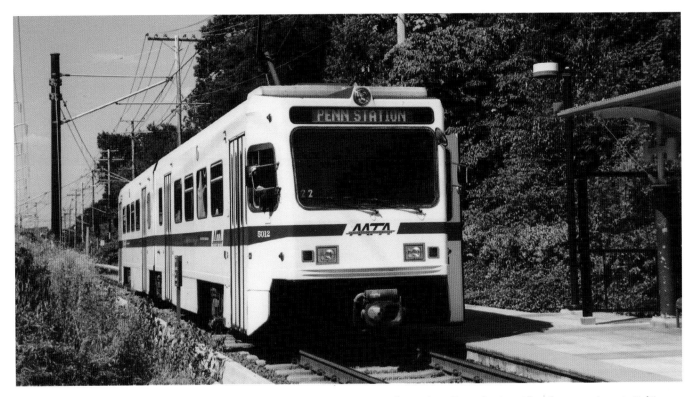

On July 5, 1998, light rail vehicle No. 5012 is leaving North Linthicum station for a trip to Penn Station. After the extensions to Baltimore Washington International (BWI) Airport and Penn Station opened on December 5, 1997, the line operated as two routes: Hunt Valley-Cromwell/ Glen Burnie and BWI Airport-Penn Station. In 2016, the line operates three services: Hunt Valley-BWI Airport, Timonium-Cromwell/ Glen Burnie with service extended from Timonium to Hunt Valley during off peak hours and weekends, and Penn Station-Camden Yards. (Kenneth C. Springirth photograph.)

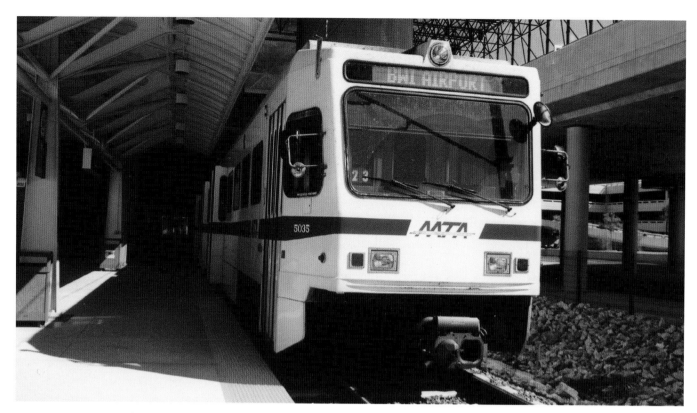

Baltimore Washington International (BWI) Airport is the location of light rail vehicle No. 5035 on July 5, 1998. On October 1, 2005, the airport was renamed BWI Thurgood Marshall Airport to honor the former Supreme Court Justice who grew up in Baltimore. The light rail line links the airport to a number of destinations in Anne Arundel County, city of Baltimore, and Baltimore County. (Kenneth C. Springirth photograph.)

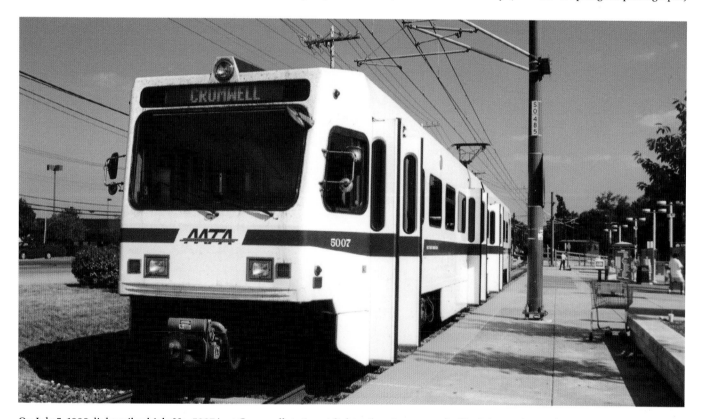

On July 5, 1998, light rail vehicle No. 5007 is at Cromwell station. A light rail maintenance facility is located near this station. MTA Maryland bus route 14 links this station with Annapolis, Maryland. To reach Penn station in Baltimore from this station, take any northbound train to Camden Yards and transfer to a light rail train labeled Penn-Camden Shuttle. (Kenneth C. Springirth photograph.)

Chapter 12

Baltimore Streetcar Museum

In 1928, United Railways & Electric Company (UR&EC) held "The Fair of the Electric Pony" a parade of vintage and modern cars. As a result of this event, UR&EC placed one car of each early type in storage for a future museum. The collection was housed at the Irvington carhouse. After Baltimore Transit Company (BTC) took over, the cars were viewed as a fire hazard. With car survival at stake, George F. Nixon, transit historian, and other dedicated rail enthusiasts were able to get BTC to save the collection until a place could be found. With help from the Baltimore Chapter of the National Railway Historical Society, the Maryland Historical Society agreed to act as a temporary host. In July 1954, the BTC donated eight vintage streetcars to the Maryland Historical Society. The National Capital Historical Museum of Transportation (NCHMT) from Washington, D.C., and the Baltimore group working together secured a site at Lake Roland in Baltimore County for the standard gauge cars from Washington, D.C., and the broad gauge cars from Baltimore. In September 1962, the Baltimore collection arrived at the site.

Neighborhood concerns over an operating railway museum in the Robert E. Lee Park made it necessary to find another location. NCHMT reached agreement in 1965, to establish their museum in the Northwest Branch Park of the Maryland National Capital Park & Planning Commission in Montgomery County, Maryland. In 1966, the City of Baltimore under Mayor Theodore R. McKeldin made it possible for the Baltimore collection to locate along the former Maryland & Pennsylvania Railroad right of way paralleling Falls Road north of the North Avenue bridge. The carhouse was erected to house the collection with city funding in 1968. Museum volunteers invested their time and money to rescue track excavated from Baltimore streets which was reinstalled at the museum. On May 6, 1970, the first streetcar operated at the museum, which officially opened to the public on July 3, 1970. The Visitor's Center opened in 1977. Baltimore's 5 foot 4.5 inches track gauge, the widest track gauge for streetcars in North America, has been maintained at the museum for prototype accuracy.

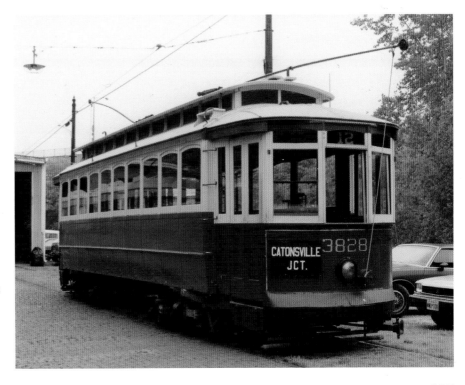

Former United Railways & Electric Company (UR&EC) double-ended ten-window (on each side) closed car No. 3828 is ready for the next assignment on May 17, 1992, at the Baltimore Streetcar Museum. This 39.17-foot-long double-truck car was built by J. G. Brill Company in 1902. Powered by two Westinghouse type 306CV motors, the car weighed 31,030 pounds and seated 36 passengers. (Kenneth C. Springirth photograph.)

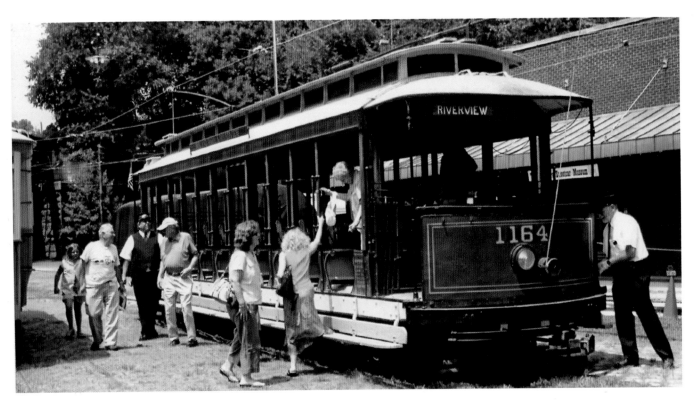

As the well-dressed knowledgeable motorman and conductor prepare for the next trip, passengers are boarding former UR&EC double end 12-bench open car No. 1164 at the Baltimore Streetcar Museum on July 28, 2007. The 40.42-foot-long double truck car (built by J. G. Brill Company in 1902) weighed 30,740 pounds, seated 60 passengers, and was powered by two Westinghouse type 306CV motors. (Kenneth C. Springirth photograph.)

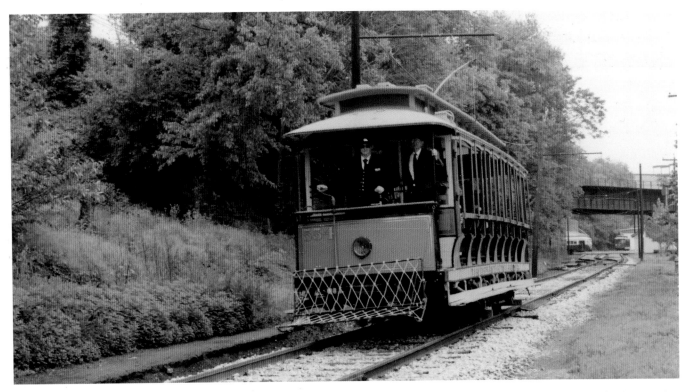

On May 17, 1992, former Baltimore Traction Company single truck open car No. 554 (built by Brownell Car Company in 1896) provides a fun ride over trackage that represents the work of volunteers for its placement and ongoing maintenance at the Baltimore Streetcar Museum. Powered by two Westinghouse type 49 motors, the 31-foot-long double-end car weighed 17,850 pounds, and seated 45 passengers. (Kenneth C. Springirth photograph.)

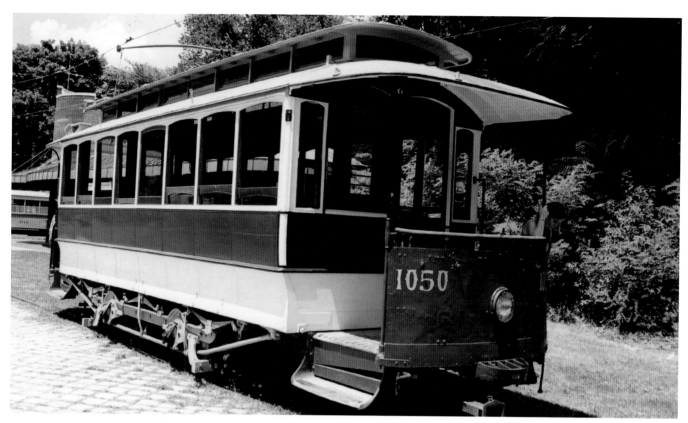

If you are a transportation enthusiast or looking for a fun activity, it is fantastic to view former Baltimore Consolidated Railway Company single-truck eight-window (on each side) closed car No. 1050 in this July 5, 1998 view at the Baltimore Streetcar Museum. This 30.67-foot-long double-end car was built by Brownell Car Company in 1898. Powered by two Westinghouse type 49 motors, the car weighed 18,300 pounds and seated 28 passengers. (Kenneth C. Springirth photograph.)

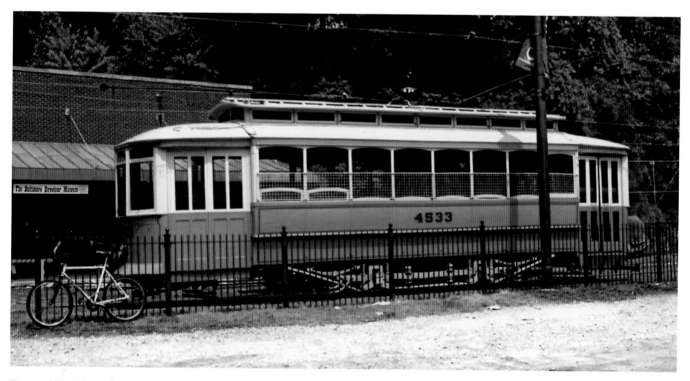

Former UR&EC single truck car No. 4533 is parked near the front entranceway of the Baltimore Streetcar Museum on July 28, 2007. Built by J. G. Brill Company in 1904, the 36.17-foot-long double-end car weighed 26,600 pounds, seated 38 passengers, and was powered by two Westinghouse type 101B motors. (Kenneth C. Springirth photograph.)

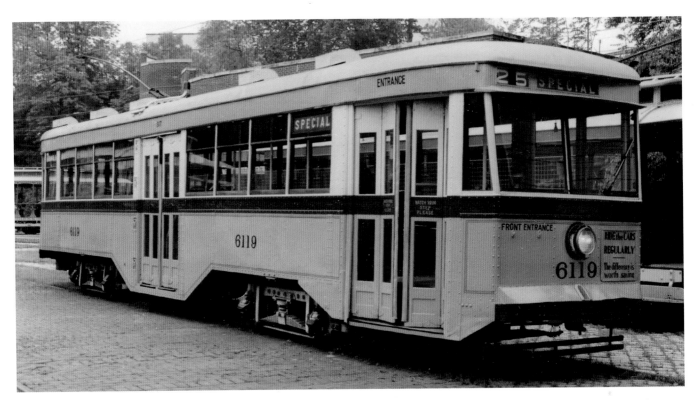

On May 17, 1992, former (UR&EC) single end Peter Witt type car No. 6119 (built by J. G. Brill Company in 1930 and named after the designer who promoted the front entrance, center exit car for faster loading of passengers during rush hours) is ready for duty at the Baltimore Streetcar Museum. Powered by four General Electric type 301 motors, the 46-foot-long double-truck car weighed 38,500 pounds and seated 52 passengers. (Kenneth C. Springirth photograph.)

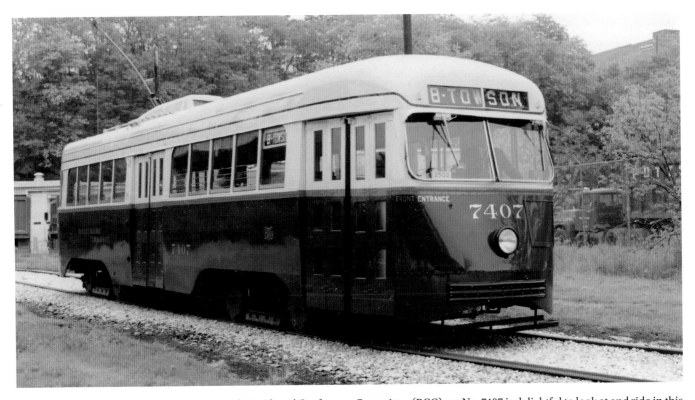

Former Baltimore Transit Company single-end Presidents' Conference Committee (PCC) car No. 7407 is delightful to look at and ride in this May 17, 1992 scene at the Baltimore Streetcar Museum. Built by Pullman-Standard Car Manufacturing Company in 1944, the 46-foot-long double truck car weighed 37,900 pounds, seated 54 passengers, and was powered by four Westinghouse type 1432H motors. This was the last regularly scheduled streetcar to operate in Baltimore on November 3, 1963. (Kenneth C. Springirth photograph.)